COVENTRY'S
MOTORCAR
HERITAGE

COVENTRY'S MOTORCAR HERITAGE

DAMIEN KIMBERLEY

The
History
Press

First published 2012
Reprinted 2016

The History Press
The Mill, Brimscombe Port
Stroud, Gloucestershire, GL5 2QG
www.thehistorypress.co.uk

British Library Cataloguing in Publication Data.
A catalogue record for this book is available from the British Library.

ISBN 978 0 7524 5448 1

Typesetting and origination by The History Press
Printed in Great Britain

CONTENTS

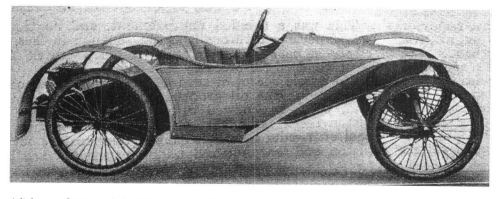

A light car of 1914 made by Walter Spittle at Cherry Street, said to resemble the 'Carden' model

ACKNOWLEDGEMENTS

In compiling this publication, I would like to thank the following organisations for their help and support: Coventry Transport Museum (Lizzie Hazlehurst-Pearson and Chris van Schaardenberg), The History Centre, Coventry (The Herbert – Andrew Mealey), Lincolnshire Archives (Claire Weatherall), The National Motor Museum (Patrick Collins and Jon Day), Christchurch City Libraries (Allison Page), Auckland City Libraries (Marie Hickie), Kelly College (Claire Harding), Warwick County Record Office (Pauline Archer), North Yorkshire County Record Office (Tom Richardson), Musée International d'horlogerie (Karla Vanraepenbusch), and the Calgary Diocèse (Bernice Pilling).

In obtaining further information and photographs, I would also like to extend my gratitude to Paul Newsome, Dave Butler, Lee Hitchin, Brian Long, John Spicer, John Maguire, Mike Maguire, Sarah J. Robinson, Pat Davis, Brian Healey, Tom Smith, Mike Jacques, Margaret Hartley, Mick Sanders, David Nalson and Katy Rayner.

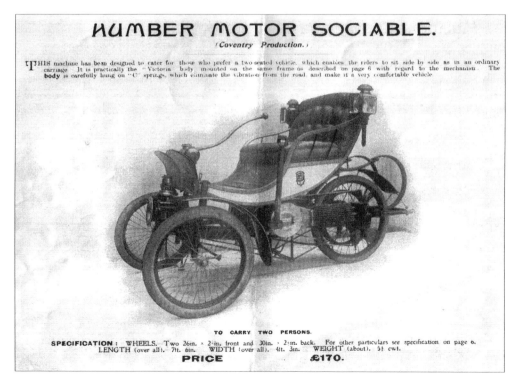

A Humber 'Motor Sociable' taken from Humber & Company's 1899 sales brochure entitled *Humber Motors*.

INTRODUCTION

Despite the variety and importance of its many products, if you were to ask anywhere in the world, 'What does Coventry produce?' invariably the answer would be – motorcars. This is not without reason, for Coventry was the birthplace and today is the centre of the British Motor Industry.

So said a 1951 publication entitled *Coventry Produces*, at a time when the city really was at its height in terms of the volumes of cars being turned out of its factories and the thousands of workers employed there.

However, the motor industry had begun in Coventry some fifty-five years earlier, when the notorious engineer and company promoter Harry Lawson established a motor manufacturing works in the city – a factory he was to call the 'Motor Mills'.

At that time, Coventry was regarded as the chief bicycle manufacturing centre of the world, having commenced the production of velocipedes from late 1868. From the early 1870s, factory after factory began to spring up for the purposes of making bicycles and tricycles until the industry's peak in the 1890s. It would soon be the production of motorised transport that would steadily displace the bicycle over time, so the fact that Coventry would be its principal centre was a stroke of good fortune for the thousands already employed in the city.

This new industry, though, progressed not without difficulty as few in Britain held the engineering capabilities that had existed in European countries like Belgium, France and Germany. A publication of 1918 entitled *Coventry and its Industries* summed these difficulties up superbly:

> There were many reasons why the motor trade did not flourish at the outset, none of which had anything to do with the city in which the vehicles were built. For the most part the early failures were because few manufacturers had definite knowledge to work upon, and inventors, possessed of no engineering knowledge or experience, nor even powers of organization, were allowed to squander huge sums of money provided by a dazzled public, on their hair-brained ideas. Again, many patents were held by continental inventors, and big royalties had to be paid before manufacture could be taken in England. Further, more suitable machinery for the economical and efficient manufacture of motorcars was not in existence. As the industry developed, all this was changed; rule-of-thumb workshop methods gave place to the cold accuracy of the technical draughtsman and the mathematician. The old-fashioned calliper was displaced by the micrometer, the 12-inch straight edge by the Vernier gauge. Questions involving standardisation and interchangeability of parts and quantity production received consideration until, in a few years; the manufacture of motor vehicles was put on a scientific footing.

From that point onwards, skilled mechanical engineers, draughtsmen, coach builders, and countless related others flocked to the city from all over the country, and in some cases much further afield. Many of the city's well-established cycle manufacturers began to experiment in motor production including Bayliss-Thomas, Humber, Riley, and Swift. New companies also began to be formed purely for the purpose of making motorised vehicles, including Beeston, Carlton, Endurance, and Standard. Countless engineers, who cut their teeth at either Daimler or the Great Horseless Carriage Company soon after started up their own motor companies. Many of these pioneering concerns lasted only a year or two, whereas others went on to become great names in motor manufacture.

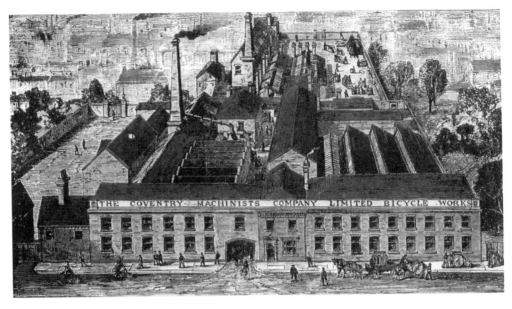

The Coventry Machinists Company made their first velocipedes from late 1868.

The Coventry Cotton Spinning & Weaving Company factory became the 'Motor Mills' in 1896. Much of this historically significant site was destroyed during the Second World War, although the Daimler offices and the old engine house remain.

In 1901, the population of Coventry was just under 70,000, yet by 1911 this had risen to 106,000, an increase of some 50 per cent. The growing motor industry was the prime catalyst for such an increase, with larger companies including the likes of Daimler, Humber, Hillman and Standard employing thousands of skilled staff between them. An influx of such magnitude forced great expansion throughout the city, as new land was purchased to build adequate housing and factories, whilst helping to alleviate the congestion of much of the city's central areas. Thus, the motor trade began to change the old city of Coventry, and would continue to do so throughout the remainder of the twentieth century.

By 1913, such was Coventry's industrial and social growth that the city boasted no less than twenty-five separate car-making companies, and was responsible for nearly a third of all car output in Great Britain. During the First World War, many of the city's

A rare interior view of the Motor Mills. Several Lawson-linked companies occupied floor-space during the early years.

Harry Lawson, one of the leading founder figures of the British motor industry.

automotive factories were turned over to that of wartime production, and, on conclusion, many more firms came into being for the purposes of making motors. Once again, however, many of these new businesses were short-lived as the Depression kicked in, yet many of the larger, well-established motor-manufacturing concerns survived and later flourished.

In 1928, the well-known companies of Hillman and Humber combined forces and within a few years both were owned by the Rootes Brothers, who were steadily building up their motor manufacturing empire. In many ways, amalgamations such as this signalled the end of many independent motor firms, as throughout the country, company after company either closed or were progressively swallowed up over the decades to eventually become global giants like the British Motor Corporation or British Leyland.

By 1950, only twelve main motorcar manufacturers remained in Coventry, although thousands were employed in their factories: Alvis, Armstrong-Siddeley, Daimler, Hillman, Humber, Jaguar, Lanchester, Lea-Francis, Singer, Standard, Sunbeam-Talbot, and Triumph. Of these, Lanchester and Sunbeam were to last only a further six years, while the Daimler marque was adopted by Jaguar in 1960. Lea-Francis and Standard were next to fall in 1961 and 1963 respectively, and by 1964, the Rootes Group-owned Hillman and Humber names had been absorbed by the Chrysler Corporation. Armstrong-Siddeley ceased the manufacture of cars in 1966, and Alvis followed suit a year later. Chrysler-owned Singer made their last car in 1970, and Triumph, who made their first cars in 1923, were taken on by Standard in 1945 – yet outlived their parent company in Coventry by some seventeen years, the last Triumph car being made at Canley in 1980. Jaguar themselves had come under the control of British Leyland in 1968, and by the mid-1980s, the only car assembly plants surviving in the city were Browns Lane and Ryton, producing Jaguar, Daimler and Peugeot models. Under Ford ownership, Jaguar made their last Daimler models at Browns Lane in 2002 and their final Jaguar models in 2005. Peugeot closed their Ryton plant just two years later; bringing an end to mass car manufacture in Coventry after the first Daimler models had appeared from the Motor Mills some 110 years earlier.

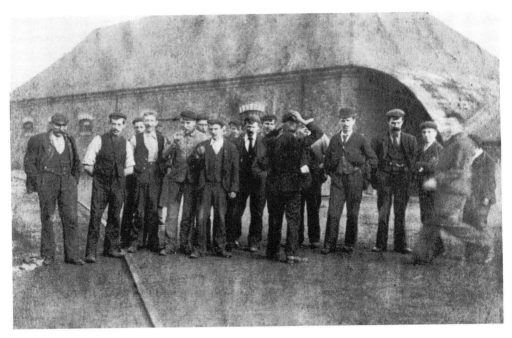

A group of Daimler/MMC workers assemble for a photograph in the grounds of the Motor Mills. Note the railway line – an old siding from the Coventry to Nuneaton route.

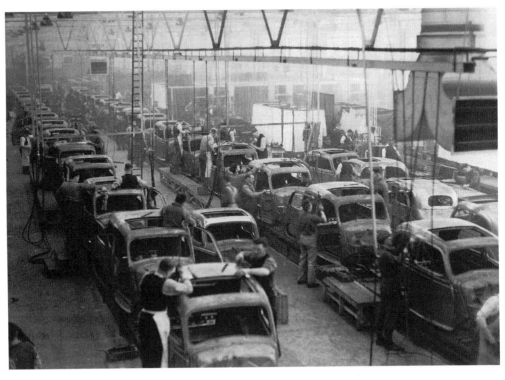

Standard Flying Eight assembly at the Canley works in 1938. The factory was first developed during the First World War.

As a city, Coventry has not been adverse to change throughout its long history. The long established weaving and watch trades both had their peaks and troughs, eventually making way for the sewing machine and cycle industries. The motor industry then began a new chapter regarding the city's industrial, social and economic fortunes, yet technology would inevitably progress and political climates would change, and, as history has taught us, no industry is guaranteed a lifetime of security.

Although Coventry is no longer looked upon as the motor manufacturing giant it once was, in terms of its involvement, there are some hopeful signs on the horizon. The London Taxi Company, established as Carbodies in 1919, continues to produce the famous black cab, whilst Jaguar Land Rover have confirmed their Whitley site as their global headquarters. Coventry Prototype Panels (CPP) have put forward proposals to manufacture the supercars of Spyker, Jenson, and Bowler at Jaguars spiritual home, Browns Lane, whilst Tata Motors have chosen the University of Warwick as their base to develop their 'Vista' electric cars.

The days of Coventry's heavy involvement as a principal centre of motor manufacture have clearly long gone, yet for those looking to explore such an eventful past, Coventry Transport Museum offers a wonderful insight into the many companies, factories and people who worked in them, as well as the many vehicles they produced.

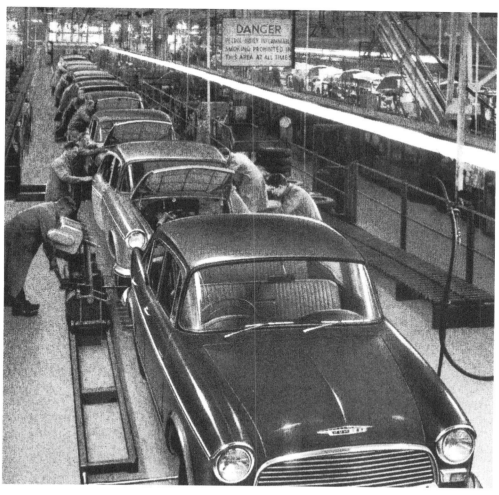

Humber Hawk Series I assembly at Ryton in 1957. The Ryton site was one of several Government-initiated 'Shadow Factories' created in readiness for the Second World War.

A–Z OF COVENTRY MOTORCAR MANUFACTURERS & MARQUES

The following is an alphabetical list of all known Coventry motorcar manufacturers and marques dating from the beginnings of the British motor industry, along with other companies whose production details are less clear. It is partly based on a list of car manufacturers originally compiled by the Museum of British Road Transport (now Coventry Transport Museum) in a 1996 publication entitled *A Brief Guide to the Motor Manufacturers of Coventry*.

Many of the larger companies and their products have been well documented over the years. Others, however, have been more recently discovered through more thorough research, where in many cases the individuals behind the origins of the businesses had been forgotten. This list therefore hopes to provide, where possible, information surrounding the people who founded or worked for the companies. It also hopes to either prove or disprove whether some of the businesses or individuals included made complete cars. This list does not aim to cover complete company histories, or technical details of all products, yet instead aims to concentrate on the formations of the companies. The list does not include Coventry motor firms of more recent years but instead focuses on the origins and peak of the industry in the city.

The dates supplied are those in which the individual companies are thought to have produced motorcars based on research compiled to date. The dates shown in brackets indicate the probable lifespan of the company whilst in Coventry working in other areas outside car production. This list also includes manufacturers who produced forecars, cyclecars, and other near related vehicles.

If you have any new information, or photographs relevant to any of the following companies and individuals, then Coventry Transport Museum would be very interested to acquire such information and supporting evidence in order to update their records.

ACADEMY, 1905–1908
E.J. West & Co., Canal Bridge Motor Works, Foleshill Road

Enoch J. West had been developing cars under the 'Progress' name from 1897 at Foleshill, but by 1905 he also won a contract to build complete chassis for a London-based motoring school. Powered by Coventry-built 14/20hp White & Poppe motors, the 'Academy' car was also fitted with dual clutch and brake controls for tuition purposes. These cars were specifically manufactured for the National Motor Academy located at

The Academy car at Matlock Road, Coventry, in 1906. The driver is Turberville Smith.

Boundary Road in Notting Hill, London, and managed by Mr Turberville Smith (b. 1861) who offered twelve lessons for £3 3s. In 1906, a special Academy TT car was prepared and driven by Smith himself, although he reportedly ran out of fuel in the fourth round. West was thought to have supplied such vehicles until 1908, when he concentrated more heavily on the production of his own West-Aster range. His association with Smith, however, would continue for many more years.

(See also Progress, Ranger, and West.)

ACME / COVENTRY ACME, 1919 (1902–1933)
Acme Motor Co. Ltd, & Coventry Acme Motor Co. Ltd, Earlsdon Works, Osborne Road, & 6 Lincoln Street

The Acme Motor Company began life at works in Osborne Road, Earlsdon in 1902 with a working capital of 1,000 in £1 shares, not far from rivals the Rex Motor Manufacturing Company. Exactly who the men were behind the initial formation is not fully known, yet Frederick Allard of the Earlsdon cycle firm Allard & Company may have played a part. Acme began by making motor-bicycles powered by 2hp Minerva engines before later gaining enough knowledge and experience to build and manufacture engines of their own. It was indeed the production of motorcycles that became the bread and butter of the business, yet they later began to diversify by making sidecars by 1911. During the First World War they adapted production to that of assisting in the war effort, making parts for motorbuses and lorries including brake cams and blocks, gudgeon pins, and shell noses for the French government. Shortly after the conclusion of war in 1919, Acme were thought to have commenced the manufacture of motor bodies but were also listed in that year's Spennell's Coventry Business Directory under 'motorcar manufacturers', but, as yet, no evidence has been found to support this. Some senior employees known to have worked for the firm at this time included George Henry Hemingway (b. 1884) as Managing Director, Charles Albert Franklin (b. 1893), William Ellis (b. 1891), and William John Robb (b. 1860). It is believed that during wartime, Acme also began using the trade name 'Coventry Acme' and continued business, although not without difficulty, until 1922. At this point they merged with neighbours Rex to become the Rex-Acme Motor Company, specialising in motorcycle manufacture until 1933.

(See also Allard and Rex.)

AERO & MARINE, 1910–1927
Aero & Marine Engine Co., 61a Stoney Stanton Road

The Aero & Marine Engine Company was established sometime prior to 1910 through a partnership existing between four engineers – George Johnson, Daniel Hurley, James Martin and Albert Smith. Suitable premises were secured at Stoney Stanton Road next door to the Temperance Billiard Hall, where the partnership commenced business as 'motor and marine engine makers' and 'aeroplane fitters'. Whether any of these activities extended to that of complete car production, however, is unlikely. Birmingham-born Smith, and Johnson, who hailed from Crewe, left in late 1911. The company, renamed 'Coventry Aero & Marine', was then continued by Hurley and Martin, who by 1915 became engaged on government contracts making 'seaplane and chassis parts' to help in the war effort. Johnson, Hurley and Martin also independently set up at the Alpha Motor Works in 1904, whilst the Coventry Aero & Marine Engine Company appears to have dissolved around 1927, when all resources were consolidated to form the Alpha Engineering Company.

(See also Alpha and Forman.)

AIRCRAFT, 1919–1927
Aircraft Motor & Engineering Co., Motor & Engineering Works, Shakleton Road, Spon End

The firm were first seen listed in the 1919/20 Spennell's Coventry Business Directory hidden away at their Shackleton Road Works as 'motor car manufacturers' and were continued to be listed as such until 1927, yet actual details of engines, bodies, or vehicles built are not fully known. Arthur Henry Pattison (b. 1861) was known to have been works manager, and other staff included W. Woodford, George Barson, and Henry Victor Brooks. These premises were later thought to have been taken over by Alfred Grindlay's firm, Grindlay (Coventry) Ltd., makers of quality side-cars and high-powered 'Grindlay-Peerless' motorcycles which ran until 1939. Later occupants included William H. Lenton's Ritz Engineering Company, formed in 1941.
(See also C.M.S.)

ALBATROS, 1923–1924
Albatros Motors Ltd, Albatros Works, Croft Road

Albatros Motors began at Croft Road in the early 1920s making two light models powered by four-cylinder Coventry-Climax engines. An 8hp version could be purchased for £160, whereas the 10hp would cost between £210 and £260. Uncertainty surrounds the precise details regarding the individuals who founded the business, with two key names being noted by numerous sources. One possibility is Albert Ross, who cleverly manipulated his name to that of his business title, and the census reports of the time do indeed disclose a man of the same name who may fit the bill. It reveals an Albert Ernest Ross, born in Coventry in 1892 and the son of a Birmingham cycle filer. By the time Coventry's main industry had swung from cycles to motors during the early stages of the twentieth century, Albert, along with his father William and older brother John, were all working in the motor trade – Albert and his brother as 'motor turners' and William as a 'motor fitter', all residing at Berry Street. Albert was known to have married an Edith Beasley in 1922 and lived at Kensington Road by 1924, showing a rise in status. The second individual to be linked to the business is Herbert Thomas Wickham Manwaring, born at Tunbridge Wells in 1897. The son of a farmer and landowner, after attending the Royal Naval College as a Naval Cadet, he reportedly ran a motor garage in Kent whilst was also known to have mixed in aviation circles during the First World War. In September 1921, he applied for a patent (180,263) concerning 'improvements in wheels for tractors' whilst living at Horsmorden in Kent. It has been suggested that he began Albatros Motors in Coventry in 1923, choosing the name after Albert Ross, who had once been his manager and mentor at an unknown motor company. Regardless of the speculation, Albatros hit difficulties in 1924 and were soon wound up, only a handful of cars ever making full production.

ALLARD, 1898–1902 (1889–1902)
Allard & Co. Ltd, Earlsdon Cycle Works, 38 Moor Street, Earlsdon

Allard & Company were first set up as cycle manufacturers in 1889 at Moor Street through a partnership established between Frederick Allard, Benjamin Done and George Pilkington. They began through marketing their 'Royal Allard' safety bicycles until 1898, when they also began experimenting with motors. These initial models consisted of a De Dion type tricycle as well as a variation of the Benz car known as the 'Express', both being exhibited at Crystal Palace. Following this came belt-driven 2.5–3hp voiturettes, powered by engines based on the De Dion units, constructed using tubular frames and sourced by Pilkington's extended family business, the Birmingham Motor Manufacturing Supply Company. Such was the demand for these that Allard were not able to take their booked stand at the Royal Agricultural Hall due to

all resources needed in Coventry. Some unfortunate circumstances surrounded the business in July 1900, when the *Autocar* reported the fatality of a driver of an Allard motor. It was described as a four-wheeled vehicle of light construction, with two seats facing each other, being one of the firm's standard types known as the 'Rapid'. The article went on to say that one of Allard's works managers, Mr Montgomery (James), had the unfortunate duty of 'escorting the deceased out of Coventry on an Allard tricycle'. In 1901 they built their first motorcycle and Fred Allard himself was known to have raced a modified version of this in competitions. In 1902, they exhibited an Allard 9hp light car at the 8th Annual Motorcar Exhibition at the Agricultural Hall, London. Later that year business associates, the Birmingham Motor Manufacturing Supply Company, took over Allard, creating a new enterprise called the Rex Motor Manufacturing Company at larger works on Osborne Road, involving the Pilkington and Williamson brothers. Concerning the actual founders of Allard, however, Benjamin Done (b. 1853) of Kings Norton had left by the early 1890s, well before any motors were developed, joining forces with George Shuttleworth at Days Lane as 'manufacturers of cycle parts'. George Pilkington (b. 1861) of Birmingham had first met Allard at the Coventry Machinists before forming a partnership in 1889, and remained at the firm all the way through to the BMMSC takeover. He was then known to have held a senior position at Rex for much of its existence in Coventry. Frederick William Allard himself was born in Northampton in 1867 and arrived in Coventry some twenty years later. A keen cycle racer, a series of amateur victories saw him turn professional by the early 1890s, reaching the heights of 'Safety Champion of the World'. He appears to have severed his ties in the motor trade by the time of the Rex foundation, but was known to have represented the Rex Company on the national racing circuit for the next few seasons, and also owned a number of pubs in Coventry until his death in 1922. Also in 1922, the Coventry Acme Motor Company were seen to have been marketing 'Allard' cycles, yet whether Fred Allard was actually involved in the creation of this firm, which began in 1902, is not clear.
(See also Acme and Rex.)

ALLIANCE, 1898
The Alliance Cycle Co., 16 Grosvenor Road

This company was listed in the *Applications for Registration of Trade Marks* in August 1898 at Grosvenor Road. The man behind the firm was given as George Williamson, a former employee of the Coventry Machinists Company, who registered the 'Domino, Nomad and Incog' trademarks under his Alliance cycle firm. His business activities were stated as being 'bicycle, tricycle, other velocipede, and motorcarriage manufacturer', yet whether he actually realised all of these intentions will probably never be fully known. Number 16 Grosvenor Road was soon after occupied by Fred Kerby (b. 1866), owner of the Roulette Cycle Company.

ALPHA, 1904-1927 (1901-1987)
Johnson, Hurley & Martin Ltd, Alpha Motor Works, 55 Gosford Street

George Johnson, Daniel Hurley and James Martin had, like so many others to go it alone, previously worked for the Daimler Company before forming a partnership with Edwin Forman in 1901, making engines from their own designs at Days Lane. In late 1903, Johnson, Hurley and Martin decided to leave, and instead established a new company, tucked away in premises at Court 21, 55 Gosford Street, next to the Scott Tyre Works. First appearing in the 1904 Coventry Trade Directory under 'motor manufacturers', the three engineers devised their 'Alpha' engine, which was also believed by some to have been fitted to a car of the same name early on, but full details are scarce. Again like many, all hailed from outside Coventry. George Johnson (b. 1875) came from Crewe, Daniel Henry Hurley (b. 1868) from Hackney in London, and James

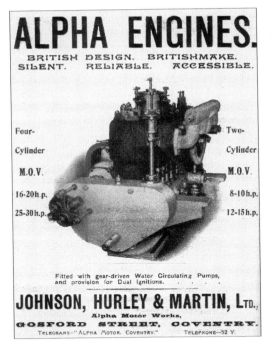

An advert of Johnson, Hurley & Smith showcasing their 'Alpha' engines.

Richard Martin (b. 1876) from Inkford Brook in Warwickshire. It would appear that it was with the manufacture of engines that the company really concentrated their efforts, later joined by Harry Cantrill (b. 1891) by around 1910. The same year they also began the Aero & Marine Company, and a year later applied for a patent (15,298) concerning 'improvements in valveless two-stroke internal combustion engines'. By this time, the main partners and their growing families were all well established in Coventry, the census reports revealing that Johnson (motorcar engineer) was living at Clara Street, Hurley (petrol engine manufacturer) at King Richard Street, and Martin (motorcar engineer) residing at Walsgrave Road. During the First World War they were contracted to make 'chassis and other seaplane parts' for their supporting part. From 1919 they were seen regularly under 'motorcar manufacturers' in the local trade directories, but in 1927 reformed as the Alpha Engineering Company, and a move to Stoney Stanton Road followed soon after. By the mid-1930s they were described as 'makers of Petrol Engines for industrial purposes', and after the Second World War steadily became more mechanical and general engineers. One final move came about in the 1950s, to Osborne Road, Earlsdon, and Alpha continued in engineering right up to 1987, with Daniel Hurley's son, Edward George Hurley (b. 1902), being listed as Chairman.
(See also Aero & Marine, and Forman.)

ALVIS, 1922–1967 (1919–1967)
T.G. John Ltd, Alvis Car & Engineering Co. Ltd, Holyhead Road

A once very famous name in British motoring, the origins of the Alvis Company was established shortly after the Great War in Coventry. Beginning as T.G. John Ltd at Holyhead Road and Lincoln Street in 1919, the company initially offered 'Electra' internal combustion engines for use, ranging from aeroplanes to cars and motorcycles. The company was founded by Thomas George John, who was born in 1880 at Pembroke Dock, South Wales. John followed his father into employment at the HM Dockyard, and was qualified as a naval architect by 1904, winning two scholarships with the Royal College of Science. He then went on to work at Vickers Limited in 1907, before joining Siddeley-Deasy in 1915 as works manager and chief engineer. After purchasing the American engineering firm of Holley Bros in Coventry following the war, John, with vital support from Geoffrey P.H. De Freville, set about creating a car that would unsettle the current light car market in Britain. Although not particularly competitive at prices from £750, the end result, in March 1920, was good looking and well engineered, its four-cylinder 1460cc engine being able to reach an impressive 60mph – in some cases a good 20mph more than its Coventry competitors. Much of the design and name of this first 'Alvis' 10/30 model is credited to De Freville himself, yet he did not remain with the company for long. Born at Chatham in Kent in 1883, in 1902 he found work at the Long Acre Motorcar Company at London, then agents for Wolseley motors and promoters of the 'Olol'

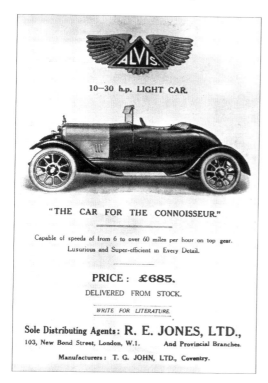

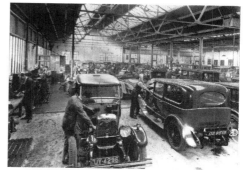

Alvis 'Silver Eagle' cars at the repair shop on Holyhead Road.

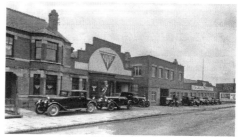

An advert showing the 10/30 Alvis model. The car was developed under T.G. John Ltd, prior to becoming the Alvis Car & Engineering Company.

A view of the Alvis works during the 1930s. This factory was all but destroyed during the Second World War and a new plant erected on land on the other side of the bridge.

registered lubricant. In 1914, at Wandsworth, he founded the company of Aluminium Alloy Pistons Limited, makers of castings and pistons for aero and tank engines. As Siddeley-Deasy became one of his first customers, so did his introduction to the works manager Thomas G. John, later making De Freville one of his founder employees at T.G. John Ltd. The workforce expanded rapidly to around 200, many of which had made the move from Wales, including George Edgar Morse (b. 1881) as foundry manager. In 1922, the company changed its name to that of the Alvis Car & Engineering Company, while at around the same time John secured the services of George Thomas Smith-Clarke (b. 1884), William Marshall Dunn (b. 1894), George Hope Tattersall (b. 1883), Charles Percy Joseland (b. 1899), and the young Arthur Francis Varney (b. 1907), among others. The company developed a solid reputation for their touring and sports models, notably the 12/50 Sports, the Silver Eagle, Crested Eagle, Firefly and 'Speed' series. During the Second World War, the company, by then known as Alvis Ltd, became involved in military vehicle projects, and from the late 1940s onwards this would become the staple concern of Alvis, going on to produce armoured cars and tanks including the 'Stalwart' and 'Scorpion' service models, amongst others. The factory was badly damaged during the Blitz, yet from 1946 onwards, with John J. Parkes (b. 1903) as Managing Director, the company produced a series of stylish TA, TB and TC models until eventually being acquired by the Rover Company in 1965. The final car to carry the famous Alvis name and built at Holyhead Road was the beautifully designed TF21 model with a top speed of 127mph. Alvis then concentrated on their military vehicle contracts on the site until closure in the early 1990s, the site has since been redeveloped as the Alvis Retail Park, the name itself being the only remnant of a motor manufacturing company once highly respected throughout the world.
(See also Buckingham and Marseal.)

ARIEL, 1907–1915 and 1922–1925 (1898–1965)
Ariel Works Ltd, Ordnance Works, Midland Road

The roots of the Ariel company name began in 1894 under the title of the Cycle Components Manufacturing Co. Ltd at Bournbrook in Birmingham. Becoming the Ariel Cycle Company in 1897, the business was managed by the Scot, Charles Sangster (b. 1873), who, after completing his apprenticeship at a London cycle manufacturers, arrived in Coventry in the early 1890s, gaining further experience in the trade. He joined Cycle Components in 1895 along with the Australian Selwyn Francis Edge (b. 1868), and both were prominent in convincing the owners, the Du Cros brothers, to develop motorized transport by 1898 – the first effort taking the form of a 1¾hp single-cylinder De Dion-powered tricycle. Their first car came about in 1901, being a 9-10hp tonneau-bodied model, fitted with many special features including a self-starting device and high-tension electrical ignition. In 1906, Ariel Motors Ltd sold off their Selly Oak Factory to the French car company Société Lorraine de Dietrich to raise some much-needed capital. Arrangements were then made by Sangster to have the 'Ariel-Simplex' motors made at the Coventry Ordnance factory, a branch of famous ship-builders Cammell Laird. Two models were entered in the 1907 TT with A.E. Harrison and Charles Sangster as drivers, both cars performing very well. Work ceased in 1915 and the Ordnance Works transferred production to assist the war effort, making massive naval guns amongst many other things. Car production resumed in 1922 with the Model 9 – a 998cc two-cylinder light car, followed by a 1097cc four-cylinder called the Model 10, lasting until 1925. The company's Ariel motorcycles, however, excelled and continued to be made at Birmingham until 1965.
(See also British Motor Traction, and Swift.)

ARMSTRONG SIDDELEY, 1919–1966 (1902–1966)
Armstrong-Siddeley Motors Ltd, Parkside, Cheylesmore

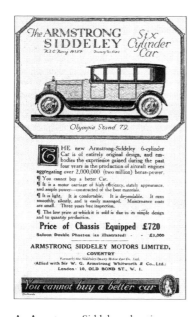

An Armstrong-Siddeley advertisement of 1919 promoting their six-cylinder model. Note the distinctive style of radiator and bonnet.

In October 1919, the Siddeley-Deasy Motor Manufacturing Company became Armstrong-Siddeley Motors Limited in a merger with the Armstrong-Whitworth Company of Newcastle-upon-Tyne. By now, John Davenport Siddeley, who was 53 years old, had made a personal fortune and had increased profits during the Great War, seeing both his sons, Cyril and Ernest, return from the Front intact. One would think that at such an age Siddeley would have been making plans for retirement, but it was to be a further seventeen years before he was to finally step down. Although, following the war, Siddeley had branched out in other engineering areas, on the car front the first model to use the Armstrong-Siddeley name was the Model 30, a six-cylinder 4960cc all-weather tourer, which ran until 1932. Smaller 14hp and 18hp models followed in the early 1920s, and in 1928 the sliding-type gearbox was abandoned in favour of their new 'self-changing' gear. By 1930, four models were on offer ranging from 12hp to 30hp. Like so many other Coventry motor companies, the Second World War saw a transfer of production, in this case to mostly that of aero engines, frames and gearboxes, and, inevitably, the factory became a prime target of the German Luftwaffe. With such a heavy concentration of factories in close proximity in Coventry, very few buildings escaped total obliteration and

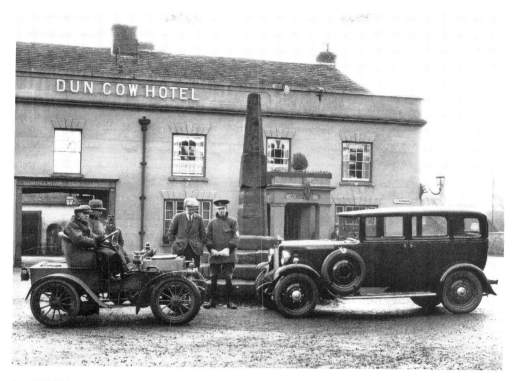

An old Siddeley autocar parks in front of an Armstrong-Siddeley model outside the Dun Cow Hotel at Dunchurch, Warwickshire in the mid-1920s.

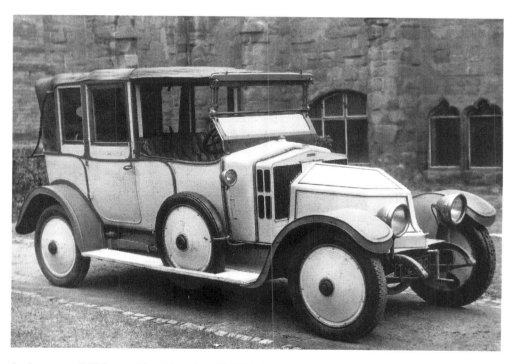

An Armstrong–Siddeley model positioned outside Whitefriars Monastery, Coventry.

Parkside was no exception and suffered immensely. Following the end of hostilities in 1945, Armstrong-Siddeley commenced car manufacture with the Hurricane model, followed into the 1950s with the Lancaster and Whitley saloons – all testament to their increasing involvement with the aero industry. Their most celebrated cars, however, were the Sapphire and Star Sapphire range, produced at the 25-acre Parkside site in great numbers from 1952 until the final ones built in 1966. Siddeley, a resident of Crackley Hall at Kenilworth for much of his life, was awarded a Knighthood (CBE) in 1932 for 'public services in connection with mechanical development in the Defence Forces'. In July 1935, he took the Armstrong-Siddeley Board of Directors by surprise when he sold his interests in the company to form Hawker-Siddeley Aircraft, eventually resigning from Armstrong-Siddeley in September 1936. This marked a significant end to one of the country's true motor pioneers, yet his name was still to remain with the company to its end in the mid-1960s. In the early years of Deasy and Siddeley-Deasy, when he had a relatively small workforce, John Siddeley reputedly took great pride in knowing each of his employees by name or, failing that, sight at least. But when he announced his retirement, one of his reasons for doing so was his admitted inability to no longer do this, but with a workforce of some 6,000 by this time, most would consider it forgivable. On the day he left, it was reported that there was little or no fuss; clearing his office, saying no farewells and quietly walking away. A deeply private and religious man, Sir John Davenport Siddeley became Lord Kenilworth in 1937 and soon after purchased Kenilworth Castle for the nation. He also gifted £100,000 each to Fairbridge Farm Schools and Coventry Cathedral. He died in Jersey in 1953 at the age of 87, just two weeks after the death of his wife of sixty years, Sara. Today, Parkside, once home to so many famous companies, incorporates no motor manufacturing facilities, yet has instead been developed by Coventry University as a Science & Technology Park.

(See also Deasy, Siddeley and Siddeley-Deasy.)

ARNO, 1908–1912 (1906–1915)
Arno Motor Co. Ltd, Arno Works, Dale Street, & Court 32, 85–86 Gosford Street

The Arno Motor Company began life at Dale Street to the rear of the Triumph Works in 1906, making TT and Touring motor-bicycles fitted with their own 3.5hp engines. Two years later they also began experimenting with the production of motorcars fitted with 20-25hp four-cylinder engines made by White & Poppe of Holbrooks, being displayed at the 1908 Stanley Show priced at £375, and lasting until around 1912. From this point onwards, Arno concentrated on motorcycles including a model called the 'Red Arno' in 1914 – 3.5 and 4.5hp racing machines that faired reasonably well at the Isle of Man Tourist Trophy events. This proved a costly business, yet the company did gain a contract to supply 'machinegun tripod feet, lashing hooks and other gun carriage parts' during the initial stages of the First World War, but they appear to have ceased trading soon after. To date, nothing certain is known about the individuals behind the Arno name, but the business was known to have been situated at Gosford Street for the most part of its existence, next door to both the Titan Motor Wheel Company and the Regent Motor Sidecar Company. The factory itself belonged to Samuel Gorton (b. 1854) and was later leased to the motorcycle and sidecar manufacturer and motorcar dealer William Montgomery (b. 1871), which may be connected. Another speculative link could be that of German-born Arno Sthamer (1868-1938), who was seen working as a 'cycle works clerk' in Coventry around the turn of the century after his wholesale tobacco business had failed in Leicester. By 1911 Sthamer and his family were living at Little Heath, Foleshill, where he was working as a 'commercial clerk in the cycle and motor trade'. After his first wife Louisa died in 1913, he married again at Kings Norton, Birmingham, which, interestingly, is where the Arno Motor Company name was wound up in 1915. In further support, in 1909 The Motor Radiator Company moved business from London into the Arno Motor Company's Dale Street works. This company was part-owned

by fellow German Hans Zimmerman, who may well have been an associate of Sthamer, and Siegfried Bettmann, whose Triumph factory was also situated off Dale Street. *(See also Motor Radiator and Triumph.)*

AURORA, 1903 (1902–1905)
Aurora Motor Manufacturing Co., 12 Norfolk Street

Swiss-born Charles Bourquin (b. 1875) first arrived in Coventry during the 1890s and found work as a 'watch maker' on his own account at Norfolk Street, Spon End – at that time a predominately watch manufacturing area of the city. Bourquin must have had quite a diverse engineering background because by 1902, he also began marketing his 'Aurora' motor-bicycle under the trading name of the Aurora Motor Manufacturing Company – one appearing at the Royal Agricultural Hall. These took the form of an adapted bicycle frame powered by a 2.5hp vertical Coronet engine, yet had a tendency to 'skid quite freely' according to some sources. The following year he added the Aurora Tri-Motor to his limited output, a 3.5hp fore-car along similar lines to the motor-bicycle using Coventry-built MMC, Condor and Whitley motors. In September 1904, *The Times* reported a news story which no doubt heavily embarrassed Bourquin:

> Charge of Thefts – The Magistrates at Coventry heard yesterday charges against Charles Bourquin, a local motor manufacturer, for stealing motorcycles and watches of the total value of £140. The watches were entrusted to the prisoner for repairs. He pawned two and the others were found on him in London. The cycles were alleged to be the property of local tradesmen. He afterwards sent them away, one being left at Euston Station. The prisoner was committed for trial at the quarter sessions on both charges.

Clearly not one of his proudest moments, it would seem that Bourquin had already decided to abandon Coventry and start afresh in London, and, by allegedly stealing the property of his

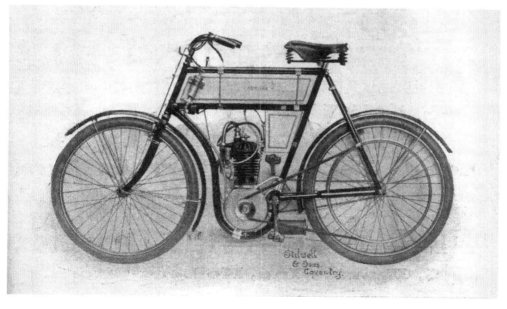

An Aurora motor-bicycle of 1903. The company's founder, Charles Bourquin, was not averse to controversy.

customers, thought that the proceeds would no doubt help to line his pockets. Bourquin may have stayed in London or spent time abroad over the following years as no trace of him can be found yet in 1914 he married a Miss Martha Wieneke at Marylebone. He also appears to have shelved motor engineering and resorted back to his original trade, as by 1924 he was working as a 'high-class watch maker' at Holborn, and continued to do so right the way through to 1963, at the grand old age of 88.

AUTOVIA, 1936–1938 (1890–1969)
Autovia Cars Ltd, Ordnance Works, Midland Road

The Riley Company made their first motorised vehicles in 1898, becoming a successful, reputable car manufacturer in their heyday. In the mid-1930s, the Riley board, spearheaded by Victor Riley (b. 1876), took the bold decision to create a car targeted at the luxury market, finding separate premises at Midland Road. The car was to be called the 'Autovia' with Gordon Marshall positioned as general manager and B.R. Hester-Baker as secretary. The key figure, however, was the former Daimler and Lea-Francis employee Charles Marie Van Eugen, who was given the position of chief designer under the new company title of Autovia Cars Ltd. Dutch-born Van Eugen first arrived in Coventry in 1913, and had gained plenty of experience before joining Lea-Francis ten years later, notably being responsible for the Lea-Francis 'Hyper' in which Kaye Don won the 1928 TT. In 1935 he and two other Lea-Francis draughtsmen were poached by Riley and given an office, where they set about making improvements to the existing Riley V8 engine. The concept was to create a stylish model to challenge the 25/30hp Rolls-Royce market and initially three prototype cars were built. These 2.8 litre cars were said to be capable of reaching speeds of up to 90mph and consisted of many notable features including a pre-selector gearbox. At Midland Road, some forty men were drafted in from Riley to begin full production, with the intention to make twenty cars per week. The finished results were stunning, and although the car took first prize in the £1,000 class at the 1936 Ramsgate *Concours d'Elégance*, the venture was doomed. In 1938, the Riley businesses collapsed and with the new Autovia models being priced from £975, there were only a few very cautious buyers of such a new brand. It is believed that only around fifty cars were ever built and the business was purchased by Jimmy James Ltd. Van Eugen, eager to face a new challenge, went on to work for the Wolseley Motor Company.
(See also Riley.)

AWSON, 1926–1932 (1919–1979)
Awson Motorcarriage Co. Ltd, 14 Awson Street

The origins of the Awson Motorcarriage Company began in 1919 when Oscar Grunau (b. 1891) began making high-quality veneered dashboards in Coventry. Grunau hailed from Lithuania, the son of a coachbuilder, and was reportedly smuggled out of his country in 1910, finally making his way to Scotland. He later found employment at the Daimler Company in Coventry prior to the war, eventually settling at Mount Street after a series of lodgings. In 1919, he and fellow Daimler coachbuilder David Guild (1881-1939) took out a patent (153,956) concerning upholstered seat cushions for vehicles. By 1923, he joined forces with Guild, establishing the business of Guild & Grunau, coachbuilders at 14 Awson Street, with James Dalrymple (b. 1888) also being added to the ranks. The same year, Grunau married local woman Grace Roe, making a home at Awson Street in front of the works, and having three children in total. In 1924, the company became the Awson Motorcarriage Company, being listed in that year's Coventry trade directory under 'motor body builders, motorcar manufacturers, and motor accessories manufacturers'. By the outbreak of the Second World War, they were amongst a division of firms who were recognised as employing a workforce of more than 100 men. By 1952 this figure

had reached over 250, with Oscar Grunau listed as Managing Director, and James Dalrymple as secretary, and during the same year, Grunau became President of Coventry's Rotary Club. It is not known to what extent Awson were concerned with the actual production of complete motorcars during the mid-1920s to early 1930s, but it is clear that the company's main business activity was in the construction of motor bodies, interior polished wood work, upholstery, and reputedly part of the wooden frames used in the construction of the Morris Minor Traveller. Oscar Grunau died in 1964 aged 73, but the business was carried on by his son, Oscar Wilfred Grunau (1924-1998), until the late 1970s, when they were based at Bayton Road, Exhall.

B. & A., 1937–1939
B. & A. Motors (Coventry) Ltd, 19–21 Payne's Lane

Apart from being listed in the 1937-1940 Coventry Trade Directories as 'motorcar manufacturers', nothing else is known about B. & A. Motors Ltd, nor the individuals behind it. A few years earlier though, in 1934, a company called Haywood, B. & Co. Ltd, 'motor engineers', were seen to be occupying premises at nos 19-21 Payne's Lane, but whether they were connected to the later B. & A. business is open for debate. Yet in further support, a Mr Bramley Haywood (b. 1883) was seen listed as an 'engine tester' in Coventry way back in 1911, residing at Grantham Street. Hayward was still listed much later in Coventry in 1939/40, living at Crescent Avenue, Stoke, not too far from Payne's Lane.

BAKER, 1922
Baker, F.W., 'Rothsay', Pinley

The 'Baker' of 1922 was an unusual one-off three-wheeled cycle car made by F.W. Baker of Pinley, Coventry. It was first highlighted and pictured in a December 1925 issue of *The Light Car and Cyclecar*, with the tag-line 'What Is It? – A striking little three-wheeler seen in Coventry recently. Would the owner oblige us with details please?' Indeed the owner, Frederick William Baker, did oblige, and gave full details of his creation in the next edition. It was constructed using components from

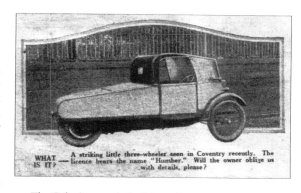

The 'Baker' was typical of the early 1920s period, when hundreds of experimental cyclecars were being assembled all over the country – often in the back yards of houses.

an 'old' 6hp Humber motorcycle that he adapted into an enclosed-bodied cycle car. The 750cc water-cooled engine was situated behind the front cabin in the tail, with transmission being by a three-speed gearbox and chain. The body was entirely home-made, 'being constructed from match boarding, crate wood and plywood, while the top was finished off with leather'. With rack and pinion steering, Baker stated that the cycle car 'holds three passengers in comfort, and is capable of over 40mph'. Baker stated that it was his intention to put the design into practice and could be sold for somewhere between £60 to £70, but it is seems doubtful he ever did.

BARNETT, 1921–1932 (1912–1964)
A. Barnett & Co., Lloyds Bank Chambers, 22–28 High Street

Very little is known about the manufacturing details of this firm, indicated to have commenced the making of cars from premises at the High Street, Coventry from 1921. What

is certain is that the company relates to Arthur Barnett (b. 1863) who was known to have formed his own business at High Street from 1912, making 'Invicta' bicycles and motorcycles. By 1919, Barnett famously joined forces with Gordon Francis (b. 1890), forming the company of Francis-Barnett, well-known makers of lightweight motorcycles through to 1964. However, he appears to have retained his original firm, A. Barnett & Co., also seen listed the same year at 58 West Orchard as 'cycle and motorcycle manufacturers'. By 1921/22, the Coventry Spennell Directory listed the company also as 'motorcar manufacturers' and were last seen in the 1931/32 Directory under the same heading, yet whether an actual complete car or cycle car was ever produced is so far unknown.

BAYLISS, 1919–1927 (1874–1965)
Bayliss, T. & Co., Excelsior Works, 287–295 Stoney Stanton Road

Far from a straightforward entry, Bayliss, T. & Co. were listed as 'manufacturers of motorcars' after the First World War in Coventry, yet the origins of the business stem much deeper. Thomas Bayliss (1843-1905) of Birmingham, John Thomas (1833-1902) of Banbury, and John Slaughter (1834-1912) of Aylesbury were all employees of the Coventry Machinists Company when they first commenced the manufacture of cycles in late 1868. By 1874 the three formed a partnership, trading as Bayliss, Thomas & Company at Earl Street, and then Lower Ford Street, making 'Excelsior' ordinary cycles of very high quality. After some twenty-one years of pure cycle making, the company were one of the first in Coventry, and indeed the country, to venture into motor production. By this time the three founders were getting on in years and nearing retirement, so it was down to men such as Thomas Bayliss junior and works manager Harry Martin to develop the motoring side of the business. In 1896, the company released a motor-bicycle and tricycle powered by 2¾hp MMC engines, being labelled 'unnecessarily fast and powerful' by some. By 1902, the company exhibited no less than forty Excelsior machines at Olympia, the largest quantity by any firm. The organisers, however, would not permit the machines to be shown inside the exhibition hall, and instead insisted that they remain in the grounds, where 'explosion would be minimal'. To counter this, Martin offered free rides to anyone who wanted a go, many of which had never ridden nor even seen a motor-bicycle before. According to Martin, more than 250 people enjoyed the experience without any incidents. In 1904, a 4½hp tri-car was instead developed for general comfort purposes and exhibited at the Stanley Show, and this was continued by William Herbert Carson (b. 1868) in 1906, replacing Martin as works manager. In 1909, a subsidiary business was formed as the Excelsior Motor Company, with additional premises being found at Stoney Stanton Road, and, in many ways, this period signalled the end of Bayliss, Thomas & Company in Coventry. The three founding members had all died, and the product for which they had become famous, the cycle, had been steadily phased out. All motor production slowed during the war years, and like so many other local businesses, manufacture was partly transferred over to parts and armaments. In the summer of 1919, the Excelsior Motor Company was bought by R. Walker & Son of Birmingham, moving all plant and machinery to Kings Road, Tyseley, while the Lower Ford Street factory was taken over by the newly formed Francis-Barnett Ltd. At Birmingham, the production of Excelsior motorcycles resumed and in 1922 the company began making cars also, but were forced to do so under the 'Bayliss-Thomas' name as an 'Excelsior' car was already on the market through SA des Automobiles Excelsior of Belgium. The first Bayliss-Thomas model was a light car powered by a 2.5 litre Coventry-Simplex engine, later joined by a smaller Meadows-powered version in 1923. All car production ceased in 1929, the company opting to concentrate on motorcycle manufacture, of which they did very well until 1965. However, the mystery surrounds why a company called Bayliss, T. & Co. were seen to have been listed as 'manufacturers of motorcars' from 1919-1927 at the 'Excelsior Works' (287-295 Stoney Stanton Road) in Coventry trade directories of that time, and, more importantly, what was going on inside? The answer could well rest with William H. Carson and the Coventry sidecar makers Mills-Fulford. Carson was

known to have worked for Bayliss, Thomas & Company from 1906, transferred to Birmingham during the R. Walker & Son takeover, and remained with the business through to 1923, when he left to become sales director for Mills-Fulford back in Coventry. The last time Bayliss, T. & Company are seen in Coventry is in the 1926/27 Directory under 'motorcar manufacturers' at 287-295 Stoney Stanton Road, yet sharing the same premises are the well-known Coventry transport manufacturing names of Mills-Fulford, Rex, Hobart, Fulwell and Maxim. Considering that back in 1911, Coventry-born Carson was seen to be employed as a 'commission agent in the cycle and motor trade', then it is likely that the defining answers remain with him.
(See also Rex.)

BEESTON, 1896–1901
Beeston Motor Co., Parkside, Quinton Road & Little Park Street

When Harry Lawson first decided to stake a claim on the British motor industry, few would have predicted just how much of an impact he and his companies would have. In 1896, Lawson adapted the cycle firm of S. & B. Gorton Ltd to that of The New Beeston Cycle Company with a huge nominal capital of £1,000,000, and, on obtaining licenses to use De Dion-Bouton patents, commenced the production of 1¼hp tricycles at works at Parkside. Lawson's prospectus for the new company stated that 'miles of benches were to be erected for the production of bicycles and motor cycles'. In the first London to Brighton Run of November 1896, the only English participant was in fact a 1¼hp Beeston tricycle, a copy of the De Dion-Bouton model, but significant in that it was one of the first motorized vehicles to be made in Coventry. In 1898, under the management of Samuel Gorton (b. 1854), they produced quadricycles and chain-driven motor-bicycles with engines mounted over the front wheel. In addition to this, Lawson promoted a Beeston motor-tricycle, which was fitted with a Hansom Cab over the rear as a cheaper alternative to that of buying a complete motorcarriage. A year later, seemingly under the subsidiary name of the Beeston Motor Company, production extended to that of a number of 3.5hp De Dion-powered voiturettes. Being of 'spur-gear' transmission, the engine was hidden beneath the seat, but lack of evidence in company sales literature would suggest not too many were sold and Lawson no doubt concentrated more on his Daimler motoring output. Gorton himself hailed from Wolverhampton, arriving in Coventry with his brother Bernard during the early 1890s to form their own cycle company. By 1901 the Beeston Company closed, but because of its close association to Lawson, and in turn Humber, much of the Beeston workforce quickly found suitable employment.
(See also Humber and Lawson.)

BILLING, 1900
E.D. Billing, Lower Ford Street or Holbrook Lane

The 'Billing' was an obscure limited production model thought to have been made at either Lower Ford Street or Holbrook Lane at the turn of the last century. Reported to have been also known as the 'Burns' or 'Billings-Burns', the car was described as a two-seater open-bodied voiturette powered by a 2¼hp De Dion engine mounted at the front, shaft-driven with tiller steering. The actual brainchild of the motorcarriage can now be revealed as Eardley Delorney Billing, born at Kensington in 1873. The son of a Birmingham gas stove manufacturer, it is probable that Billing arrived in Coventry (his mother's home town) around 1896 and found employment at the Motor Mills, and was known to have been involved with the manufacture of E.J. Pennington's motor tricycle along with Ernest Courtis. By 1898, Billing teamed up with Arthur Hallett (b. 1875) to form the Endurance Motor Company, which lasted a couple of years, initially finding premises at Gosford Street. By December of that year they had developed their

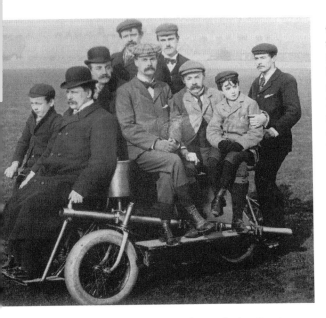

Eardley Delorney Billing first worked on Pennington designs at the Motor Mills before joining forces with Arthur Hallet. Here he is crouched at the back, with bowler hat.

own motor engine – 'Billing's and Hallett's system' – and attempted to keep pace with the larger and better financed motor firms by attending shows and motor trials, often represented by a Mr J. Burns. In early 1899, Billing married Ada Marston, the daughter of a Coventry watch maker, the marriage certificate revealing that Billing's address at this point was 23 Lower Ford Street, the home of his new wife's family. By late 1901, Billing had all but severed his commercial ties with Coventry, returning to London, where he briefly went into partnership with a William Charles Birney (b. 1869) under the title of the Central Motor Company. As the decade progressed Billing grew steadily interested in aviation and, in 1910, invented a device for 'teaching the art of flying without leaving the ground', becoming an 'aeronautical engineer works manager' and residing at Byfleet with his family. Sadly, he died at Colchester at the young age of 42 in 1915, but as a point of interest, his younger brother, Noel Pemberton Billing (1880–1948), became something of a celebrity during his working life. Also involved in aviation circles, he founded the beginnings of the Supermarine Aviation Works in 1913 – a business that went on to build the famous 'Spitfire' fighter plane. He was also an avid writer and journalist, and became a Member of Parliament in 1916, known for his very controversial and extreme right-wing views. *(See also Endurance and Pennington.)*

BLUEBIRD
(See Motor Panels.)

BRAMCO, 1920–1922 (1902–1923)
Bramco Ltd, St Nicholas Street, Ellys Road, & 300–330 Widdrington Road

An abbreviation of British American Components, Bramco Ltd was set up in 1902 by former *Autocar* journalist and Daimler shareholder Henry Sturmey. At around the same time, Sturmey also established another company in Coventry at Widdrington Road, acting as agents for American-made Duryea carriages under license from the Duryea Power Company. Having spent considerable time touring American and Canadian motor works in 1899, Sturmey clearly saw a niche in the British market to exploit proven American motors, yet it was the business of motor parts and accessories that Bramco concerned themselves with initially. Over the years, products offered by Bramco were varied, ranging from cycling trouser fasteners, paraffin lamps, valve-cap pumps and visor caps. Steadily the company also began offering more heavy-duty technical products, including the 'Olson Conversion Unit' – enabling standard motor chassis to be adapted for commercial purposes, and to promote this Bramco offered a 22hp Ford-Olson 15-20cwt van for £160. Joined by Thomas Vincent Redstone (b. 1889), the company was re-registered by Sturmey in 1912 after the closure of his other nearby concern, Sturmey Motors Ltd, and naturally, business slowed up throughout the First World War. After the war, the company was once again re-reg-

istered, this time as Bramco (1920) Ltd, and it was during this time that Sturmey began to offer more in the way of complete vehicles, including a 'Stanley' steam car, as well as Ford models fitted with 'Andrew Power Transmitters' and 'Warford six-speed transmissions'. In June of that year, Sturmey and Bramco (1920) Ltd applied for a joint patent relating to 'improvements to wheels for motorcars', while the following year's Coventry Trade Directory listed the company as 'manufacturers of cars, trucks, and American auto-components'. No further entries are found for Bramco after 1923, and it is thought that Sturmey all but retired from his own business affairs at this time. *(See also British Business Motors, Duryea, and Sturmey Motors.)*

BRITISH BUSINESS MOTORS, 1912–1913
British Business Motors Ltd, 160 Widdrington Road, & Cunard Works, Aldbourne Road

British Business Motors Ltd was yet another company related to Henry Sturmey, begun with a working capital of £50,000 in July 1912 after the closure of Sturmey Motors Ltd. After extending both the Widdrington and Aldbourne Works to accommodate a drawing office, machine shop and stores, it is believed that BBM attempted to continue in the direction of Sturmey Motors with the design and manufacture of commercial vehicles, with Selwyn Francis Edge (b. 1868) as Chairman and Henry George Burford (b. 1868) as Managing Director. Indeed, the 1912/13 Coventry Spennell Directory listed the business under 'motor manufacturers' and separately as 'manufacturers of Cunard commercial vehicles'. With further managerial experience from the likes of Cecil Perry (b. 1876), Charles Henry Gray (b. 1879) and Harry Tempert Vane (b. 1875), the company appeared to be in safe hands, yet ultimately the venture somehow failed, being wound up by January 1913. Never a man to give up easily, Sturmey then concentrated on his remaining business, Bramco Ltd, which lasted until 1923. *(See also Bramco, Cunard, Duryea, and Sturmey Motors.)*

BRITISH CHALLENGE
(See Challenge.)

BRITISH MOTOR COMPANY, 1895–1900
British Motor Co., 61 Hertford Street, Conduit Yard, & 40 Holborn Viaduct

The British Motor Company is suspected to be another trading name heavily associated with Harry J. Lawson. Begun as early as 1895 at 40 Holborn Viaduct in London, and Hertford Street, Coventry, this company pre-dates both his Daimler and Great Horseless Carriage Companies, known to have been created soon after at the Motor Mills. Considering that there were no known manufacturing premises along Hertford Street during this time, this strongly suggests that number 61 was purely used as registered offices, and although cars, motorcycles, omnibuses, vans and even motor-launches were touted in the company prospectus, it is very doubtful that any of these were actually manufactured there under the British Motor Company title. Thought to be an early off-shoot of the British Motor Syndicate, BMC were also documented as being later based at both Conduit Yard alongside the Coventry Motor Co., and also the Motor Mills, with Coventry historian Alfred Lowe reporting that 'the leading spirit of the company is Mr E.J. Pennington, an American Gentleman, who is the inventor of a motor which is small, compact, light in weight, and of high power'. Also known to have been involved with the company were Edwin Perks (b. 1867), Charles Jarrott (b. 1876), and works manager William Allen Taylor (b. 1861). The British Motor Company were last seen at Conduit Yard off Fleet Street in 1900, before being wound up in August of the same year. *(See also British Motor Traction, Coventry Motor Company, Lawson, Pennington, and Singer.)*

BRITISH MOTOR TRACTION, 1901 (1900–1908)
British Motor Traction Co. Ltd, Conduit Yard, Fleet Works, Fleet Street, & 40 Holborn Viaduct

The British Motor Traction Company was first registered in May 1900, and listed in the *Kelly's Warwickshire Directory* of the same year as 'motorcar, motor manufacturers and factors'. The address given at this time was Conduit Yard, so seemingly the shared premises of the Coventry Motor Company – makers of the 'Coventry Motette' from 1896. The British Motor Traction Company has been recorded by some to have been a reinvention of Harry Lawson's British Motor Syndicate, yet in reality it was in fact a continuation of the British Motor Company. By 1900, however, it would be doubtful that Lawson would have played any part in the re-organisation of this brief venture, as by this time, he was quickly being discredited by former associates due to some of his suspect business dealings. Instead, he sold most of his patents for a minimal sum, and three other men of note were known to have been heavily involved in the formation of British Motor Traction – these being Charles E.H. Friswell, Charles Osborn, and Selwyn Francis Edge. Friswell, born in London in 1871, was a well known car dealer and later became Managing Director of the Standard Motor Company in Coventry. Osborn had been the first secretary at the Daimler Motor Company from 1896, a position he was to similarly take up at British Motor Traction. Edge was born in Australia in 1868, yet had moved to England with family three years later. He became a very famous racing cyclist in his teenage years, and in 1893 moved to Coventry, where he gained a position at the Rudge Cycle Company – a firm he also represented on the racing circuit. He later became a manager at Dunlop before eventually spearheading the famous Napier Company, going on to become a highly successful racing driver. In terms of actual motor production, British Motor Traction's involvement is unclear, yet there have been suggestions that a De Dion-powered car was built for them by the Humber Company in 1901 under license. The business was wound up in 1908 after years of little activity. *(See also British Motor Company, Coventry Motor Company, Lawson, Humber, and Standard.)*

BROADWAY, 1913
Broadway Cyclecar Co. Ltd, King William Street

Manufactured at small works on King William Street, the 'Broadway' was a short-lived cyclecar powered by a German-built 8hp air-cooled Fafnir engine with V-type belts for final drive. It was said to have had a large and roomy body, wire cable and bobbin steering, and fitted with a B&B carburettor and Bosch magneto. It was offered for £80, yet it is thought that very few were actually sold. The business was established by the carpenter/builder John Twigg (b. 1858) of Uttoxeter and his son Ernest (b. 1885), who transferred their building skills to that of sidecar makers by the time they moved to Coventry in the early 1900s. In March 1909, Ernest applied for a patent (5,955) regarding 'electric sparking plugs', demonstrating his engineering qualities prior to his Broadway light motors. By the time that the Broadway cycle car was available, Twigg and son were also offering 'Broadway' and 'Kernut' sidecars out of the same Hillfields address. Twigg took the name of 'Broadway' for his sidecar and cyclecar business, because that's where he lived – at 'Broadway House', Spencer Park, in the Earlsdon area of the city. With war looming in Europe, it was a bad time to branch out in business and it is thought that John and Ernest Twigg soon reverted back to the construction industry.

BROOKS, 1900–1902
Brooks Motor Co. Ltd, The Motor Works, 41 Holbrook Lane

With a working capital of £2,000, the Brooks Motor Company was founded as 'motorcar, motor manufacturers and factors' by Henry Brooks and Henry Wimshurst in September

1900 at 41 Holbrook Lane – the rented yard of Joseph Hughes, oil and firewood dealer. Brooks was born in 1862 at Egham, Surrey and trained as an 'engineers apprentice' at Wantage, Berkshire, before finding his way to Coventry in the late 1890s. Henry James Wimshurst was born at Milford Haven, Pembrokeshire, in 1864 – the son of an affluent ship-builder. He trained as a commercial clerk in

The Brooks car of 1901 was one of many early, short-lived motor companies.

Liverpool before he too found himself in Coventry by 1897, applying for a patent (8,822) concerning 'improvements in gas or oil engines' in April of that year. It is quite probable that both he and Brooks took up positions at the growing Daimler or Great Horseless Carriage concerns and became friends, but the fact they lived next door to each other on the Foleshill Road would have only increased their familiarity with one another. According to a 1908 *English Mechanic* account, the company helped develop the 'Crawford Speed Gear' initially and exhibited this at the Agricultural Hall, London. This would suggest a definite professional working association with the Canadian, Middleton Crawford, the man behind the Crawford Gear Company, formed in 1901 also at Holbrook Lane. Before long, Brooks commenced the manufacture of 8hp and 12hp light cars powered by Belgian-made Pinart front-mounted engines. Models were available in two- and four-seated bodies with shaft-drive, and known to have been exhibited at Crystal Palace by 1902, yet the fact that the business went into voluntary liquidation later that year would suggest that not many were sold. The premises on Holbrook Lane were then taken up by the Force Motor Syndicate, also believed to be makers of motors until 1905. Wimshurst later found work at Enoch J. West's Progress works for a spell before moving away from Coventry altogether, although he continued to work as a mechanical engineer. Brooks went on to become a 'superintendant motor engineer' at the Taxi Cabs Garage in Fulham, London by 1911. This, unfortunately, is where the trail runs dry for now.
(See also Crawford and Force.)

B.S.A., 1921–1926 and 1933–1936 (1861–1972)
Birmingham Small Arms Co. Ltd, British Hotchkiss Factory, Gosford Street
B.S.A. Cars Ltd, Radford Works, Sandy Lane

The Birmingham Small Arms Company was established as a limited company in 1861 after being known to have supplied arms and ammunition in support of the Crimean War. In 1880, the company added the manufacture of bicycles to their output and by 1905 became involved in motorcycle manufacture – a successful product that was to remain right the way through until 1972. B.S.A.'s first cars arrived in 1907 and, three years later, the company took control of the Daimler concern in Coventry. Some sourced accounts suggest that both car and motorcycle production may have been taken up by the Daimler factory as early as 1911, and in an article from a 1969 issue of the *Veteran & Vintage* magazine, reports of a 1915 B.S.A. car 'almost entirely built by the Daimler Company of Coventry but carrying a Birmingham chassis and number plate' adds interesting support. However, certainly by 1921, B.S.A. 'TB Ten' models were known

to have been assembled at the Hotchkiss works at Gosford Street following B.S.A.'s choice of power-unit, the same premises which soon after became the home of Morris engines. These were thought to have been followed by the 11, 12, 14 and 16 models until 1926. As B.S.A. Cars Ltd, production resumed in Coventry in 1933 at the Radford Daimler works with new 'Ten' and 'Light-Six' saloons, and, later, 'FWD' models until 1936.
(See also Daimler, Hotchkiss, and Stoneleigh.)

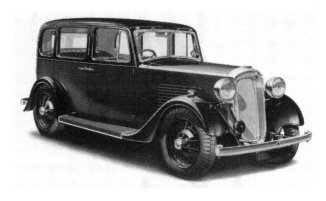

A B.S.A. Light Six model of 1935. After B.S.A. took control of Daimler in 1910, B.S.A. models were believed to have been made at a number of Coventry sites over the following decades.

BUCKINGHAM, 1912–1923 (1911–1941)
J.F. Buckingham, The Buckingham Engine Works, 159 Spon Street
Buckingham Engineering Co. Ltd, 15 Dover Street, & Holyhead Road

James Buckingham had first started business in Coventry in 1911, briefly joining forces with William George Manly at Spon Street. He was born James Frank Buckingham in 1887 at Blackheath in Kent, the son of Colonel Frederick James Buckingham of the 18th Hussars. Being from quite a privileged background and with his father away for long periods, James (along with his two brothers) was sent to Kelly College at Tavistock, Devon at the age of nine, where he excelled in Greek, Chemistry and Mathematics. After leaving in the summer of 1901, he first worked for Sunbeam in Wolverhampton before gaining a position at the Riley Motor Company in Coventry by about 1905. He spent six years at Riley in the fitting and running shops, whilst also gaining experience with clerical duties and even some competition racing during that time. Highly regarded by the Riley family, he became a Director of the board in December 1909, but by March 1911 submitted a letter of resignation, which was accepted by the board 'with regret'. His first known address in the city was at 35 Melville Road, but by 1911 he was lodging at 21 St Nicholas Street and working as an 'automobile engineer' on his own account. He may well have been with Manly at this

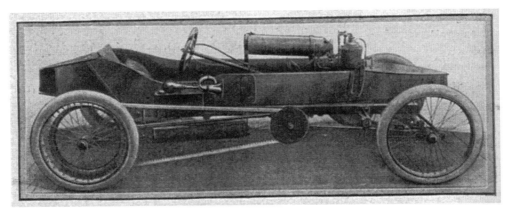

In late 1912, Buckingham also devised his 'Chota' racing model, seen here in a stripped-down form.

point, and/or possibly with R.M.S. Maxwell, a 'mechanical engineer in internal combustion engines', also lodging at the same address. In late 1912, Buckingham created his experimental 746cc 'Chota' cycle car, purely for his own use initially. It proved so successful, however, in hill-climbs and time-trials, that Buckingham decided to venture in to full-scale light car production. Variations of the Chota appeared during 1913, and the following year, a coupe called the 'Buckingham Palace', a 'Standard-Twin', and a 65mph 'Sporting-Twin' became available, alongside the supply of his own 'Buckingham' engines. During the war years, Buckingham invented an incendiary tracer bullet for anti-Zeppelin use, the factory producing some 26,000,000 in that time, and 'Give 'em a burst of Buckingham's' was believed to have become a well-coined phrase by the gunners that fired them. For such services, he was awarded £10,000 and an OBE in 1920, but continued with the production of 10hp 'Buckingham' cycle cars, some twenty to thirty of which were made at Thomas G. John's company at Holyhead Road. Ultimately, the arrival of cars like the Austin Seven weighed heavily on all cycle car manufacturers of the period and progressively slowed demand. For reasons such as this no more Buckingham's were made after 1923. Buckingham himself died in 1956, but continuing as an engineering firm the business transferred to Offchurch, which was later bought by Eagle Engineering of Warwick in 1941.

(See also Alvis, and Manly & Buckingham.)

CALCOTT, 1913–1926 (1886–1926)
Calcott Bros Ltd, XL Works, 165 Far Gosford Street

The Calcott name began as cycle manufacturers at East Street in 1886 under the title of Calcott Bros & West. The brothers were William (1847-1903) and James (1850-1924), both hailing from the Radford side of Coventry, and the sons of a ribbon box maker. James first worked in the watch trade, then later as a boot manufacturer, while William began his career as a greengrocer and draper, before both choosing to start a cycle manufacturing company by the mid-1880s. The other side of the original partnership was the experienced cyclist Enoch John West, who left in 1891 to form his own cycle firm, E.J. West & Co. Ltd, and a few years later, the Progress Cycle Company. On his departure, the business was re-established as Calcott Bros Ltd under the Directorship of William Calcott Junior, specialising in the 'XL' machine, and this would later become the name of their works on Gosford Street. By 1905, they had started experimenting with motorcycles but did not seriously enter the market until 1910/11 with 3½hp machines using Coventry-built White & Poppe engines. In 1913, they also added the production of lightweight cars to their output, initially with the Calcott 'Ten', a four-cylinder 1460 model. This car, along with the later 10/15 model, saw the most success in terms of sales, and, along with some other less popular variations, it is believed that some 2,500 machines were built in total. Cycle production looks to have stopped in 1924 after the death of James Calcott, while at the same time it is known that former Humber and Sunbeam employee Leo J. Shorter (b. 1886) was brought in as chief engineer. Although Shorter was heavily involved with the development of the 10/15 model, as well as the larger 12/24 and 16/50 cars, the business was steadily running into difficulties. Motorcycle and car production continued until 1926, when the business completely dissolved, the car side being bought by the Singer Motor Company. Later accounts of the Calcott brothers reveal two very different personalities. According to Triumph founder Siegfried Bettmann in his autobiography *Struggling*, James Calcott was 'a devout nonconformist and would quote the bible at any given opportunity', while William Calcott was quite the opposite, who 'liked a glass of beer or whiskey and died a fairly young man in rather distressing circumstances'.

(See also Progress and Singer.)

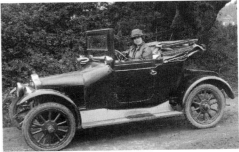

Above: A Calcott model of about 1914. Light cars were even more popular with women motorists after the conclusion of the First World War.

Left: The Calcott works during the early 1920s. The company originally began as cycle manufacturers in 1886.

CARBODIES 1946–Present (1919–Present)
Carbodies Ltd, Old Church Road, West Orchard & Holyhead Road

The well-known business of Carbodies began after the First World War, when Robert Jones decided to set up his own motor-body company. Robert 'Bobby' Jones was born at King Street, Bury in 1874, the son of a 'marine stores dealer'. On leaving school he enrolled on a two-year engineering course before being apprenticed as a coach builder at Lawton's in Manchester. After marrying Lillie Bridge in 1898, the couple moved to Toxteth in Liverpool before Jones gained a position at Humber in Beeston – his first taste of motor body construction. By 1907, he and his young family made the move to Coventry, where he became engaged as the first works manager at Charlesworth Bodies, and by 1911 he was a resident at 104 Kingsway, employed as a 'motor body builders foreman'. In 1912 he briefly became general manager at another Coventry coach-building firm, Hollick & Pratt, before returning to Liverpool again to work at Watson's. Jones and his family did not return to Coventry until 1919, when he was taken on by the Foleshill Road timber merchants Gooderham & Co. Jones quickly established a body-making arm of the business at Old Church Road, and soon after bought the company and found new premises at Hill Street, and thus Carbodies was born. Early customers included the likes of Alvis and Crouch, forcing another move to nearby West Orchard, and among the first employees were Bobby's son Ernest, William Dawson, James Bell, and Ben Johnson. Following a serious fire in 1923, and a constant lack of space with little scope to expand, Carbodies moved one final time in 1928 to Holyhead Road, opposite the Alvis factory. With son Ernest being given greater responsibility, Carbodies then grew as a business, gaining contracts over the following years, which included the likes of Daimler, Ford, Humber, Jaguar, MG, Morris, Singer, and even Rolls-Royce. During the Second World War much of the factory transferred production to that of aircraft components, and in 1946 they combined forces with both the Austin Motor Company and Mann & Overton, taking responsibility for assembling taxi-cab bodies to Austin chassis. This unification saw the birth of the Austin FX3 taxi model and over the following decade some 7,000 were produced, the vast majority bound for London. In 1954, Jones, at the age of 81, sold his business to B.S.A. for a reputed £1m, and passed away four years later. Ironically, his passing happened the same year that perhaps the most celebrated Carbodies product was unveiled – the restyled FX4 model. The FX4 as a design would become famous the world over and synonymous as being distinctly British over time, alongside icons

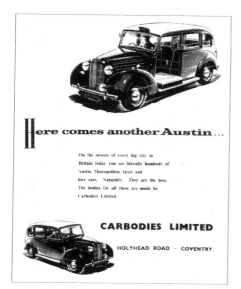

Carbodies began in 1919 and made their first bodies for Austin taxi models from 1946. Many world-famous car companies disappeared from Coventry over time, yet, fortunately, Carbodies still make taxis there to this day.

such as the telephone box, the bowler hat, and the British 'Bobby'. Complete manufacture of the FX4 was not adopted by Carbodies until 1971, and following the collapse of B.S.A. the company was taken over my Manganese Bronze Holdings, and by 1984 London Taxis International. To date (2012) the company trades as the London Taxi Company, and since the first FX3 model rolled off the Holyhead Road production line in 1946, more than 100,000 have followed, albeit by variation. As an endnote, Bobby Jones was a small man in stature, standing at just 5ft tall. Some employee accounts, however, reveal that he could be a feisty, stubborn, no-nonsense man, who, on frequent occasion, would keep his staff firmly on their toes through fear of the sack if they stepped out of line. On one such occasion, it is said that he sacked a man on the spot for walking through the grounds of the factory after the morning shift had already started. Shocked, the man replied that he couldn't be sacked as he didn't work at Carbodies but instead worked at the Alvis factory across the road and was simply taking a shortcut!
(See also Charlesworth, and Hollick & Pratt.)

CARLTON, 1901–1902
Carlton Motor Co. Ltd, Carlton Works, 250 Lockhurst Lane

Carlton are yet another early Coventry motor company that have left very little by way of evidence to compile a thorough history. Began at Lockhurst Lane at the beginning of the last century, they are first seen listed in the 1901 Coventry Trade Directory under 'motorcar, motor manufacturers and factors' as well as separately under 'engineers'. The original 'Carlton' model itself was a belt-driven two-speed single-cylinder voiturette powered by a 6hp Aster engine. Two larger models followed, a 12hp twin-cylinder and a 24hp four-cylinder, again propelled by the favoured Aster power unit until 1903. The original founders of this brief business had been forgotten over time, but it can now be revealed that the company was succeeded by the Coronet Motor Company. The *Automotor Journal* informs us that Coronet began in April 1902, acquiring the business carried on by W.J. Iden at Foleshill as the Carlton Motor Company. This relates to Walter James Iden (b. 1873) the son of George Iden, and as the lace manufacturer Joshua Perkins and his sons were known to have backed Coronet, then chances are they also financed Carlton too. Later, in 1903, another Carlton Motor Company appeared at Cricklewood

THE
CARLTON MOTOR CO.,
Engineers and Manufacturers,
Motor Fittings and Detail Work made for the Trade.

REPAIRS.

Owing to pressure of outside Motor and Engineering orders, we have been unable to finish exhibits in time to show.

LOCKHURST LANE, FOLESHILL, COVENTRY.

An advert of the Carlton Motor Company, managed by Walter Iden from 1901.

in London, as testified in the 1903 Automobile Show, offering complete chassis and engines, yet whether there were any ties to Coventry or whether the name was simply transferred is unclear. The original Carlton works were later taken over by the magneto makers Morris & Lister. *(See also Coronet and Iden.)*

CENTAUR, 1900–1905 (1876–1931)
The New Centaur Cycle Co. Ltd, 59 West Orchard & Humber Road

The Centaur Cycle Company was established at Thomas Townsend's former silk factory situated at West Orchard in 1876, through an unlikely partnership formed by Edward Mushing and George Gilbert. Gilbert, born in Coventry in 1852, was apprenticed at the celebrated art metal worker Francis Skidmore's before joining the Coventry Machinists Company in 1870. Mushing, born at Grandborough, Warwickshire in 1843, had been for many years a Coventry schoolmaster yet resigned the position to start the Centaur business with Gilbert, and between them they forged a very reputable cycle company, registering the 'Centaur' bicycle by 1886, known as 'the King of Scorchers'. By this time, the firm was also producing tricycles, rowing apparatus, roller skates, and, bizarrely, tennis rackets. With the expertise of John Henry Trickett (b. 1874), in 1900 Centaur began making cars as well as chain-driven 3hp Humber powered motor-bicycles. The cars were quite typical of the period, being four-seated dos-a-dos types powered by 4.5hp single-cylinder De Dion engines using belt transmission. Joined by Walter Gilbert Jenks (b. 1867) and Albert William Parkes (b. 1877), by 1904 they began to use their own engines, claiming 'the difficulty of starting and the possibility of a back fire to the discomfort of the rider is entirely overcome'. It is thought that cars were developed by the company for around five years, yet it was with the motor-bicycle and the cycle that both Gilbert and Mushing concentrated their efforts ultimately. In 1910 Mushing died, and the business (along with Harry Trickett) was taken on by the Humber Company, who moved production to their new factory at Stoke, Coventry. Humber produced the Centaur motorcycles practically as replicas of their own until 1915, but were seen to have marketed Centaur cycles until 1931. Gilbert took to farming in 1910 at his home at Crabmill Farm in Foleshill, until his death in 1915. *(See also Humber.)*

Centaur began as cycle manufacturers as early as 1876, yet made a few motorcars from 1900, such as this one, designed by John Trickett.

CHALLENGE, 1912 (1901–1940)
Challenge Motor Co. Ltd, Challenge Works, 201 Foleshill Road

Although originally used as a trademark by George Singer from the 1870s, the first entry for the Challenge company name was seen in 1901, as the Challenge Cycle Co. at 24 Bishop Street alongside Francis Salmon O'Brien (b. 1863), 'Cycle Agent'. It was the O'Brien family who were behind the Challenge business, supported by the fact that in May 1908, his wife Ada O'Brien appeared in the Registration of Trade Marks trading as the Challenge Cycle Co.

In 1909 the business title was changed to the Challenge Cycle & Motor Company, by now at larger premises at Foleshill Road. It was the production of safety cycles that O'Brien started out with, but added 'Coventry-Challenge' motor-bicycles to his output in 1903. In the 1911/12 Coventry Spennell Directory, as well as cycles, Challenge were also listed under 'motorcar manufacturers', yet exact details have so far been untraceable, not helped by the untimely death of Francis O'Brien in 1913. If correct though, then the likelihood is that either a light car or cycle car was tested on the market, but was either not too well received, or was shelved once the prospect of war became apparent. Military bicycles were produced during the war years, and, on conclusion, standard cycles and 'Coventry Challenge' motorcycles took their place. All manufacture appears to have ended in 1940, but the original Challenge Works still remain on Foleshill Road to this day.

CHARLESWORTH, 1914 (1907–1956)
Charlesworth Bodies Ltd, 128 Much Park Street

Charlesworth Bodies Ltd began in 1907 at premises on Much Park Street, formerly used by the Standard Motor Company. The business was founded by two men, Charles Gray Hill and Charles Steane, who cleverly combined their Christian names with the word 'worth' to form the company title. Hill, born at Islington in 1864, was a building contractor by trade, and had married George Singer's daughter Louise in 1896 after designing and building her father's statement home five years earlier – Coundon Court. Hill was also the elder brother of Christopher J. Hill, Director of both Climax Motors and Brett's Stampings in Coventry. Steane was born in Coventry in 1873 and apprenticed in carpentry and joinery on leaving his formative education. By the turn of the century it appears he became employed by Hill as 'builder's manager', and is known to have been involved in the construction of the Grand Theatre at Clapham Junction. As Coventry's motor industry grew, the two men joined forces to establish a motor body business, with Robert Jones, later to establish his own motor body business as 'Carbodies', appointed as works manager. In the production of Charlesworth motor bodies, their first customers included Hillman and Singer locally. For one year only, in 1914, the Bennett's Business Directory of Warwickshire listed Charlesworth as 'motorcar manufacturers' yet it is highly unlikely that they produced any of their own complete cars under the 'Charlesworth' name. By the outbreak of the First World War, the company made both car and ambulance bodies for the War Office, and later gained contracts with a host of well-known motor companies including Alvis, Bentley, Daimler, Humber, Morris, Siddeley-Deasy, Sunbeam and Rolls-Royce. Charlesworth also made bodies for the short-lived Dawson Motor Company from 1918, and from the early 1920s onwards, key employees included the likes of Oliver J. Critchard (b. 1879) and Samuel B. Jackson (b. 1879). The business ran successfully throughout the following three decades and is thought to have finally closed in 1956.
(See also Carbodies, Climax, Dawson and Singer.)

CHOTA
(See Buckingham)

CHRYSLER, 1967–1978 (1925–Present)
Chrysler UK Ltd, Ryton-on-Dunsmore, & Humber Road

The Chrysler Corporation of America was founded in 1925 when Walter Chrysler (1875-1940) reorganised the Maxwell Motor Company, which had begun in 1904. The first 'Chrysler'-named cars were six-cylinder powered models with four-wheel hydraulic brakes, aluminium

A Chrysler Alpine S model of 1976. The Chrysler Corporation took full control of the Rootes Group in 1967.

pistons, and even complete interior lighting. After almost forty years of creating a brand through reputable trading, in 1964, Chrysler, then the third largest car producer in the world, extended their business interests to Europe and acquired the minority stake in the Rootes Group of Great Britain, taking over full control three years later. Inheriting many complex problems from Rootes, Chrysler's takeover was fraught with further difficulties combining labour disputes, production delays, poor sales, and the quick introduction of American man-agement techniques and manufacturing methods. Although Chrysler invested heavily in the Ryton and Stoke sites in Coventry, by 1975 this had culminated in losses of nearly £70m and so, in 1978, Peugeot-Citroen bought out the Chrysler interest in the Rootes Group and renamed the company Talbot, thus reviving a famous name in the motor industry. Whilst under the control of Chrysler, the Ryton plant production cars included the re-badged Chrysler Avenger and Hunter models, whilst the 'Imp' was made at Linwood in Scotland.
(See also Peugeot-Talbot.)

CLARENDON, 1902–1905 (1901–1910)
Clarendon Motorcar & Bicycle Co. Ltd, Dale Street, & Clarendon Works, 77 Moor Street, Earlsdon

Starting out at small premises in Dale Street in 1901 alongside the Hamilton Motor Company, Messrs Hammon & Smith commenced the manufacture of cycles, motor-bicycles, and, as their title would suggest, motorcars on a very limited scale. Better known for the production of 'Clarendon' motor-bicycles, their machines were fitted with Coventry-built engines including Hamilton, Birch, Whitley and Coronet. Fewer details are known about their dealings with actual car manufacture, but their restricted output was thought to have consisted of 7hp shaft-driven two-seater voiturettes, quite common of the period. It is not certain who the Mr Smith was in the partnership, yet in April 1900 Birmingham-born Harry Ambrose Smith (b. 1873) was known to have applied for a patent (6,282) relating to 'variable speed gears for motorcars' whilst at Widdrington Road, Coventry, and so may very well be

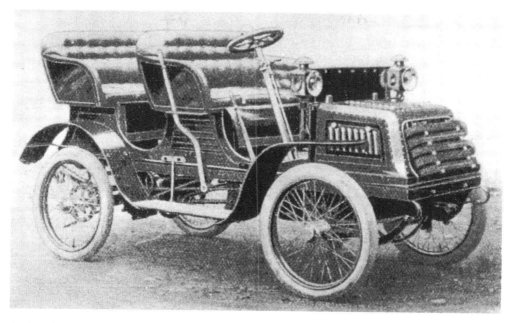

A Clarendon double Phaeton of 1902. The owners, Hammon & Smith, also made motor-bicycles.

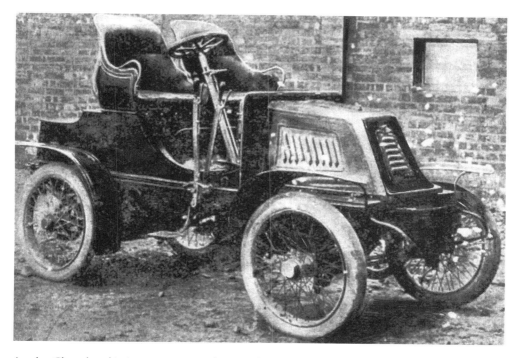

Another Clarendon, this time a two-seater voiturette of 1903.

connected. Mr Hammon, however, is William George Hammon, born in Coventry in 1868 and the son of a local watch manufacturer. William first plied his trade as a watch case maker, then commercial traveller before turning to the developing motor industry by the turn of the century. The 'Clarendon' company name was chosen due to the fact the Hammon

family lived at Clarendon Street in Earlsdon from the late 1890s. On moving to larger works at Moor Street, in September 1902, William Hammon 'of the Clarendon Works, Earlsdon' applied for a patent (19,306) relating to motorcycles. Just before the closure of Clarendon, he was listed as a 'manager of motor works' living in Earlsdon with his family. Whilst living at Whor Lane, Earlsdon in 1909, he was seen to have taken out two further patents (22,527 and 25,646) relating to motorcycles. It is believed that the Coronet Motor Company took over the running of Clarendon at some point but due to financial difficulties they made no more complete motor vehicles after 1910. William Hammon died in 1917 aged 49.
(See also Coronet.)

CLEMENT, 1908–1914
Swift Motor Co. Ltd, Parkside, Cheylesmore

In motoring terms, the Clement name first began in France when Gustave Adolphe Clement (1855-1928) commenced the manufacture of both 'Clement' and 'Gladiator' cars from 1898. Clement, who had earlier made his fortune in cycle manufacture, left the company in 1903 – the name being taken over by Harvey Du Cros of Dunlop tyre fame. Du Cros and his family already held a large stake in both the Ariel Company in Birmingham, but also the Swift Company in Coventry, and in 1908 the Du Cros brothers arranged for 'Clement-Gladiator' cars to be built at the Swift Works at Parkside. Most probably under the guidance of Swift senior works managers Robert Burns and Arthur Tomlinson, these new models bore very similar appearances to that of some of the 10/12hp to 18/28hp Swift cars simultaneously being built, yet were sold as 'All-British Clement' vehicles and priced higher. A 12/14hp four-cylinder model appeared in 1913, yet this was to be the final Clement to come out of the Swift factory, the last one being in 1914 as the Great War approached.
(See also Ariel and Swift.)

CLIMAX, 1904–1907
Climax Motors Ltd, St George's Works, 138 George Street

The company of Climax Motors Limited arrived in 1904 with a working capital of £5,000, finding small works at George Street, with a separate garage at St Mary's Street. Labelling themselves 'pioneers of high-class motors at moderate prices', Climax initially imported French-made Minerva motors, but as these were found (by them) to be unreliable, decided instead to construct cars of their own. Behind the business was Triumph Company founder Siegfried Bettmann, Brett's Stamping's Director Christopher John Hill (b. 1871), and Joseph Mayfield (1869-1958). The final part of the four-way partnership was Charles Walter Hathaway, the engineer responsible for the first Triumph motorcycles and most probably the designer and engineer behind the Climax models. Years later, Bettmann, in his memoirs, stated, 'We could not see, or would not see that even then, the motorcar was a most intricate object to make', but make them they did, building three-speed shaft-driven cars powered by both Aster and White & Poppe engines from 14hp to 20-22hp.

PIONEERS OF

High=class Motors

AT MODERATE PRICES.

PROMPT DELIVERY.

PRICES RIGHT.

PAYMENT ARRANGED

Send for Illustrated Catalogue, etc., to

Climax Motors, Ltd.,
COVENTRY.

Garage : St. Mary's Street, Centre of City.

Climax Motors were another small manufacturer who found the motor market a difficult nut to crack.

Another member of the small Climax workforce was known to have been James Shaw (b. 1861), formerly of the well-known Coventry hollow tube manufacturers, Shaw & Sons. In September 1906, two Climax cars were entered in the Tourist Trophy race with E.W. Leather and Thomas Watson as drivers, yet neither performed too well. Although Cecil Harvey Lamb (b. 1881) was appointed as sales manager in April 1907, unfortunately, after just three years of trading, the Climax business was wound up. The George Street works (which still exist) were taken over by Edward Player's newly formed engineering company, Sterling Metals Ltd, while both Bettmann and Hathaway decided to further concentrate on the Triumph Company affairs.
(See also Triumph and Charlesworth.)

CLULEY, 1920–1932 (1890–1992)
Clarke, Cluley & Co. Ltd, Globe Works, 15 Well Street, & Gas Street

The business of Clarke, Cluley and Company was established at Well Street as cycle manufacturers and textile machinists in 1890, next to the great 'Vulcan' works. The original founding partnership consisted of Ernest Clarke (b. 1870), George Storo Smith (b. 1840), Daniel Blakemore (b. 1846), and Charles Cluley, and at the Globe Works they commenced the production of 'Globe' and 'Clincher' safety cycles. Charles James Cluley was born at a small court dwelling in Spon Street, Coventry, in 1866, and being the son of a grocer's porter, it is clear that he had a very restricted upbringing. On leaving school, it is thought that he followed his elder brother into an iron works, before somehow reaching the heights of 'cycle manufacturer' by 1890, residing at St John's Villa on Cox Street. In the summer of 1900, Smith retired, and not long after the company began experimenting with the production of motor-bicycles and fore-cars powered by Minerva, MMC, and Salorea engines, as well as others of their own making. By 1906, both Clarke and Blakemore had moved on, so it was left to Cluley to drive the business forward, along with support from the likes of James Florendine (b. 1872) and John Raby (b. 1867). Motor manufacture appears to have been dropped by 1911, Cluley opting instead to concentrate on the production of cycles and tricycles as their reputation continued to grow. During the First World War, the company was contracted to build 'landing wheels, propeller bosses, and flanges for aircraft; shell bases, and also all kinds of tubular work for aircraft, machine work for aircraft engines and mechanical transport vehicles'. Perhaps such contract work became very profitable for Cluley, as in 1920 he decided to venture into motor production once again, having additional works erected at nearby Gas Street. Joined by sons Samuel and Norman, the first 'Cluley' badged models were light cars designed by Cecil Charles Bayliss (b. 1896), with input from Arthur Alderson (b. 1875) powered by 1328cc four-cylinder 'All-British' engines of their own making. Production was thought to have continued until 1928, yet the 1932 Coventry Trade Directory continued to list them under 'motorcar manufacturers'. By 1933, they were seen listed as 'motor engineers' and by 1935/36 as 'general engineers' at the Globe Works, Gas Street, with Charles

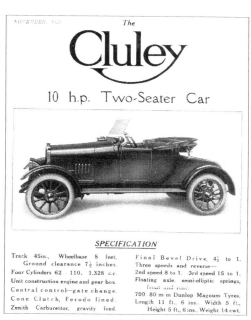

The **Cluley**

10 h.p. Two-Seater Car

SPECIFICATION

Track 45in., Wheelbase 8 feet, Ground clearance 7½ inches. Four Cylinders 62 – 110, 1,328 c.c. Unit construction engine and gear box. Central control—gate change. Cone Clutch, Ferodo lined. Zenith Carburettor, gravity feed. Final Bevel Drive, 4½ to 1. Three speeds and reverse— 2nd speed 8 to 1. 3rd speed 15 to 1. Floating axle, semi-elliptic springs, front and rear. 700·80 m·m Dunlop Magnum Tyres. Length 11 ft., 6 ins.. Width 5 ft.. Height 5 ft., 6 ins.. Weight 14 cwt.

A Cluley 10hp model of 1920. Again, the origins of the business began as cycle manufacturers.

J. Cluley and son Norman J. Cluley as Director's. At this time it was reported that they had a workforce of just seventeen, but had been acting as sub-contractors to Rolls-Royce, working on Merlin aero engines during the Second World War. Much of their Gas Street works were destroyed during the following raids, and a move to Moorland Avenue, Kenilworth followed in peace time. At Kenilworth, they became engaged in sub-contract work for the aero-engine and helicopter industries. As a business, Clarke, Cluley and Company spanned over 100 years, being wound up at Siskin Drive, Bagington, Warwickshire in 1992 with A.T. Winter given as Director.

CONDOR, 1912, and 1933–1940 (1911–1955)
Condor Motor & Fittings Co., 182–184 Broad Street Garage, Broad Street, Great Heath

The origins of the 'Condor' name go back to around 1911, when Ernest Sidwell started business on his own account as a 'motor engineer and accessories dealer'. The son of a Coventry steam engine fitter, Ernest was born in 1879 and briefly worked as a silk weaver before entering the motor trade. While working in the Coventry textile industry, Sidwell, clearly of an inventive mind, set about making improvements, applying for two patents during 1903 relating to 'needle or shuttle-less looms', whilst residing at Harnall Lane. His next patent (17,819) of 1910, ties in with his change of career, relating to 'carburettors for internal combustion engines', by this time living at 182 Broad Street and offering himself the title of 'manager of a motor accessories depot'. Some years earlier, in 1906, Thomas William Quinney (b. 1865), a former local butcher, began a business called the Motor Accessories Company at 182-184 Broad Street, and it would appear that this was where Sidwell found employment as manager initially before possibly acquiring the firm around 1911. In January 1912, however, *The Cyclecar* reported on a 'unique three-wheeled cycle car' as built by the Condor Motor Company of Coventry to the specifications of a customer. Unusually, it had two-wheels on one side of the open body and a third wheel on the other side, like an isosceles triangle, with the 4hp Condor engine situated between them. It would seem that initially, though, Sidwell began making engines as well as a few high-powered motorcycles, and he appeared to have two separate businesses running; the Motor Accessories Company, and the Condor Motor Company, whilst being privately listed as a 'manager of a motor company – employer' in the 1911 census. By 1914, it seems that the Motor Accessories Company was no more, and instead Sidwell now ran two businesses from Broad Street – the Condor Motor & Fittings Co., and the Micro Garage Co., as well as being listed separately as 'Sidwell, E., motor engineer'. During the war, the Condor Company produced 'detail work for aeroplane engines, limit gauges, and special testing instruments for the Royal Aircraft Factory'. Still concerned with the manufacture of engines and motorcycles in 1919, they also became 'specialists in aero-engine valves', which was continued throughout most of the 1920s. For much of the 1930s, however, local trade directories listed Condor as 'motorcar manufacturers', but information surrounding any complete vehicles have so far proved difficult

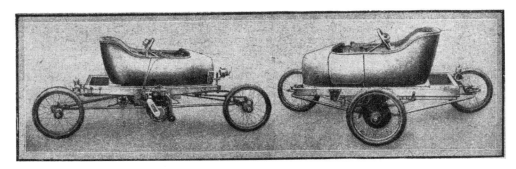

An unusual motor developed by the Condor Motor & Fittings Co. from 1912.

to trace during this period. By now, Ernest Sidwell's son, Alfred (b. 1905), began to take on more responsibility as the workforce continued to grow, and by the beginning of the Second World War, Condor was employing over 100 people. Company details are scarce following the war, yet Alfred Sidwell was seen to have been Director by 1948, and the last entry found was in 1955, where the firm were seen to be 'manufacturers of model diesel engines for planes and race cars'.

COOPER, 1922–1923 (1919–1968)
The Cooper Car Co. Ltd, Lythalls Lane

The Cooper Car Company began after the First World War at 78 Ampthill Road in Bedford, with a three-cylinder air-cooled 11hp prototype model being developed initially. In 1922 the business transferred to Lythalls Lane, Coventry with the production of 1368cc Coventry-Climax powered 'Cooper' light cars using Moss gearboxes and priced between £235 and £300. The man behind the name of the business was Edward J. Cooper (b. 1883) of Elstow, Bedford, and another individual known to have been heavily involved was Samuel Herbert Newsome, who had met Cooper during the war. Born in Coventry in 1902 and the son of a local watch manufacturer, Newsome was educated at Oundle Boarding School near Peterborough. Against his parents' wishes for

him to become a barrister, Newsome went on to complete an apprenticeship at the Calthorpe Motor Company in Birmingham before assisting in the development of the Cooper car. Also during the early 1920s, Newsome opened up a garage at Walsgrave Road, repairing and tuning cars and cycles. This new business grew with the Coventry car industry, where he became the first retail agent in the city to sell 'Standard' cars. Taking on larger premises on Corporation Street, S.H. Newsome & Company also became agents for both Riley and Jaguar and reached a £1m a year turnover by 1957. Due to extensive Blitz damage and subsequent central redevelopment, the company built a brand new dealership at Kempas Highway, which still functions today independently as a Peugeot dealership. *(See also Newsome and Warwick.)*

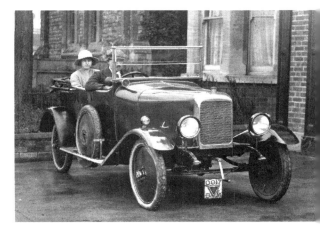
Sammy Newsome sits behind the wheel of the Cooper car whilst at Amphill Road, Bedford.

CORONET, 1903–1906 (1896–1910)
Coronet Motor Co. Ltd, Coronet Motor Works, 83–87 Far Gosford Street

Coronet began as cycle makers in 1896 at former watch making premises in Hearsall Lane, Chapelfields, where Richard Fowkes (b. 1857) of Redditch was known to have been the first works manager. Also involved in the creation of the company was Leopold Edward Harris (b. 1868), with investment from the coach lace manufacturer, Joshua Perkins (b. 1840), who seemingly had his hand in a number of local cycle and motorcar companies around this time, and later was to become Coronet's commercial manager. London-born Harris first arrived in Coventry in the 1880s to work in the watch trade becoming a 'watch manufacturer's manager' by 1890. Installing Frederick Lewis as manager, by 1903 Coronet had relocated to much larger works formerly used by Townend Bros. at Far Gosford Street with a working capital of £20,000. Primarily producing cars as well as motor bicycles in small quantities, these were made to the design of Brighton-born Walter James Iden (b. 1874) as chief engineer, after the closure of the Carlton Motor Company.

The 16-20 h.p. "CORONET"—Net Cash Price £525 - 0 - 0.

THREE METHODS OF PURCHASE THROUGH FRANK PEACH & COMPANY, LIMITED.

No. 1. One Quarter of the Net Cash Price payable down and the Balance when the Car is ready for Delivery.

No. 2. £131 - 5 - 0 Cash down and Twelve Monthly Payments of £35 - 8 - 9 commencing One Month after Delivery.

No. 3. £131 - 5 - 0 Cash down and Four Quarterly Payments of £106 - 6 - 3 commencing Three Months after Delivery.

THE CAR BECOMES THE ABSOLUTE PROPERTY OF THE PURCHASER IMMEDIATELY ON DELIVERY.

A description of the Coronet car of 1905. The enterprise ran from 1896, originally as cycle makers.

Iden, whose father George had also formed his own motor company at Parkside from 1903, was known to have applied for at least patent (12,426) during his time at Coronet, concerning variable speed and reverse gearing. The motor cars, assembled using both British and French components, were available in a range of sizes from 8-16hp, the larger being of shaft-drive on four0seated Tonneau bodies. Also known to have been suppliers of engines to firms such as Crypto and Jones, in 1906, Coronet fell into difficulties and were thought to have been taken over by the Humber Company who took over the Far Gosford Street premises. By 1910, the name was dropped and the factory was converted into housing. Harris appeared to have left Coronet relatively early on, eventually becoming a sales manager for a motor fittings company in Wolverhampton. Walter Iden was known to have moved to London, becoming unemployed by the London General Omnibus at Westminster.
(See also Carlton and Iden.)

COVENTRY ACME
(See Acme.)

COVENTRY CENTRAL, 1903
Coventry Central Garage Co., Fleet Street Works, Fleet Street

To date, the Coventry Central Garage Company has only been seen listed once, as 'motorcar manufacturers' at Fleet Street in the 1903 Coventry Trade Directory. Although it is not known who was behind the business, the garage may have had a connection with the likes of Arthur Hallett, Charles Hamilton, or Ryley, Ward & Bradford, all of which were known to have previously occupied the Fleet Works in a motoring capacity. Another and more likely contender, however, could be George Iden, who was known to have begun his Iden Motor Company at the Fleet Works from 1903. As no evidence has yet been found to substantiate actual car manufacture, then Coventry Central's involvement in that respect is extremely doubtful.
(See also Iden.)

COVENTRY CHALLENGE
(See Challenge.)

COVENTRY ENSIGN, 1913 (1909–1949)
Coventry Ensign Cycle & Motor Co. Ltd, 201 Foleshill Road, Bishopsgate Green

Beginning as the Ensign Cycle Company around 1909, the reformed Coventry Ensign Cycle & Motor Company was yet another small pre-war manufacturer set up in the city. They made a fresh start in 1913, with an entry in the *Applications for Registered Trade Marks* listing them as manufacturers of 'motorcars, motor cycles and cycles'. As yet, it is not clear who the individuals were behind the firm, yet interestingly the very next entry is that of the Coventry Progress

Cycle & Motor Co., listing the exact same address and business activities. This would indicate a possible connection to Enoch John West (1864-1937) who founded the Progress Cycle Company in 1896, but was also known to have built 'Progress' motors at Stoney Stanton Road from 1898, and later Foleshill Road. No details of any actual 'Coventry Ensign' cars have so far come to light, but in 1919 they were known to have produced a basic motorcycle fitted with a 292cc JAP engine. This was offered for a few years, before Ensign opted to once again concentrate on cycle production until closure in 1949, with Gerald A. Paine listed as Director.
(See also Progress and Remington.)

COVENTRY MOTETTE
(See Coventry Motor Company.)

COVENTRY MOTOR BODIES, 1914 (1910–1914)
Coventry Motor Bodies Ltd, Cow Lane

Although Coventry Motor Bodies Limited were seen listed in the 1914 Bennett's Business Directory of Warwickshire under 'motorcar manufacturers' at Cow Lane, lack of any further evidence would suggest otherwise. It is believed that the company started around 1910 in premises formerly used by the Whitley Motor & Engineering Company. They were initially listed as 'accessories manufacturers', yet by 1912, the Kelly's Coventry Directory listed them as 'motor body manufacturers' – clearly as their full title would indicate. The coming of the First World War probably cut short this enterprise and the individuals behind the company are so far unknown.
(See also Whitley.)

COVENTRY MOTOR CO., 1896–1899 (1896–1903)
Coventry Motor Co. Ltd, Parkside, & 16 Conduit Yard, Spon Street

In October 1896, Harry J. Lawson bought the UK rights to the French Leon Bollee Tri-cars for a reputed £20,000. He then established the Coventry Motor Company at Parkside, with the intention of building British versions of the Bollee design, with Lawson, T. Robinson, T. Chile, H.C. Newman, H. Jordan and Charles Jarrott as Directors. These 2½hp three-wheelers were given the name of 'Coventry Motette' and were developed and built under the supervision of Charles McRobie Turrell at some old industrial works situated off medieval Spon Street, locally known as 'Conduit Yard'. Turrell was born in Coventry in 1875, the son of William Turrell, the Headmaster of Wheatley Street School. On completing his education in 1889, he served his apprenticeship at the cycle makers J.K. Starley & Company before joining the Coventry Gas & Electrical Engineering Company. At the age of just 21, he gained a very significant position at the British Motor Syndicate as Harry Lawson's secretary, having the complete responsibility of allocating vehicles for demonstration purposes. This included the 'Emancipation Run' from London to Brighton of 1896, in which Turrell, adorning as ever his naval cap, drove a Coventry Motette model. The initial workforce allocated to Turrell included the likes of Frederick Henry De Veulle (b. 1881) as works manager, electrical engineer John Russell Sharp (b. 1877), and the young Ernest Rush Dell (b. 1884). Others included William Letts (b. 1873) later of Crossley Motors, and Percival L.D. Perry (b. 1878) – later to become the Ford Motor Company's Head in Britain. During 1897 the company released a ladies open-framed motor-bicycle, and Turrell applied for a number of patents in conjunction with Lawson, F.H. De Veulle and George Accles. In the same year a Coventry Motette model was paraded through the streets of Coventry during the annual Godiva Procession on the roof of a Daimler lorry. With the drivers being dressed as clowns, the side of the lorry

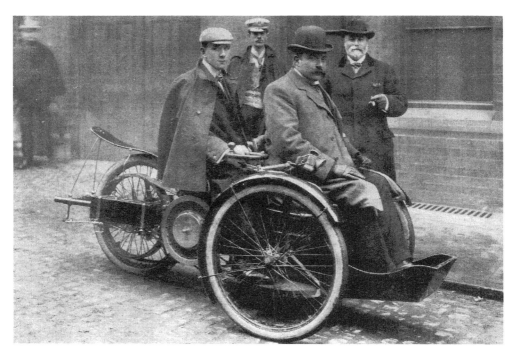

Charles Jarrott sits at wheel of a Coventry Motette, as made by the Coventry Motor Company from 1896.
Charles McRobie Turrell, stood at the back in cap, managed the firm.

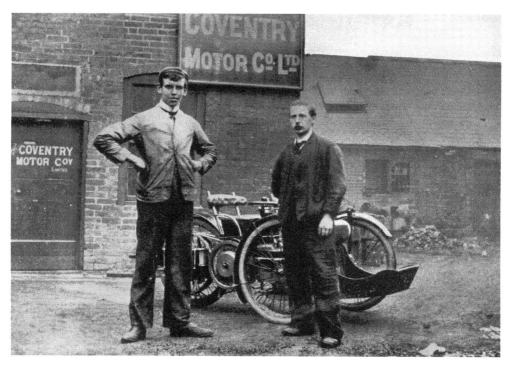

A rare glimpse into the works of the Coventry Motor Company situated at Conduit Yard, an old industrial area
now long gone. John Russell Sharp stands on left.

read 'any fool can drive a Coventry Motette'. By 1899 Turrell joined forces with Accles at Birmingham, and shortly after he joined the Pollock Engineering Co. at Ashton-under-Lyne – makers of the Turrell light car. From 1904 he became a London-based consulting engineer, always active in motoring events and becoming a Member of the Institution of Automobile Engineers in 1907. With Lawson long gone due to his questionable dealings, the Coventry Motor Company continued to trade until 1903.
(See also Lawson.)

C.M.S., 1929–1931 (1910–1996)
Coventry Motor & Sundries Co. Ltd, 34 Spon End

The Coventry Motor & Sundries Company was thought to have begun some time prior to 1910 at Clarence Street, Hillfields through William Edward Mann (b. 1865). It was later taken on by former Riley worker Alfred R. Grindlay, who also had a hand in the creation of three other motor-related businesses in Spon End, Coventry. Alfred Robert Grindlay was born in Coventry in 1876, the son of a local watch finisher. On leaving school it is thought that young Alfred bypassed the watch trade and instead joined one of the many cycle firms in Coventry, seen to be a 'cycle frame builder' by the turn of the century. This may well have been for the Riley Cycle Company, as he was known to have applied for a patent (24,683) in 1911 whilst a motor works foreman at Riley regarding 'improved means for carrying spare wheels' for motorcars. It is then thought that during the First World War he joined forces with Thomas Edward Musson (b. 1875) as Musson & Grindlay, sidecar makers at Spon End, and at around the same period it is believed that he also took over the Coventry Motor & Sundries business. By the late 1920s, Alfred's two sons, Reginald Robert (b. 1900), and Alfred Stephen (b. 1910),

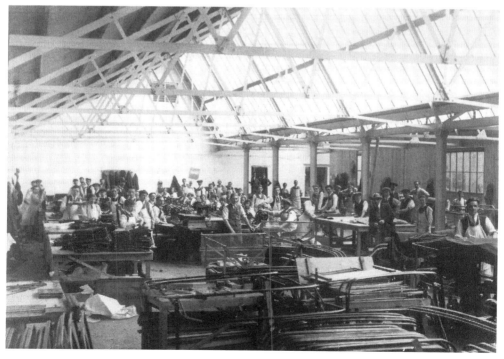

Coventry Motor & Sundries catered for much of the motor trade, including the manufacture of sidecars and motor bodies.

began to take greater responsibilities in the company, and along with their father developed a two-seater sports car based on the original Morris 8 light car. It was available in two versions called the C.M.S. Sports and Super Sports and sold from £142 to £155. According to John S.F. Grindlay (b. 1940) in 1966, around 200 were built. The chassis were supplied by Morris Motors and the coachwork was undertaken by the Coventry Motor & Sundries, available in either red, black or blue. Production lasted around two years, and the company reverted to general motor body building and engineering, lasting right through to 1996. The Grindlay family were also involved in the production of high-powered Grindlay-Peerless motorcycles from 1923–39, and the formation of the Coventry Engineering Company in 1936. During the war, in 1941, Alfred Robert Grindlay was appointed Mayor of Coventry. His Coventry Engineering Company was later listed in the *Directory of Coventry Manufacturers* of 1950 with Alfred as Director (CBE, JP), and lists them as 'specialising in jigs, fixtures, gauges, plastic moulds and press tools'.
(See also Riley.)

COVENTRY PREMIER, 1914–1924 (1875–1924)
Coventry Premier Co. Ltd, 8 Lincoln Street, & 1–7 Read Street

The origins of the 'Premier' name go back to 1875, when William Hillman joined forces with William Herbert to form Hillman & Herbert as cycle manufacturers at South Street. William Hillman was born at Lewisham, Kent in 1847 and worked alongside the likes of James Starley, Josiah Turner and George Singer at the very beginnings of Coventry's involvement with cycle development during the late 1860s. William Herbert, brother of Alfred Herbert of machine tool fame, was born in Royal Leamington Spa in 1858 and took care of the financial side of the operation. Becoming Hillman, Herbert & Cooper by 1880, at the Premier Works they continued making bicycles, tricycles and even sewing machines of high quality for a number of years, before becoming the Premier Cycle Company in 1891. Although William Hillman himself had commenced manufacture of cars in partnership with Louis Coatalen from 1907, it was not until the following year that the motor was employed under the 'Premier' name, with a 3.5hp White & Poppe-powered motor-bicycle. It would be a further six years before the company made a motorcar under the 'Coventry Premier' name, when former Clement-Talbot designer George W.A. Brown (b. 1881) joined the firm as works manager. This experimental work was cut short, however, and during the war production switched to that of making aero engine valves, pistons, connecting rods, tractor axles, shell heads, and military pedal cycles. From 1919, Brown had moved on to work for Arrol-Johnston Ltd, but at Coventry Premier car manufacture resumed with the introduction of an 8hp two-cylinder three-wheeled machine called the 'Super Runabout', assisted by former Villiers employee Georges Funck. Within a year the company began to struggle, and so the Singer Company, located nearby at Canterbury Street, bought the Coventry Premier concern for £97,000 and maintained their production, yet in reality wanted primarily to secure the additional factory space. Singer's works manager at that time was William E. Bullock (b. 1877), who stated in 1967, 'Premier had taken orders for 2,000 of the three-wheelers but they hadn't a hope of meeting commitments and cash had run out. We carried on making the car under the Coventry Premier name but were soon wishing we hadn't'. Bullock adapted the rear end to make a four-wheeled light car that were sold as 8–10hp models, not too dissimilar to their own Singer 10 models, until 1924. William Hillman had died three years earlier in 1921, but there was some irony in the fact that his Premier business was taken over by the Singer Company. Established as a cycle business by George Singer in 1874, both he and Hillman had prior to that apprenticed at John Penn & Sons in Greenwich, and arrived together in Coventry during the late 1860s to work at the Coventry Machinists. From humble origins both became self-made millionaires through the cycle trade yet their names lived on as car makes up to the late 1970s.
(See also Hillman, Hillman-Coatalen, and Singer.)

COVENTRY VICTOR, 1919–1938 & 1949 (1904–1990)
Coventry Victor Motor Co. Ltd, 137-139 Cox Street, & Humber Avenue
Morton & Weaver Ltd, 137 Cox Street

The origins of the Coventry Victor name began in 1904 when Thomas Morton and William Weaver joined forces as 'engineers and toolmakers' at Cox Street, opposite the Sydenham Palace public house. Thomas Edwin Morton was born at Birmingham in 1870, the son of an electro plater and part-time barber. Little is known about his school years or apprenticeship but by 1891 he was seen to be working as a 'pencil case maker', and ten years later as a 'clerk in a machinist office' in Birmingham. William Arthur Weaver (d. 1960) was born in Peterborough in 1885, the son of a 'brewer's agent and lace manufacturer'. He apprenticed in engineering in Manchester and was involved in much experimental work concerning tractors and steam engines. How he and Morton met is completely unknown, yet in 1904 they indeed formed a partnership – made even more surprising by the fact that at that point Morton was aged 34, and Weaver aged just 19 or 20. Weaver also appeared to be something of a distant partner early on, applying for patents from a residential address in Manchester until at least 1906. As Morton & Weaver Ltd, they first started out making horizontally-opposed engines and grinding machines. In 1911, they added the business of the Coventry Victor Motor Company at the same Cox Street premises to concentrate on the motor engineering aspects, while Morton & Weaver focused on tool-making matters. During the First World War they were engaged with making 'small parts for airplanes' and 'various tools and machining for the British ordnance and small arms factories', which proved beneficial. In February 1919 the company was re-registered with a working capital of £2,000, naming both the founders as Directors. Shortly afterwards they produced a part canvas-bodied light four-wheeled car to test their new water-cooled 750cc flat-twin engine, yet ultimately it was to be the manufacture of Coventry Victor motorcycles they decided to apply themselves to through much of the 1920s and 1930s. However, in 1926 they marketed a three-wheeled cycle car powered by their 688cc 'vibration less' proprietary engine, of which several variations followed until 1938. In 1928, H.J.Vidler drove one of these 749cc machines to victory at the Cyclecar Grand Prix event at Brooklands. Surprisingly, their central Cox Street works escaped the air raids of the Second World War, and much later, in 1949, they developed a 'Venus' small saloon model powered by a 747cc flat-four motor, but this did not find its way into full production. After this point, Morton and Weaver opted to focus on 'Victor' diesel engines and petrol marine engines, and existed as a company in Coventry until 1990. Motoring aside, Weaver was also heavily involved in aviation throughout his active career, being the first person in Britain to 'leave the ground' in a monoplane aerofoil in 1905 whilst in his 'Weaver Ornithoplane'. He built a second model in 1910, which flew successfully at Hampton, whilst also becoming President of the Coventry Aeroplane Building Society, of which Thomas Morton was also a member.

Another three-wheeler, this time by Morton & Weaver's Coventry Victor business.

Although a limited number of cyclecars and light cars were made by Coventry Victor over many years, it was the manufacture of engines and motorcycles for which the company were most famed.

CRAWFORD, 1901–1903
Crawford Gear Co. Ltd, Holbrook Lane

The Crawford Gear Company was registered in June 1901 with a modest working capital of £1,000 with an address given at Holbrook Lane. The man behind the firm was the Canadian Middleton Crawford, who originally hailed from Wiarton, Ontario, born in 1860. He first arrived in England around 1890, residing at the Inns of Court Hotel in London, along with his British wife Alice. His occupation at this time was given as a 'mining engineer', going on to patent a machine for 'pulverizing gold bearing quartz' by 1894. Crawford then spent the following years travelling to and from America on business whilst he continued his mining engineering projects, but while overseas in August 1895 he received word that his young wife had died suddenly. This clearly hit Crawford hard as he was admitted to the Pueblo County Mental Asylum soon after, described as becoming 'insane ever since her death' in the local American press. Either this was a slight overstatement or Crawford made a remarkable recovery, as by 1896 he had returned to London, this time working as an 'electrical engineer'. In 1900 he first patented his 'Crawford Variable Speed Gear', known to have been supplied to the Brooks Motor Company of Coventry, also at Holbrook Lane. Considering this, then it is very probable that Crawford's company worked out of the same address as Brooks, as very few industrial premises have been identified in this area at that time. In terms of actual motorcar production, no hard evidence exists as yet that would suggest a complete car bore the 'Crawford' name, so perhaps the known business link to the Brooks Motor Company was as far as it really went. However, when the company was registered in June 1901 with a working capital of £1,000, their stated objectives were to 'carry on the business of engineers, founders, motor, motor-cycle, carriage, cycle, and vehicle manufacturers, factors, and dealers' to add support to such claims. Whilst in Coventry, Crawford was listed as a 'motorcar engineer' on his own account, lodging at 129 Broad Street for a time, and was also involved in the formation of the Priory Motor Company. In 1902, he also developed methods to improve exhaust silencing, and continued his work and interest in the motor industry through improvements in steering axles. After 1903 he was seen to have formed an engineering partnership with Arthur F. Martin back in London, which dissolved in 1911. He then returned to America and set up home in Spokane, Washington; the last record seen of him concerned his 'improvements to Rotary Pumps' for the Spokane Irrigation Pump Company in 1922.
(See also Brooks, Force, and Priory.)

CROMWELL, 1911 (1907–1941)
Cromwell Engineering Co., 94 Stoney Stanton Road

The origins of the Cromwell Engineering Company began in 1904 at Colchester Street as 'engineers' yet were also seen to be listed as 'motorcycle manufacturers' by 1907. Evidence strongly suggests that the founder was Frederick Payne, born at Thrapston in Northamptonshire in 1862, and son of Mark Payne, once an engineering foreman to George Stephenson. After apprenticing under his father at both Thrapston and Kettering, Frederick arrived in Coventry along with his brothers George and Walter in the 1880s and found employment in the cycle trade, finding lodgings at ancient Freeth Street. He then formed a partnership with Thomas Frost and Alfred Bonnick as 'gas and oil engineers' but had left by 1893. by the turn of the century it's thought that he was working for his younger brother Walter at Payne & Bates Limited, as the 1901 census shows him to be employed as a 'motor car fitter' and living at Lockhurst lane with his growing family. During this period he would have worked on models such as the 'Godiva', 'Shamrock' and 'Stonebow' amongst other things, providing him with plenty of experience to go it alone by 1907. Under the Cromwell Engineering name, the business developed a decent reputation as engine makers and suppliers, but was also believed to have experimented with complete cars by around 1911. However this involvement with car production was very brief, and as a consequence, little in the way of details exist. As an engineering firm however, Cromwell excelled, branching out to also make motor accessories. In 1919, Frederick Payne, now going by the title of Managing Director, applied for a patent (150,560) regarding 'improvements to screw and nut mechanisms' whilst the company was at 133 Foleshill Road. Payne himself died in 1943 aged 80, but the business was wound up two years earlier with G. Godwin as Secretary.
(See also Payne & Bates.)

CROUCH, 1912–1928 (1899–1928)
Crouch Motors Ltd, 34 Bishop Street, Tower Gate Works, Cook Street, & Stoney Stanton Road

A Crouch light car of the early 1920s. Crouch made their first cars from 1912.

Crouch Motors Limited were set up at 34 Bishop Street as 'small car manufacturers' in 1912. Tapping into the light car and cycle car market, one of their first offerings was the Crouch 'Carette' at £132, an odd-looking three-wheeled car powered by a 1000cc Coventry-Simplex V-Twin engine, and within a year, four-wheeled versions became available. During the First World War, Crouch Motors became subcontractors to Coventry's Ordnance Works, whilst also choosing to reconstruct themselves as Crouch Motors (1915) Ltd. After the war they commenced motor production with a £260, 10hp, two-seater light car, by now made at the Tower Gate Works on Cook Street. Crouch adverts of the time stated that the car 'was the result of 23 years practical experience of motor manufacture'. Indeed, John William Fisher Crouch (known as 'Willie') was born at Atherstone in 1883 and had started his career aged 14 as an apprentice at the Daimler Works in Coventry. His father, John Crouch (b. 1856), had married the daughter of a wealthy North Warwickshire hat manufacturer, eventually becoming manager at the factory in Mancetter. He later acquired the business, but by the mid-1890s had sold it on and moved his family to Coventry, where he established a haulage contracting operation. He was known to have had an

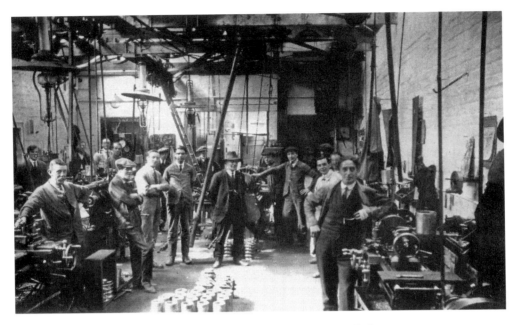

Staff at Crouch take time out to pose for a photo whilst at their Tower Gate Works.

interest in the beginnings of the British motor industry and owned imported French machines, and whilst his son was busy plying his trade at Daimler, began his own motor agency at Ryley Street. John Crouch junior was known to have then spent time in Manchester as a Foreman at a motor works, before returning to Coventry to briefly work for Siddeley-Deasy in 1911. With financial backing and business support from his father, by 1912 they started their own motor company, designing seven different models over sixteen years production. The company was reconstructed a second time in 1924 and subsequent models included a 12/30hp model and the 11.9hp British Anzani-powered 'Super-Sports'. The company closed in 1928, yet it is believed that at its peak some 400 staff were employed, turning out a modest twenty-five cars per week. *(See also Motor Agency.)*

CUNARD, 1901–1905
Cunard Motor & Engineering Co., 19 Chauntry Place, & Round Tower Works, Leicester Street

During the early-1870s, at a time when Coventry's cycle industry was still very much in its infancy, increased numbers of families began to migrate to the town as more career opportunities arose. John Shaw (b. 1839) of West Bromwich was a typical example of such migration, moving his wife and four sons to Bradford Street, Coventry around 1876. Initially plying his trade as a black-smith, Shaw saw a great opportunity and began his own hollow tube manufacturing company at Dale Street, at which all his sons became employed. Interestingly, in the early 1890s, Shaw & Sons made a flying machine called the 'Aerial Monster' to specifications supplied by a Major Moore of the Royal Engineers in India, at a cost of £1,000. According to the *Coventry Standard* of 29th of August 1891, 'the machine was designed along the lines of a flying fox, the wings moving upward and downward, making fifty motions a minute'. Three horse power electric motors were to be used for motive power but it never flew, yet this feat did indeed signify that the firm were clearly aviation pioneers. John Shaw's eldest son, James (b. 1861), later went on to form his own business. Being first employed at the Coventry Machinists Company in the mid-1870s, he then joined Singer & Company before working for his father making hollow tubes. In 1880, he invented

a roller-wheel to replace chains on tricycles, which were taken up by Bayliss, Thomas & Co., and he also created a safety cycle with a lever and sun and planet motion. By the turn of the century, he began the Cunard Motor & Engineering Company at Leicester Street, in premises formerly occupied by the cycle manufacturers Jones, Venn & Company. Cunard were listed in the Coventry Trade Directories from 1901-1905 as 'motorcar, motor manufacturers and factors' and were known to have made their own engines called the 'Cunard', 'Yelston' and 'County'. Cunard commercial vehicles were later offered by British Business Motors, thought to be under the control of Henry Sturmey, yet whether the two are related is unclear. When this business closed in 1905, James Shaw briefly worked at the Climax Motor Company before joining the engine makers White & Poppe, where he remained for the rest of his working life. On his own reminisces of early motoring, in 1920 he stated, 'I remember once starting from Coventry on a Benz car for Skegness, and it took me a week to get there. There was a breakdown at Leicester, and I had to return home to do repairs. I re-started on the Thursday, and soon she was at her old games again; but I was in Lincolnshire at last'. He died at Northend near Banbury in 1931. *(See also British Business Motors, Climax, Sturmey, and Priory.)*

DAIMLER, 1896–2002 (1893–2002)
Daimler Motor Co. Ltd, The Motor Mills, Drapers Fields, & Radford Works

It was a mechanical engineer named Frederick Richard Simms (1863-1944) who established the beginnings of the Daimler name in Britain. Born in Hamburg, Germany but of Warwickshire ancestry, in 1893 he formed the Daimler Motor Syndicate – holding all Daimler patent engine rights in the UK. This foundation had followed a several year association with Gottlieb Daimler (1834-1900) who had been propelling carriages through motive power from 1885 along with fellow German Wilhelm Maybach (1846-1929). During the summer of 1895, Simms sold the Daimler patent rights to Harry J. Lawson for £35,000, who, by the November of that year, established the British Motor Syndicate with an initial working capital of £150,000, with Lawson himself as the principal shareholder. The Daimler Motor Company was then floated, being registered on the 14th of January 1896 for the purpose of making British motor vehicles on a mass production scale. The funds were in place, yet a suitable factory had yet to be secured. On visiting a motor works in Birmingham, and contemplating a move to Weyman & Hitchcock's oil-engine factory at Cheltenham, ultimately a site was chosen and purchased in Coventry in April 1896, a city of which Lawson knew very well. Amid rumours that Lawson had personally bought the site before the floatation of the Daimler Company, the factory was a large one – formerly owned by the Coventry Cotton Spinning & Weaving Company. Having been gutted by fire in 1891, the building had been completely restored by insurers at great expense but had been left vacant ever since. On hearing the news of the new tenants, the *Autocar* stated, 'This looks as if Coventry, which is already the head centre of the cycle industry, may also be looked upon in the future as the chief centre of the autocar industry'. How right they were to be, and on completely fitting out the four-storey works with suitable plant and machinery, a mass recruitment campaign ensued. Many skilled engineers would enter the factory halls of the Motor Mills from that point in time onwards, including the likes of James S. Critchley (b. 1866) as first works manager, Arthur Altree (b. 1867), Ernest Instone (b. 1873), and the Dutchman Johannes van Toll (b. 1861). The company's first cars were very experimental types in late 1896, but it was the following year where manufacture really took off with a range of 4hp models including the 'Dryden' and 'Burleigh' Dog-carts, the 'Covert', 'Siamese', 'Marseilles' and 'Norbeck' Phaetons, the 'Cranford' Wagonette, the 'Rougemont', and the 'Knightley' Victoria with prices between £294 and £335. By August, Major General Hugh Parker Montgomery (1829-1901) took delivery of a Daimler Cranford Wagonette – the first order of a British-built Daimler motor. Some week's later company Director Henry Sturmey caused a nationwide sensation by driving a Daimler carriage 929 miles from John O'Groats to Land's End in just over ninety-three hours. Royal patron-

James Critchley holds the tiller of one of the first British Daimler models at the Motor Mills in late 1896, with Arthur J. Drake as passenger, and Otto Mayer and Alfred Bush sitting in the rear.

Francis Baron steers the front Daimler model, again at the Motor Mills in 1897.

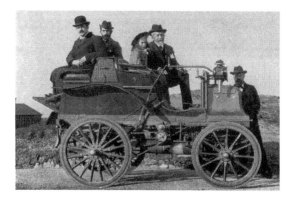

Daimler Director Evelyn Ellis sits proudly in the front of a Daimler model with his daughter, Mary, after reaching the top of Malvern Beacon in 1897.

age also boosted the company's profile immensely, with HRH the Prince of Wales purchasing a 6hp Daimler model after the success of the Thousand Miles Trial of 1900. By this time, Lawson's involvement had all but been severed, and after James Critchely's departure in 1901, the post was taken up by chance by the American mechanical engineer Percy Martin (1871-1958) while on holiday in England, and Herbert W. Bamber (b. 1867) was appointed works manager. The company now employed some 350 men making around twelve cars per month, and, by 1904, 600 men were engaged making around twenty-five cars per month. Daimler as a company was also reconstructed in 1904 and the factory extended to accommodate the demand for the quality motor vehicles being produced. In 1906, the first live-axle driven cars were turned out, and two years later the well-received 'Silent-Knight' engine was released after being developed by technical advisor F.W. Lanchester, while a second factory was erected on land purchased at nearby Radford. In 1910, Daimler were amalgamated by B.S.A. as some 5,000 were employed at the two Coventry factories, and during the First World War the company contributed massively by making artillery shells, staff cars, ambulances, tank and aero-engines, lorries, and aeroplanes – the completed aircraft flown from the Radford Works own airstrip. The production of cars recommenced in 1920, while Ernest Instone resigned the following year after some twenty-five years service. Daimler fitted their first radio inside one of their models in 1922, as both Daimler and B.S.A. cars continued to be produced in numbers, and, in 1931, the famous Birmingham car manufacturer Lanchester was purchased, being made at the Radford site from that point until 1956. Having held a senior position at the firm since 1901, in 1934 Percy Martin retired. The Radford Works became the main car manufacturing facility in 1937, yet in November 1940 and April 1941, 70 per cent of the factory was destroyed

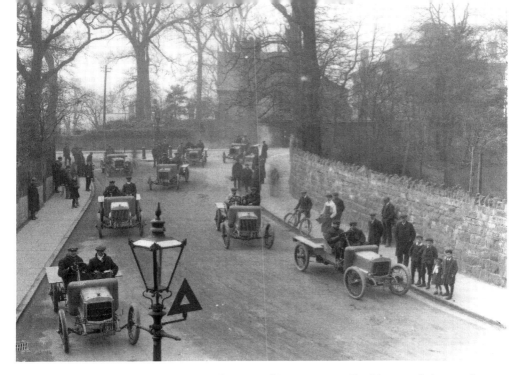

During the early years of the industry, the streets of Coventry were rife with motors being tested. These Daimler models were pictured from an upper window of the company's offices on Sandy Lane.

while the original Motor Mills was all but obliterated. Car production resumed once again in 1946, the fiftieth anniversary year, with the DE 27, a six cylinder 4.1 litre, and the DE 36 – a larger 4.6 litre straight-eight model. Being under the reigns of Sir Bernard Docker (1896-1978) from 1941, Daimler as a brand excelled, and by the early 1950s they were producing models such as the 2.5 litre Consort Saloon, the 2.5 litre Special Sports, and the rather expensive Straight-Eight Hooper Limousine at £5,554. By this time the reconstructed and extended Radford plant now boasted nearly 1.4m square feet covering 65 acres. The Daimler 3.8-litre 'Majestic' was launched in 1958, but by June 1960, Jaguar had absorbed the famous Daimler name at a cost of £3.4m, and used it as their luxury car brand at Browns Lane until 2002.
(See also GHCC, Jaguar, and MMC.)

DAISY, 1912–1925 (1912–1939)
Daisy Motor Co., Daisy Motor Works, 96a Far Gosford Street

Beginning at Far Gosford Street in 1912, the Daisy Motor Company bore the listing of 'motor-car manufacturers' at the same address until 1925. The man behind the business was given as Alfred Spurgeon, the son of a silk weaver and born in Berry Street, Coventry in 1874. On leaving school in the late 1880s he joined the growing cycle trade along with his older brother Walter, remaining in the industry for many years. In 1907, Spurgeon applied for a patent (14,605) relating to cycle rim brakes whilst living at Spencer Street. By 1911, Alfred was seen listed as a 'cycle agent & repairer' on his own account at Far Gosford Street, while his younger brother William (b. 1884) was listed as a 'motor mechanic'. William's expertise may well have been key with regards to the family's impending involvement with motors, as by the following year the Daisy Motor Company was formed. However, to date, no such details have surfaced as to provide what form of vehicles, if any, were ever made. By 1919/20, Alfred was listed at three separate addresses on Far Gosford Street, offering an insight into what a diverse businessman he was – as the 'Daisy Motor Works' at 96a, as a 'Confectioner' next door at 96, and as a 'Cycle

& Motor Agent' at number 80. His association with the Daisy Motor Works appears to have ceased in the mid-1920s, but his cycle agent business was known to have been continued by his daughters Rhoda and Hilda at Foleshill Road up to the war.

DALTON & WADE, 1901–1903
Dalton & Wade, 146 Spon Street

The former 'National Cycle Works' at 146 Spon Street were taken over in 1901 by Frederick Dalton and Francis Wade to develop motors. Frederick William Dalton was born in Chelsea, London in 1875, the son of the vicar of St Luke's, the Reverend William H. Dalton. After studying mechanical engineering in both London and Leicestershire, Dalton had found his way to Coventry by 1901 and formed a partnership with Wade. Francis Richard Wade hailed from Beeston, Nottinghamshire in 1873, the son of a hosier. He chose not to follow his father and elder brother into the hosiery and haberdashery business, and instead studied engineering. Wade may well have worked at the Humber Company's Beeston works towards the late 1890s, but he was definitely known to have briefly worked alongside John R. Jones in London in 1900, regarding steam engine indicators. By 1901 he was seen to be in Coventry, lodging at Coundon Road and listed as a 'mechanical engineer', and certainly by March that year he had teamed up with Dalton, finding premises at 146 Spon Street. Dalton and Wade applied for two patents together whilst in Coventry; in March 1901 (5,032) regarding 'improvements in oil engine carburettors and vaporizers', and in March 1902 (7,025) concerning 'improvements to exhaust valve mechanisms of internal combustion motors'. They also made their 'DAW' motor-bicycles about the same time, powered by either Minerva engines or power units of their own manufacture. It is not known for certain whether they extended such activities to that of building complete cars, yet based on their working knowledge it would seem highly likely. However, the partnership was not to last and while Dalton's subsequent activities are unknown, by November 1903 Wade had moved to Stetchford in Birmingham, where he continued his developmental work regarding internal combustion engines. He then formed

A Dalton & Wade advert showing their motor-bicycle engines, yet they may have also extended their output to cars also.

a partnership again, this time with former associate John Reginald Jones as Wade & Jones Ltd, at Colmore Row, Birmingham, yet this broke up in 1910. Never straying too far from Coventry, by 1911 Wade and his growing family were seen to be living in rural Meriden with Wade himself being listed as a 'consulting engineer'. After the war he settled once more in London, taking out many more patents in a number of fields for the remainder of his working life, including ones concerning motors, ladies handbags, turning lathes, and even shaving razors by 1927.

DAVISON, 1919–1930
Davison Car Engineering Co. Ltd, 68 Clay Lane

The first occasion where the Davison name appears in Coventry in motor engineering terms was as early as 1902, with former Lucas employee Augustine Campbell Davison. For around six years he produced Minerva- and Simms-powered 'Davison' motorcycles at the cycle manufacturer Philip Dingley's Viaduct Works in the city, with administrative offices given at Camden Road, London. Not thought to have any other connection, the next time the Davison name reappears in Coventry was in 1919, with the Davison Car Engineering Company seen listed as 'motor engineers', based at 68 Clay Lane. Suggested to have been involved in actual car manufacture, lack of evidence would suggest otherwise, and if discovered to be true, then it must have been very brief. Exactly who this Davison was is not certain, yet an Egbert Davison (b. 1887), a motor works draughtsman, was seen to be in Coventry from 1911 up to the Second World War. Incidentally, between 1926 and 1930, a business going by the name of the 'Davidson' Car Company was also suggested to have built cars at 62 Clay Lane, Coventry. Whether these two companies are associated or whether this is down to a general transcription error is open for debate.

DAWSON, 1918–1921
Dawson Car Co. Ltd, Clay Lane

Alfred Dawson had been a works manager for the Hillman Motor Company for a number of years, but in June 1918 decided to start his own business, that of the Dawson Car Company at modest works on Clay Lane. Alfred John Dawson was born at Wolverhampton in 1883, the son of a London-born engineering coppersmith. He became an apprentice metal turner on leaving school and after marrying Ada Wainwright in 1906, the couple made their way to Coventry, Alfred securing a position at Hillman as an engineer's tool maker whilst making a home at 32 Kingsway. Eventually working his way up to works manager, by 1918 Dawson had decided that he knew enough to make a start on his own. Using a British bulldog as his emblem, he and his small team commenced the production of 1795cc four-cylinder powered light cars with bodies fitted by Charlesworth of Coventry, selling from £750. In total, it is thought that sixty-five or so were built, but by 1921 Dawson changed the name of the business to that of the Clay Lane Engineering Company. It is not known how long this revised general engineering business lasted, but the works on Clay Lane were known to have been soon after taken over by the Triumph Company. In July 1940, at the age of 58, Alfred, his wife Ada and their daughter Kathleen left for Australia to begin a new life.
(See also Charlesworth, Hillman, and Triumph.)

DEASY, 1906–1911
Deasy Motorcar Manufacturing Co. Ltd, Parkside, Cheylesmore

The Deasy Motorcar Manufacturing Company was formed in February 1906 with a nominal capital of £150,000 for the purposes of making 'private motorcars, omnibuses and delivery vans'. The man behind the name was the Irishman Captain Henry Hugh Peter Deasy, born in Dublin

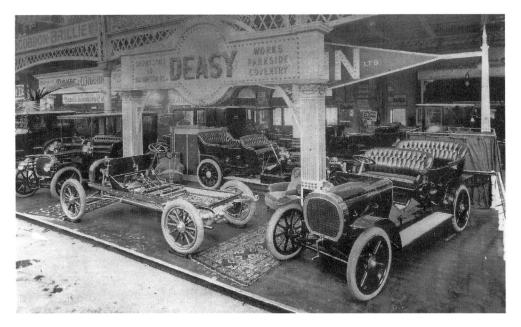

Captain Henry Deasy had taken a very keen interest in the developments of motoring from its very beginnings, before establishing his own company in 1906.

in 1866. Said to be 'tall and handsome with personality', he became a high-ranking cavalryman in the 16th Queens Lancers, serving mostly in India, but had retired his military duties by 1896. A founding member of the Cavalry Club at Piccadilly and still only in his early thirties, he then embarked upon travelling Central and East Asia, becoming one of the very first Westerners to compile a detailed account of Tibet and Chinese Turkestan. For this feat, in 1900 he was awarded with the Royal Geographical Society Gold Medal for his work in surveying almost 40,000 square miles of the Himalayas. In 1901 he married Delores Hickie, and two years later he formed his first motor business at 10 Brompton Road, London, under H.H.P. Deasy & Co., becoming importers of Swiss-built Martini cars as well as French-made Rochet-Schneider models. To help promote the two products, he drove a 14hp Martini touring car up a Swiss mountain rack railway track from Caux in a blizzard (to 6,485 ft), crossed thirty-four of the highest passes in Europe, and drove a Rochet-Schneider from London to Glasgow. In collaboration with former Daimler and Rover designer Edmund W. Lewis, he formed the Deasy Company in Coventry, finally securing premises formerly used by George Iden for £12,179, after considering land near to the General Wolfe Hotel. Aiming to make 200 car units per year, the first cars on offer were 20hp four-cylinder models 'marked by power and originality'. Before long the company adopted a piecework system with a working week of fifty-four hours from Monday to Friday with a half day on Saturday. Employees known to have worked at Deasy early on included Albert C. Hills (b. 1864), William George Williams (general manager), Hubert C. Clark (b. 1879), Albert G. Asbury (b. 1877), Percy J. Barker (b. 1891), Albert Hayfield (b. 1889), Edward Flogdell (b. 1873), J.A. Simmons, George T. Mason (b. 1883), Edgar Goddard (b. 1883), and Walter Kimber (b. 1891). As time progressed, Deasy, having literally a distant involvement in production, became increasingly frustrated with Lewis and what he saw as a lack of actual progress and results. Being a competitive driver of some note, Deasy made arrangements with Lewis to hastily prepare two cars for the 1906 TT race with R.A. Bell and John W.F. Crouch as drivers, yet one failed to start and the other broke down. Deasy cars then failed to enter the following year's race, and in June 1907, Deasy resigned his position of Chairman and joint Managing Director yet remained on the board. Former Coventry Machinist employee William G. Williams became the replacement MD, resulting in Lewis demoted to con-

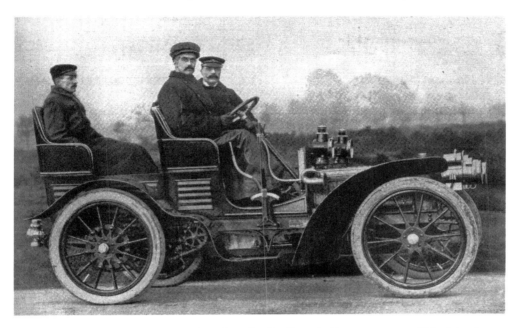

Prior to forming the Deasy Motor Manufacturing Co., Deasy had been a promoter of Martini and Rochet-Schneider cars. Here he is at the wheel of a Rochet-Schneider model in 1904.

sulting engineer with H.A. Smith replacing him as works manager. Relationships continued to fall apart, coming to a head in May 1908 when Deasy completely resigned. Production ticked over slowly with their 25/35/45 models but the turning point came in June 1909, with the appointment of John Davenport Siddeley as joint Managing Director along with George Roddick (b. 1864). Siddeley's drive and expertise was a massive boost for the company and in October he announced that his distinctive 14-20hp and 18-28hp 'J.D.S. Type' motorcarriages would soon be made available from £565, with the tag-line 'Not how cheap, but how good'. Such cars and their performance reviews, combined with Siddeley's natural leadership, enabled the company to grow and in 1911 it was decided to change the business title to that of the Siddeley-Deasy Motor Manufacturing Company. As an endnote to the company founder, Henry Deasy moved to Sutton after severing his ties with Lewis in 1908, becoming Managing Director of the A1 Tyre Co. Ltd. It was reported that he was always popular with the ladies, an observer at one of his lectures to the Ladies Automobile Club stating, 'the excellence of the intrepid captain's lecture suffered through the disgraceful behaviour of the ladies who moaned, groaned, giggled, gurgled and buzzed as to drown the captain's voice.' He died in 1947 aged 80 and was listed as a Major.
(See also Iden, Siddeley and Siddeley-Deasy.)

DOHERTY, 1904–1910 (1902–1920)
Doherty Motor Components Co. Ltd, Trafalgar Works, 8 Upper Well Street, & Earl Street

The origins of the Doherty Company began in 1902 as a motor accessories business at Day's Lane in a partnership formed by four men – William Henry Doherty (b. 1867), James Walsh (b. 1873), James Bayley (b. 1876), and Frederick John Page (b. 1866). Their main work included the manufacture of high-class bonnets, radiators and tanks, but by 1904 Walsh, Bayley and Page had moved on, forming a likewise company at Wolverhampton as Walsh, Nicholls & Co. Picking up the pieces, Birmingham-born Doherty then formed the Doherty Motor Components Company at Upper Well Street, joined by his younger brother Alfred (b. 1875). Continuing primarily as

HONEYCOMB GILL RADIATOR
(Patent No. 25480).

THE
DOHERTY
MOTOR COMPONENTS
LTD.
COVENTRY

Manufacturers of——

RADIATORS, LUBRICATORS,
BONNETS, OIL DISTRIBUTORS,
TANKS, SILENCERS,
WINGS, FANS, etc., etc.

Illustrated Trade Lists on application.

MECHANICAL LUBRICATOR
Type M.I.

Although suggested to have made complete cars, Doherty's main activities centred around the production of high-quality motor radiators.

a motor components manufacturer, at around the same time Doherty also joined forces with Frederick Thomas Jackson (b. 1864) as the Jackson-Doherty Radiator Company at Godiva Street but had left by 1908 – Jackson going on to form the well-known Coventry Radiator Company. Sourcing additional works near to Palace Yard on Earl Street, Doherty regularly attended annual motor shows, exhibiting their quality workmanship as demonstrated in their tanks, bonnets, wings, and silencers – yet were best known for their first-class motor radiators. Surviving as a motor accessories manufacturing business until 1920, on the odd occasion from 1904 to 1910 the business was also listed under 'motorcar manufacturers' in local trade directories, yet it would seem highly unlikely that any complete motor vehicles ever left either the Trafalgar or Earl Street factories during the eighteen years of production.

DONALD HEALEY, 1946–1970
Donald Healey Motor Co. Ltd, 105 Little Park Street, & Canterbury Street

The Donald Healey Motor Company was set up in 1945 at Millers Road, Warwick by D.M. Healey, the well-known racing driver and auto engineer. Donald Mitchell Healey was born at Perranporth, Cornwall in 1899, the son of a grocer and baker. A former employee of both Humber and Triumph in Coventry, the latter in a senior capacity, in 1946 his new company was seen to be also listed at 105 Little Park Street, Coventry, as 'manufacturers of, and dealers in, new and second-hand cars, and vehicles and conveyances of all kinds', with Healey and J. Watt as Directors. Surprisingly, they were also listed much later in the 1970 Coventry Trade Directory under 'car manufacturers' at Canterbury Street, most probably in the former Singer works. Although listed as car makers in Coventry, it is unlikely that any of Healey's cars were built there. Indeed, Donald Healy's son, Brian, stated that the Little Park Street address concerned their company solicitors. The Canterbury Street reference, however, remains a mystery for now. *(See also Triumph.)*

DURYEA, 1904–1907 (1893–1917)
The Duryea Co., 185–210 Widdrington Road

In relation to motor manufacture, the Duryea name began as far back as 1893 when brothers Charles and Frank Duryea constructed a 'Ladies Phaeton', regarded by many to be the first gasoline-powered carriage to be constructed in America. During 1898 and 1899, Daimler Director Henry Sturmey undertook a tour of France, Germany, Canada and America for the purpose of

investigating overseas motor manufacturing techniques, and whilst taking in the sites of companies such as Dion-Bouton, Benz and Ford, Sturmey was also believed to have visited the Duryea Power Company works at Peoria. Earlier in 1896, two Duryea carriages took part in the first London to Brighton run, and as Sturmey was also known to have been involved in the notorious event, then this may have been the occasion where he first made contact with the Duryea brothers. Having resigned his position on the Daimler board, in 1902 Sturmey erected works at Widdrington Road and acted as agent for the sale of Duryea 'Power Phaeton' models, widely marketing the products in the automotive journals whilst attending all motor exhibitions of note. Interestingly, while at the Royal Agricultural Hall Show of 1902, Sturmey also offered Ford motors – remarkably a year before the actual Ford Motor Company began and a further nine years before British Ford models commenced production in Manchester. By 1904, Sturmey re-registered the company with a working capital of £30,000 and,

The Duryea Brothers were one of the first to make motorized vehicles in America. Henry Sturmey later made English versions under license.

soon after, he and his assembled workforce commenced the actual production of Duryea motorcarriages under licence from the Duryea Power Company of America. The early British-made models were of tiller steering and powered by 12–15hp engines positioned beneath the driver's seat made by Willans & Robinson of Rugby. By 1906, the Widdrington Street Works were managed by John Henry Bishop, a consulting engineer formerly resident of Cheltenham, who had a 'long association in workshop organisation in some of the largest factories in America'. It is believed that only around fifty Duryea carriages were built at the Coventry factory, but by 1907 Sturmey abandoned the Duryea name and registered the new company of Sturmey Motors Ltd instead. *(See also Bramco, Daimler and Sturmey.)*

DUTSON & WARD, 1903 (1885–1903)
Dutson, Ward & Co. Ltd, 105 Gosford Street

Another fleeting venture, Dutson, Ward & Company were seen listed for one year only under 'motorcar manufacturers' in the 1903 Coventry Trade Directory. Although uncertainty surrounds who Ward was, Dutson relates to either John Dutson or John William Dutson, a father and son outfit who were specialists in enamelling and electro-plating for the cycle trade. John Dutson senior was born in Coventry in 1845, the son of a blacksmith from Bury in Lancashire. He first apprenticed under his father, but later turned to the watch trade in Coventry, becoming a watch guilder. By the mid-to-late 1880s, it had reported that Dutson was the first to introduce electro-plating to Coventry, where he would not have been short of customers. The company of Dutson, J. & Co., were known to have first been based at the 'Plating Works' in West Orchard, but by the mid-1890s at Gosford Street, by that time managed by John W. Dutson. It is very probable that the business of Dutson, Ward and Company was a continua-

tion of the original enamelling and electro-plating firm, but whether they ever extended such activities to that of complete motorcar manufacture is so far unknown. John William Dutson was known, however, to have become the owner and landlord of the Black Horse public house in Spon End by 1911, which still functions as a pub of the same name to this day.

EMMS, 1922–1923 (1922–1924)
Emms Motor Co. Ltd, Walsgrave Road

The Emms light car made a brief entry into motor manufacture in 1922, from unknown premises on Walsgrave Road. With a choice of either a 9.8hp or 10.8hp Coventry Simplex four-cylinder engine, prices ranged from £230 to £285 with an option to purchase a self-starter for an additional £25. Three body styles were made available and it was the hopeful intention of the company to capture the growing female driver market. For unknown reasons, the venture failed to really take off, and in a little over a year the company had seemingly disappeared. By 1924, however, an 'Emms' motor engine was seen to be on offer, built by the Gulson Engineering Company of Coventry. Exactly who Mr Emms was remains a mystery, yet a few past individuals possessing the same surname and once residing in the city may hold some clues. These include Edgar Emms (born at Birmingham in 1896), Robert Coates Emms (born at Cambridge in 1895), or his brother Edward (born at Kings Lynn in 1899). Another possibility could be that of Albert Edward Powell Emms, born in Derbyshire in 1881. Although he was a letterpress printer by trade, he may have had the means or knowledge to branch out into motor manufacture, but again this is speculation. Established a few years earlier in 1919, the Gulson Engineering Company included Albert Donald Hutchinson, Herbert Hayward, and Albert Upham as founder members, yet whether the elusive Mr Emms also worked there has yet to be established.

The Emms Motor Company briefly entered the motor market in 1923, but were not around for long.

ENDURANCE, 1898–1900
Endurance Motor Co. Ltd, 84 Gosford Street & Holbrook Lane

Another early motor producer in Coventry, in 1898 Endurance set about making a derivative of the popular Benz model, initially in works previously occupied by Frederick Kerby's Roulette Cycle Company at Gosford Street. The two key men behind the business were Eardley D. Billing (b. 1873) and Arthur Hallett (b. 1875), both gifted engineers and entrepreneurs who seemingly had dealings with numerous other local companies during the pioneering days of the British motor industry. Being one of only a small number of companies able to supply petrol in Coventry, early on they developed their own 3hp, 4.5hp, 5hp and 6hp horizontal single-cylinder engines for supply. Other activities included the manufacture of 'Billing' carburettors, as well as being suppliers of Charles McRobie Turrell's 'new exhaust box'. On moving to works at Holbrook Lane, by 1900 the 'Endurance' car boasted many features, including the 'crank running in an oil bath; variable electric ignition controllable from the driving seat; double exhaust silencer; water tank and cooler fitted in front of the car; circulating pump; three speeds; reversing gear; two brakes; four equal sized wheels; tangent spokes; Brampton chains; and Dunlop tyres'. Two models were exhibited at the Royal Agricultural Hall – one model to seat two persons at £200, and one to seat three or four persons at £225. In 1900, the company bravely entered one of their 5hp two-seater models into the heavily promoted 1,000 Mile Trial (class A) but it failed to complete much of the course, disappearing somewhere between Cheltenham and Birmingham during the early stages. On this and other occasions it was thought that the driver was John Burns of Berners Street, London, the South-based agent for Endurance cars. In the summer of 1900, the company went into liquidation and Billing and Hallett appear to have gone their separate ways. However, by 1902 a company called the Endurance Motor & Cycle Company were making two-seater 3hp-powered voiturettes from an address in Scarborough. Whether this company had any connections to the original firm, or took the vacant name of a defunct business, is yet to be clarified. *(See also Billing, Pennington and Priory.)*

FERGUSON, 1950–1972
Harry Ferguson Research Ltd, Siskin Drive, Toll Bar End

In 1950, Harry Ferguson (1884-1960) established a new company at Siskin Drive, close to Coventry Airport. Away from his remarkable labour-saving advancements to agricultural

A prototype estate body mounted on a Ferguson chassis of 1960. Harry Ferguson was most famed for his involvement in the manufacture of tractors.

techniques, Ferguson wanted to produce a family car well in advance of its time, and, on the back of a £3m lawsuit victory over Henry Ford, certainly had the means by which to do so. Joined by Fred Dixon, Tony Rolt, and ex-Aston Martin engineer Claude Hill, Ferguson and his team set about designing a four-wheel-drive prototype car known as the 'R2' with a strong emphasis on safety. Several prototypes followed featuring numerous experimental adaptations up to the 'R5' model of 1966, yet although companies such as Rover and Standard were approached to take on manufacture, sadly nothing ever materialised. Before his death in 1960, Ferguson also ventured into another of his passions, motor racing, with the birth of the FWD Ferguson Climax P99 car, the precursor to the Jensen FF model. Harry Ferguson Research was wound up in October 1972 with John R. Peacock given as Director, and a new company, FF Developments Limited, was established by Rolt to continue many of the Ferguson automotive principles. Ferguson of course was best known for his three-point linkage system which revolutionised farming around the world. His later TE20 tractor was first built by the Standard Motor Company in 1946 before Massey-Ferguson was formed in 1953, and just three years later over 500,000 'little grey Fergies' had been built. Production moved to Banner Lane in 1959, where Massey-Ferguson tractors were manufactured and supplied around the world until closure in 2002, the site being cleared four years later.
(See also Standard.)

FLEET, 1900-1914
Fleet Carriage & Motor Wheel Works Co., Fleet Works, Fleet Street

First seen listed at the 1900 Automobile Club's Motor Car Exhibition at the Royal Agricultural Hall, Islington – the Fleet carriage and Motor Wheel Works Co., offering the 'Shamrock' Car, as designed by Payne, Bates and Hamilton. Soon after they were seen listed in the *Porter's Cycle and Motor Car Trades Directory* of the Fleet Works, Fleet Street, 'makers of motor cars, bodies, wheels and fittings'. Fleet were last seen in the *Bennett's Business Directory of Warwickshire for 1914* under 'motor car manufacturers', yet its believed that carriage work would have been their main bread and butter.

FOLESHILL, 1905 (1905–1932)
Foleshill Motor & Carriage Company, 440 Stoney Stanton Road

The Foleshill Motor & Carriage Company first appeared in 1905, listed under 'motorcar manufacturers' in the Coventry Trade Directory at Stoney Stanton Road. However, that was also the last time, as from that point onwards they were only ever listed as 'coach and body builders' under the Foleshill Carriage Company title at the same address. Whether any cars were ever made will probably never be known and is very doubtful, but the company operated for many years until closure around 1932. The man behind the business was Ernest Henry Plummer, born in Coventry in 1871. He apprenticed as a coach painter from the mid-1880s, working his way up to foreman by the turn of the century before starting on his own business in 1905.

FORCE, 1902–1905
Force Motor Syndicate Ltd, 41 Holbrook Lane, & Round Tower Works, Leicester Street

Although listed as the Forge Motor Syndicate in local trade directories from 1903-1905 under 'motorcar manufacturers', new evidence would suggest that this company title was in fact a transcribed error. The *Automotor Journal* of 19th July 1902 showed that a new company had been registered as the Force Motor Syndicate with W.A. Taylor, C.E. Warren, and F.E. Woolliscroft as Directors. Frederick Ernest Woolliscroft (b. 1875) was a 'draper' by trade, while Charles

Ernest Warren (b. 1873) was a company secretary, which only leaves Taylor as the one with any engineering capabilities. This surely relates to William Allen Taylor (b. 1861), the former works manager of the British Motor Company, who, by 1901, was living at Radford Street in Coventry and working as a mechanical engineer. Taylor took out a number of patents whilst in Coventry and Force were known to have had addresses at both Holbrook Lane and Leicester Street up to 1905. The Holbrook Lane premises have also been identified as having been occupied by both the Brooks Motor Company and the Crawford Gear Company at around the same time. This may indicate a very possible business association to the likes of Henry Brooks and Henry Wimshurst, as well as the Canadian Middleton Crawford, who were all known to have been heavily connected with these two firms. The *Motor* journal of November 1904 also reported on the 'Force' carburettor as made by the 'Force Motor Syndicate' of the Round Tower Works, stating that it had been applied successfully to motor-bicycles. The Round Tower Works had previously been occupied by the cycle makers Jones, Venn & Co., but also by the Cunard Motor & Engineering Company between 1901 and 1905.
(See also Brooks, Crawford, Cunard, and Woolliscroft.)

FORMAN, 1904–1906 (1901–1913)
Forman Motor Co. Ltd, Sparkbrook Works, 26 Day's Lane, & Rose & Crown Yard, 21 High Street

The Forman Motor Manufacturing Company was set up around 1901 through a partnership originally existing between four Coventry Engineers – George Johnson, Daniel Hurley, James Martin and Charles Edward Forman. Better known as 'Edwin', Forman was born in 1874 at West Bromwich, the son of an 'iron manufacturer's manager'. Edwin most probably arrived in Coventry in the late 1890s and found work at Daimler or the Great Horseless Carriage Company. In early 1901, Forman, then of 78 Foleshill Road, applied for a patent (4,604) along with Martin and Johnson 'relating to carburetting devices for internal combustion engines'. In 1902, they exhibited two engines at the 8th Annual Motorcar Exhibition at the Agricultural Hall, London, one of 8hp and the other of 10hp. By 1903, however, Johnson, Hurley and Martin left to concentrate on other locally related business interests, while Forman opted to continue the company on his own account as the Forman Motor Company. This split coincided with a move to 'Rose & Crown Yard' off the High Street, taking over premises previously occupied by the Coventry Light & Engineering Company. Believed to have been predominately an engine manufacturer and supplier, Forman was also known to have produced a car in 1904, as seen taking part in the Sunrising Hill Climb of the Midland Automobile Club in July of that year. It was a 14hp vehicle using a 'continental' chassis, but the engine, bonnet, radiator, clutch and body were all made by the Forman Company in Coventry. It is believed that the production of complete cars continued for around two years on a very limited basis, and, thereafter, Forman concentrated on the design and manufacture of petrol and paraffin engines for supply until closure in 1913.
(See also Aero & Marine, and Alpha.)

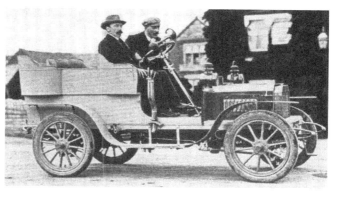

Could Edwin Forman be one of the men pictured inside this Forman vehicle?

GARRARD & BLUMFIELD, 1894–1896
Raglan Cycle Co., Raglan Works, 1 Raglan Street

In 1894, a four-wheeled open carriage was built in Coventry, powered by electrical accumulators and notable by its large, white pneumatic tyres. Labelled by many as being the 'first motorcar' to be produced in the city, it was made by the well-known cycle makers Taylor, Cooper & Bednall at their Raglan Cycle Works to the designs and specifications of Charles Garrard and Thomas Blumfield. Charles Riley Garrard was born in London in 1856 and was educated in Uxbridge. By 1878 he was known to have formed his own cycle firm offering 'Special Alliance' ordinary machines, and was also known to have worked in Coventry during the early 1880s, quite possibly becoming associates of the later Raglan concern during this period. He then became a cycle foreman at Birmingham in around 1890, before joining forces with Blumfield two years later. Thomas William Blumfield was born at Southampton in 1870 and was educated in Ipswich, the home of his parents. Like Garrard, he too spent time working in the Coventry cycle trade, lodging at the home of Isaac Woolgam and working as a 'cycle examiner, turner and fitter' by 1891. Chances are that both Garrard & Blumfield first met whilst working together in Coventry, yet once they had gone their separate ways, remained friends, as proved by a joint patent (21,147) applied for in November 1892 concerning 'improvements in and relating to electric vehicles'. Several variations of the patent followed, until eventually an actual machine was built in Coventry to its complex specifications. Harry Lawson later acquired the patent rights along with countless others, and Garrard & Blumfiled, joined by Alfred Fairley (b. 1849), attempted to perfect the concept until 1896. Just how many variations were built or sold remains unknown. *(See also Lawson and Raglan.)*

A car ahead of its time? This electric motor, designed by Garrard & Blumfield, arrived two years prior to any Daimler motors being built in Coventry.

GENERAL AUTOMOBILE, 1926–1932
General Automobile Panels Ltd, Stoney Stanton Road & 39 Moor Street

This company was first seen listed in the 1926/27 Coventry Trade Directory under 'motorcar manufacturers' at Stoney Stanton Road but also in the street section as 'motor panel manufacturers'. This would seem the more likely of the two business activities, and after a move to premises in Earlsdon the firm continued to be listed as both until 1932, when Keight A. & Co., 'spring makers', took over the Moor Street address. This was not the end of General Automobile Panels though. Instead they moved one final time, to Court 7, Spon End, next to the Black Horse Inn, but by now they were listed only as 'sheet metal workers'. After 1932 no further records have been sourced and the individuals behind the business remain so far unknown.

GLOVER, 1912–1913 (1911–1966)
Glover Bros Ltd, Windsor Street & Trafalgar Street

Henry Glover (b. 1837) first opened a chemist shop in Spon Street in the 1860s, after moving from Bishop Street, where he had lived with his parents. On marrying Fanny Lees in 1864, he and his wife were to have five children in total, three girls and two boys, yet lost their daughter Fanny to illness in 1875, aged just 5. Perhaps it was the wish of Henry to see his sons join the family business, and sure enough at least one of them, Henry James Glover (b. 1875), did so, the 1891 census showing him working as a chemist's assistant aged 16. Younger brother Hubert Walter (b. 1882), however, had other ideas, having a distinct interest in electrics over pharmacy, the 1901 census showing him to be working as an 'electrical instrument maker'. This work also included the making of photographic equipment, most probably a sideline extended through his father's business through the development of postcards and photographs. In June 1909, the *Daily Mail* enticed aviation engineers by offering large cash prizes to those who could build an aircraft and cover certain distances, including £1,000 to fly over the English Channel. The Glover brothers were fuelled by such a challenge, and so reputedly built an aircraft powered by a four-cylinder FN motorcycle engine, yet the wings were found to be inadequate and their project was soon abandoned. Eventually, Henry James was swayed by his younger brother's working interests, and by 1911 both were seen to be self-employed as 'electricians and motor engineers' at nearby Windsor Street whilst still living above their father's shop. In 1912, they developed an ultra-light flat belt-driven wooden-framed cycle car powered by a 4.5hp single-cylinder Precision engine. The following year they extended their works in order to increase production, yet it is believed that no more than twelve 'Glover' cycle cars were ever built. It is unlikely that either Henry or Hubert saw any military service during the First World War, yet instead concentrated on developing their business as a garage and motor engineering operation. Indeed, Glover Bros Ltd of Windsor Street and Trafalgar Street were listed as such from 1919, and although the partnership dissolved in late 1925, Hubert continued the business through to 1950, when he died. The final entry for the company was seen in 1966, the area then being developed for new housing.

The Glover brothers released a cyclecar from 1912 for a short time, yet existed as motor engineers until 1966.

GODIVA, 1900–1901 (1890–1934)
Payne & Bates Ltd, Godiva Street, Castle Street & Foleshill Road

If Payne & Bates hadn't registered the 'Godiva' name in 1890 for the title of their gas and oil engines, then surely it would have only been a matter of time before it was taken up later by another Coventry motor manufacturer. The company first began experimenting with complete car manufacture in 1898, mostly in the mould of Benz models, working closely on

motoring projects with the likes of Charles Hamilton and R.M. Wright, among others. By the turn of the century, it is thought that the company of Payne & Bates Ltd experimented briefly in the development of a motor-bicycle powered by an AIV engine, but also a car, which they labelled the 'Godiva'. The Godiva was available in a number of gear-driven variations, including a two-cylinder 9hp version, and two and four-cylinder models ranging from 7hp-25hp, supposedly capable of speeds up to 40mph. By a turn of unfortunate circumstances, just as Payne & Bates were starting out in motorcar manufacture, it quickly came to an abrupt end, and Payne was left to pick up the pieces. Yet struggle on he did and was still seen to be operating as the Godiva Engineering Company at Castle Street until his death in 1934. Fortunately, thanks to some notes recorded by his son Frederick George Payne (1887-1959) in 1955, it is now possible to provide an insight into the early working life of his father. Born at Thrapston, Northamptonshire in 1863, Walter Samuel Payne was one of nine children to Mark Payne, foreman to the famous locomotive engineer George Stephenson. As a young boy he spent many hours in his father's workshop and at the age of 19 moved to Coventry, where he found employment at Hatton & Willdig's foundry, and later Matterson, Huxley & Watson. It was whilst there that he met an apprentice called Jack Bates, whose parents owned a pub called the Wheatsheaf Tavern at Foleshill. It was in this pub that he met Jack's sister and future wife, Harriett, whom he married in 1885. Moving to a house next door to the Wheatsheaf, they began a family and Walter gained employment at Bonnick's on a lathe, whilst moving to Castle Street and acquiring some of his own workshops behind the Elephant & Castle, his in-laws' new pub. At their Castle Street home, Payne had a treadle lathe and drilling machine installed in one of the back bedrooms and began to make steam engines and boilers with the help of a man called Teddy James in the evenings, and steadily they began to take orders from the local weavers for engines to power their looms. Joined by his brothers Fred, George and Mathew Payne, brother-in-law Herbert Bates, David Farren, Fred Boswell and the young Arthur Shiers, orders began to flood in from local butchers, farmers and watchmakers, and agents were appointed

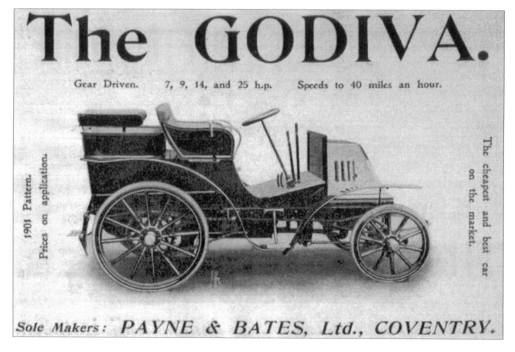

Payne & Bates were very active during the early years of motor production in Coventry, but failed to get the financial backing needed, unlike some other local firms.

around the country and further afield. Additional works were built near to the General Wolfe Hotel on the Foleshill Road, employing a workforce of some fifty men. In 1898, local cycle makers John Slaughter and William Hazlewood bought a German Benz car and asked Payne if he could copy it, which he did – a 5hp version with the body supplied by the coachbuilder's Hawkins & Peake of Bishop Street. Other variations followed, one supplied to Joseph Grose in Northampton, and another to the amusement caterer George Twigdon, who often frequented the fair at Pool Meadow. Sadly, Harriett died suddenly in 1901 of pneumonia, the same year as the Coventry flood, leaving Walter with six children, while the Bates-backed business closed after the untimely death of partner George Bates. Out of work and out of a home, family rallied round, and had it not been for a large engine order from Dan Albone of Biggleswade then life would have become very difficult for the Payne family. Frederick Payne finished his notes with the following words, 'and so ended in the year 1934 the life of Walter Samuel Payne of whom I believe everyone spoke well of who knew him. He was a steady living man, a good father, and like his father before him, was a rare engineer of his time.'
(See also Payne & Bates.)

GREAT HORSELESS CARRIAGE, 1896–1898
Great Horseless Carriage Co. Ltd, The Motor Mills, Drapers Field

With perhaps the most impressive of company titles, the Great Horseless Carriage Company (GHCC) was formed in May 1896 with a capital of £750,000, leasing space at the Motor Mills from the British Motor Syndicate. Offered for public subscription, the issued prospectus was a bold one, stating 'Vehicle Revolution!', 'A New Industry!', and 'The New Road Railways of the Future!' so as to whet the appetite of those looking to invest. Its impressive list of Directors included Harry J. Lawson, Henry Sturmey, E.J. Pennington, Gottlieb Daimler and the Comte De Dion, while the company's intended output listed 'Broughams, Landaus and Phaetons of the future, Motor Pullmans, Omnibuses, Tram Cars, and Wagonettes'. The prospectus also stated that the company had entered into a contract with the Daimler Motor Company (also heavily connected to Lawson and located at the Motor Mills), to buy 'motors' at a 10 per cent discount. At this early stage, the Motor Mills was boasted by Lawson as being the 'largest autocar factory in the world', providing an initial 70,000 square feet for the manufacture of autocars under the Daimler, Pennington and Bollee systems, while the GHCC alone were employing 200 highly skilled men. These included George Iden as first works manager, Charles Crowden, Alexander Davidson, Otto Mayer (b. 1867), Francis Baron, and Thomas Blumfield. By January 1897, the *Autocar* reported:

> . . . great progress is being made at the factory of the GHCC. It is only two months since Mr Charles Crowden got to work at Coventry, and we have seen the first half-dozen of the carriages that are being put through. Besides making the body and framing for the carriage, the company is also turning out its own wheels.

As far as the intended mass-production of complete motors were concerned, the GHCC never really got off the ground while their sister company, Daimler, seemingly excelled. Shareholders began to get restless and, in late 1897, there were reports of the business being 'in the course of voluntary liquidation with a view to reconstruction'. With the writing on the walls, this came about in January of the following year when the GHCC was renamed the Motor Manufacturing Company, another troubled Lawson concern which lasted, on and off, until 1908. In 1946, fifty years after the beginnings of the British motor industry, the *Bristol Evening World* published a story entitled 'England's Oldest Motorist'. It related to the aforementioned Otto Mayer, by this time 80 years old, who, although hailed from south Lincolnshire, arrived in Cannstatt, Germany in 1887, becoming chief-test engineer to Gottlieb Daimler. In that year

he conducted the very first test of a Daimler motorcarriage while being pelted with apples and even shot at, and, while demonstrating a German Daimler motor-carriage around Britain in 1893, was mobbed in Birmingham's market place for travelling at over 10mph. After taking part in the famous Emancipation Run of 1896, with Lawson as his passenger, he stated of the occasion, 'there was a heavy fog and rain, tens of thousands had lined the Embankment to see us off, and at times the pressure of the crowds was so great that we had to drop down to a walking pace. We arrived soaked to the skin and caked in mud'. Soon after, Mayer was appointed chief engineer and assistant manager at the Motor Mills, one of his early feats being the first motorist to conquer the Worcestershire Beacon in the Malvern Hills.
(See also Crowden, Daimler, Iden, and MMC.)

GROSVENOR, 1906–1910
Gravenor, A., Melville House, 28 Westminster Road

Another far from straightforward entry, the 'Grosvenor' car has been suggested to have existed between 1906 and 1910 at Melville Street in Coventry, yet further investigations have revealed a number of discrepancies that dampen such claims. In his book *The Illustrated Encyclopaedia of Automobiles*, D.B. Wise states that the Grosvenor of 1908 was a 40hp four-cylinder model of 7433cc with a laurel wreath emblem on its radiator. Unfortunately, he does not state where the car was made. However, although a Melville Street does not exist in Coventry, a Melville Road does, but whilst the road was constructed during the 1890s, there have at no time been any known manufacturing premises incorporated. Any confusion may relate to a family called the Gravenors, who once resided in the city, and in particular an Alfred Robert Gravenor. Born in 1883, Alfred, along with his older brother Arthur (b. 1878), were the sons of a Coventry 'gold watch case maker'. Most probably due to the uncertain future of the watch trade at this time, neither chose to follow in their father's footsteps – Arthur going on to become a furniture maker and dealer and Alfred finding employment in the growing motor industry. By 1911, Alfred had relocated to Aldershot, where he became employed as a 'motor engineer', while Arthur remained in Coventry as a 'furniture dealer employer'. Interestingly, by 1912/13, Arthur Gravenor was seen to be a resident of 'Melville House' at 28 Westminster Road, which, by coincidence or not, was formerly known as Grosvenor Street and today leads on to Grosvenor Road. Of further interest is the fact that as well as being listed as a 'furnisher' in 1912/13 at 104 Queen Victoria Road, Arthur was also listed separately under 'engineers and machinists' at 122 Queen Victoria Road. So, with all that in mind, were the Gravenor brothers behind a short-lived car called the 'Grosvenor' in Coventry?

HAMILTON, 1900–1910
Hamilton Motorcar Co. Ltd, Fleet Works, Fleet Street, & Priory Works, Dale Street

The Hamilton Motorcar Company was established at Fleet Street in 1900 by Charles Alexander Hamilton. Born in Gortin, County Tyrone, Northern Ireland in 1874, in the early 1890s Hamilton moved to London, where he studied engineering at Finsbury College, and it was during these years that he became close friends with Charles Rolls, later of Rolls-Royce fame. After returning home briefly, by 1897/8 he had secured a position at the Daimler Motor Company, finding lodgings at Ellen Porter's boarding house at Fairfax Street. At the Motor Mills he was encouraged to use his engineering skills freely, taking out a patent (12,633) relating to 'improvements in the driving gear of motorcars', of which the Daimler Company duly took on and marketed. Keen to manage his own affairs though, in early 1900 he resigned his position and secured small works at Fleet Street, financed by two associates in Londonderry, Northern Ireland named Dr Todd and Mr H. Taaffe. With a minimal workforce, Hamilton then set about designing a car he called

the 'Shamrock', being a 20hp Phaeton-type machine with a water-cooled four-cylinder engine and three forward speeds. Designed and assisted by Payne & Bates of Godiva Street, it was said to be capable of 35mph and reported to be the first vehicle in Britain to use electrical sparking plugs. The body and other key components are now believed to have been built at the Fleet Carriage & Motor Wheel Company of Coventry, which was connected to Hamilton and Arthur Hallett, secretary of the Priory Motor Co. In February 1901, Hamilton himself drove his family down to London in this car for Queen Victoria's funeral procession, and later that year the model was exhibited at the *Agricultural Show* in London, yet it is thought that only a few were ever built or sold. At around the same time some more influential friends of Hamilton, Colonel Sir William F. Wyley and a Dr Phillips, again backed

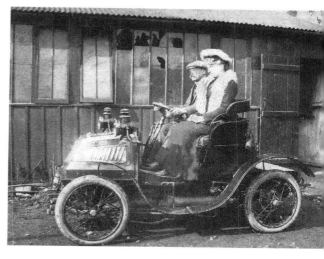

An early Hamilton car? Charles Hamilton was another busy engineer with connections to several early motor companies in Coventry.

him, this time to make 'Hamilton' motor-bicycles and fore-carriages powered by 2¼ to 4½hp engines, whilst also offering his own water-cooled engines for supply. At this time he was visited in his factory by Arthur Conan Doyle, and on repairing a rotary engine he had brought along with him, an unlikely friendship was said to have been forged between the two men. In addition to motor-bicycles came the 'Millford-Hansom', a 2¾hp-powered trailing car with carriage work body, supplied by Mills-Fulford of Coventry. Also known to have been working alongside Hamilton at this time was Charles Henry Wynn (b. 1869) of Staffordshire. In 1908, Hamilton married Edith Jane Burrell of the Park Gate Hotel at St Paul's Church, Foleshill, finding a house at Station Road, Kenilworth. The Hamilton Motor Company appears to have ground to a halt in 1910, so he quickly found employment at Humber, and later Rover, working under Peter Poppe. After a lengthy career filled with many motor engineering advances (nine patent applications in total), Hamilton completed his working life back at Daimler as an engine inspector until retirement. After spending his final years residing at Moseley Avenue in the Coundon area of Coventry, Charles Hamilton died in 1956 and is rested at Canley Crematorium.
(See also Payne & Bates, and Priory.)

HARDY, 1905 (1903–1925)
Hardy, Edward J. & Co., St Nicholas Street, & 118 Queen Victoria Road

Edward John Hardy was a well-known motor accessories manufacturer and dealer in Coventry from the early 1900s, yet in 1905 briefly delved into motor manufacture in a marginal way. Born in Birmingham in 1874, one of Hardy's first jobs was 'keeper of a circulating library', before later becoming a commercial traveller in and around the Midlands. It is believed he made the short move to Coventry in 1903, setting up at premises at St Nicholas Street. In April 1905, the *Motor* reported that he had built a 'Hardy Tri-car' powered by a 6hp Stevens engine, displayed upon the stand of Taylor, Gue Ltd at the Agricultural Hall Show. Although it was said to have had many novel features upon its chassis construction, it is doubtful many were taken up and Hardy soon returned to his dealings in accessories. Known to have resided at 40 Park Road, Coventry, Hardy traded in Coventry until at least 1925 at Queen Victoria Road, before establishing the company of Spicer, Hardy & Co. at Birmingham.

HARRIS, 1905 (1899–1940)
Harris, W.H., West Orchard

William Henry Harris was born at York Street in Coventry in 1867, the son of a Coventry watch case maker. William and his older brother Charles both apprenticed under their father, but by the turn of the century William had started up his own cycle manufacturing company at the Hill Cross Works at Upper Well Street. This company was known to have been in existence as cycle makers until at least 1940, but for one year only, in 1905, Harris was also listed in the trade directory for that year under 'motorcar manufacturers' at West Orchard. Whether any actual complete vehicles ever saw the light of day remains a mystery, but if they did, then perhaps it was in some sort of collaboration with the Centaur Cycle Company, also known to have made motors at West Orchard at around the same time.

HERON-ASTER
(See West.)

HILL, 1919–1924
Hill & Co. Sidney, Motore (Coventry) Ltd, 94 Godiva Street

This company was first seen listed in the Spennell's Directory, Coventry & District for 1919/20 as Hill & Co. Sidney, Motore Coventry Ltd, under 'motorcar manufacturers' at 94 Godiva Street. Hill's origins are unclear, but it may relate to a Sidney Hill who was born in Coventry in 1886, the son of Henry T. Hill, once pub landlord of the Shakespeare Inn on Spon Street. If so, Sidney joined the cycle trade as a youth, working as a 'machinist and fitter' for many years. After the conclusion of the First World War, Hill, of 53 Clay Lane, formed his own business and marketed the 'Hill' car (as reported by some), whilst being involved in the manufacture of automotive parts (as believed by others). However, in 1920 he featured in the *Coventry Chamber of Commerce Year Book*, advertising himself as a 'purchasing agent' at Godiva Street, and the use of the Italian word for engine (*motore*) may indicate overseas trading involvement. Two

Hill & Company were listed as car manufacturers from 1919, yet details are scarce. Sidney Hill, seen here, was thought to be the man concerned.

William Hillman made a fortune as a cycle manufacturer before embarking in the motor trade.

HILLMAN CARS for 1914

ON no account should you miss seeing our stand, where we are exhibiting our newest production the 13-25 h.p. 6-cylinder, as well as our already famous 9 h.p. 4-cylinder model. To the motorist who seeks value—defined by solid, all-round excellence—these two Hillman types are sure to be more than merely interesting. If they interest you tell our representative there.

One 9 h.p. Hillman Light Car Chassis, 4-cylinder Bore and Stroke, 60 x 120.
Two 9 h.p. Hillman Light Cars, fitted with standard two seated bodies and complete with tyres, spare wheel and tyre, screen, hood, five lamps, horn and tools.
One 9 h.p. Hillman Light Car fitted with two seated Limousine body and complete with tyres, spare wheel and tyre, five lamps, horn and tools.
One 13-25 Hillman Six Cylinder Chassis, bore and stroke 60 x 120.
One 13-25 Hillman Six Cylinder Car fitted with four seated Torpedo body, complete with tyres, spare wheel and tyre, screen and hood.
One 13-25 Hillman Six Cylinder Car, fitted with luxurious four seated saloon body, complete with tyres, and spare wheel and tyre.

Special attention is called to the dimensions of the Six Cylinder Engine as being the first English Six Cylinder of small capacity and modern design.

The Hillman Motor Car Co., Ltd.

COVENTRY. 'Grams : Hillclimb, Coventry.' 'Phone : 275 Coventry.

Stand

116

London Showrooms : 107, Gt. Portland Street, W. 'Grams : Hillclimb, Wesdo, London.' 'Phone : 2826 Mayfair.

Birmingham Agents : Messrs Jones and Robinson, Ltd., 76, Bristol St., Birmingham.

9-h.p. Two-Seater.

After the Coatalen breakup, the business title was changed to the Hillman Motor Company.

further entries followed for Hill, in the 1921/22 and 1924 Coventry trade directories as 'motor-car manufacturers', but after this date the trail runs dry.
(See also Motor Agency.)

HILLMAN, 1910–1972 (1875–1976)
Hillman Motor Co., Humber Road, & Ryton-on-Dunsmore

Born at Lewisham in 1847, William Hillman first arrived in Coventry in the late 1860s, after serving his apprenticeship at John Penn & Sons in London. Enticed by James Starley, Hillman gained employment at the Coventry Sewing Machine Company, and it was here that Hillman became involved in the new cycle industry and really began to apply his engineering skills. In November 1873 he married Fanny Moreton Brockas and, by 1875, he had formed the Hillman & Herbert Cycle Company, together with William H. Herbert at the Premier Bicycle & Tricycle Works. By 1880, the two had teamed up with George Cooper to form Hillman, Herbert & Cooper Ltd at South Street. By now, Hillman's business interests were booming with the addition of a new venture, the Sparkbrook Cycle Company. This success can be measured by the fact that his growing family were seen to be moving up in society, buying a house known as Stoke Road Villa in the leafy Stoke area of the city. The 1890s witnessed much experimentation with motor-driven vehicles in Coventry and many of the cycle companies quickly got involved. Keen not to miss out, in February 1900 Hillman applied for a patent (3,121) in relation to 'improvements to motorcars and other vehicles' and by 1902 developed an all-chain-driven 1½hp motor-bicycle, yet it would not be until 1907 that he decided to form an actual motor manufacturing concern. This initial venture was brief and, after the departure of his partner M. Louis Herve Coatalen in 1908, it was not until January 1910 that the Hillman Motor Company was officially declared as the new business title. Production of 12/15hp models resumed along with 9hp light cars up to the First World War, and during wartime the factory transferred production to that of 3-ton motor lorries, Gnome engine parts, gearboxes,

and two-seater cars for the Russian government. Manufacture of an 11hp car followed the war in 1919, but within two years, William Hillman had died at his Keresley Hall home. Son-in-law Percy Rowland Hill (b. 1877) replaced him as Chairman and Director, while the other two listed Directors – sons-in-law Thomas Sydney Dick (b. 1881) and Spencer Bernau Wilks (b. 1892) – continued to steer the ship, Wilks himself going on to make a big name for himself later at the Rover Motor Company. Soon after, yet another son-in-law (Hillman had six daughters), Captain John Black, was added to the ranks, and he too would go on to great things whilst at the Standard Motor Company in later years. 1925 saw the introduction of the popular 14hp model, but by December 1928, Hillman amalgamated with the nearby Humber Company to form a new company called Humber-Hillman Ltd, with a minority interest acquired by the Rootes Brothers. By the early 1930s, Rootes had taken full control and their first statement car became the Hillman Wizard model, a 2.1 litre model labelled 'the car of the moderns'. In 1932 this was joined by the 1185cc Minx model, another well-received family car which quickly sold by the thousands, and several variations were produced and sold successfully up to 1939. Once again, wartime production was adapted to aid the nationwide war effort, yet car production resumed at Ryton with a restyled Minx from 1945 and remained a safe product of the company until 1965. By this time the Chrysler Corporation had acquired an interest in Rootes, but used the Hillman name on models such as the Avenger until 1976, ending just over 100 years of a well-respected name in British transport.
(See also Coventry Premier, Hillman-Coatalen, Humber, and Standard.)

HILLMAN-COATALEN, 1907–1910 (1875–1972)
Hillman-Coatalen Motor Co., Pinley, & 9–11 Hood Street

In early 1907, long after many of his business rivals, William Hillman decided to branch out into complete car manufacture – all he needed was the expertise in which to do so. He found it in M. Louis Herve Coatalen, born at Concarneau, France in 1879. As a young man Coatalen served his apprenticeship with the De Dion Bouton, Clement, and Panhard et Levassor motor companies before opting to move to England in 1901. According to some sources he first found British employment briefly under Charles Crowden, before finding a more long-term contract at the Humber works in Coventry as chief engineer. It is unclear how he came into contact with Hillman, but in June 1907 the two men, joined by Harold Smith (b. 1850),

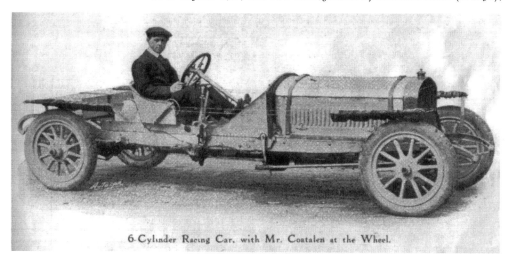

6-Cylinder Racing Car, with Mr. Coatalen at the Wheel.

Louis Coatalen had gained plenty of experience before joining forces with Hillman.

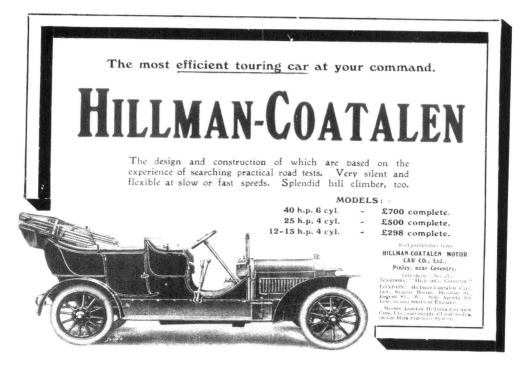

The product was good, but a clash of personalities saw an early split, and Coatalen went on to make a name for himself at Sunbeam.

held the first meeting of the Hillman–Coatalen Motor Company at Bailey Lane, Coventry. After a slow start, Coatalen designed and built a 25hp four-cylinder model, and by November 1907 this model was shown at Olympia, along with two chassis of 25hp and 40hp. There have been incorrect reports over the years that these first cars were built in the grounds of Hillman's home – Abingdon House at Stoke Green, Coventry. While it has been confirmed that Hillman did indeed live there, in 1894 he purchased land in rural Keresley, north of Coventry, and had a grand residence built named Keresley Hall, his home until his death in 1921. Considering this, the first Hillman–Coatalen cars must have either been built at Hood Street, the location of Hillman's Premier and Auto Machinery works, or in the grounds of Harold Smith's residence at Pinley, where the Hillman–Coatalen factory was known to have been progressively erected from 1907. In September 1908, Coatalen drove one of the company's cars at the Tourist Trophy 'Four-Inch' race on the Isle of Man, finishing a respectable 9th. Soon both the car and Coatalen's engineering capabilities became more widespread, and Thomas Cureton of Sunbeam acted swiftly to offer him the position of chief engineer in Wolverhampton. Whether reports of a 'private dispute' between Hillman and Coatalen offer any further substance to the split, ultimately the Sunbeam offer was accepted, and, in November 1908, he left the Hillman–Coatalen Motor Company, selling his 10,000 shares to Hillman. Although Coatalen had severed his ties with his former business partner, for some unknown reason the business title remained the same, exhibiting again at Olympia in 1908 and 1909. It was not until January 1910 that the company name was altered, becoming the Hillman Motor Company, a name that was to become one of the most favoured by families looking for affordable motoring. Coatalen went on to make a big name for himself at Sunbeam, particularly in racing. He returned to France in 1930 as a British subject, becoming Managing Director for Lockheed Hydraulic Brakes, and died some thirty-two years later at the age of 82.
(See also Crowden and Hillman.)

HOBART, 1901 (1884–1924)
Hobart, Bird & Co., Hobart Works, St Patrick's Road
Hobart-Acme Motors Ltd, Osborne Road, Earlsdon

In relation to Coventry transport, the Hobart name goes back to the early 1880s, when William H. Bird started making cycles in Coventry. Born William Hobart Bird in Banbury in 1852, by the 1860s he and his family had moved to Coventry, his father, John Bird, becoming engaged as the 'Master of the Coventry Workhouse' on Brick Kiln Lane. William apprenticed as an iron-monger and by the late 1870s was in partnership with William H. Icke (b. 1851) in Coventry trading as Bird & Icke, and it was probably during this time that he first experimented with the manufacture of cycles. In the early 1890s, Bird was known to have moved to Wolverhampton, but was back in business in Coventry towards the end of the century, as Hobart, Bird & Company at Cheylesmore. In 1901 they made their first motorized vehicles, believed mostly to be in the form of 'Hobart-Bird' motor-bicycles and tri-cars, and prior to the First World War they made a superb range of well-finished ladies' models. After some forty years in the cycle and motor industry, the Hobart name ran into difficulties and in 1923 were taken over by Coventry-based Rex-Acme, forming a new subsidiary company known as Hobart-Acme Motors Ltd at Osborne Road. Their business activities in the *Applications for the Registration of Trade Marks* for the same year stated, 'motor-cycles, pedal cycles, side-cars, cycle-cars, motor-scooters, motor-cars and similar vehicles', yet whether any cars ever carried the Hobart-Acme name is unclear. They did, however, produce a Hobart-Acme motorcycle in addition to the tried and tested Rex-Acme machines in the hope of generating further interest. Unfortunately it wasn't to be and, within a year, Hobart-Acme was no more. The Rex side did survive though, continuing to produce motorcycles until being bought by the sidecar makers Mills-Fulford in 1932.
(See also Acme and Rex.)

A rare view of the old Hobart Works positioned off St Patrick's Road when occupied by Coventry Climax.

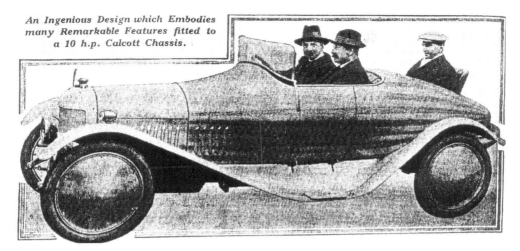

An Ingenious Design which Embodies many Remarkable Features fitted to a 10 h.p. Calcott Chassis.

In November 1915, Hollick & Pratt were seen to have designed a streamlined sports body which they fitted to a Calcott chassis.

HOBART-BIRD

(See Hobart.)

HOLLICK & PRATT, 1904–1914 (1812–1926)
Hollick & Pratt Ltd, 38 Smithford Street, & Park Works, Mile Lane & Parkside

The Hollick name goes right back to 1812 as carriage builders, and was picked up and continued by Henry Hollick, born in Coventry in 1854. During the early years of the business, he worked out of buildings known as 'Lancasterian Yard' situated off Cross Cheaping, and in 1888 he was involved in one of the very first motorised vehicles in the country, making the carriage for John Kemp Starley's electric-powered tri-car. In 1902, Hollick, of 38-39 Smithford Street, exhibited four motor bodies at the 8th Annual Motorcar Exhibition at the Agricultural Hall, London. Soon after he teamed up with his son-in-law, Lancelot Wilfred Pratt (b. 1881), to forge the beginnings of a very successful name in the field of coach and motor body-building – Hollick & Pratt Ltd. The company went on to produce many fine bodies for such names as Calcott, Hillman, and, most successfully, Morris, and at one time was managed by Robert Jones, later of Carbodies fame. Such was the trade between Morris and Hollick & Pratt that in 1923 Morris bought the business at Mile Lane, renaming the works Morris no. 2 Body Plant (Coventry) by 1926. Although undoubtedly a motor coach manufacturing business, for ten years from 1904, Hollick & Pratt were also listed under 'motor car manufacturers' in local trade directories. It is highly unlikely that much activity occurred outside of general body-building, but in November 1915 they were seen to have created a streamlined open-sports 'Torpedo' body fitted to a 10hp Calcott chassis and complete with dickey seat. It is not clear if it was widely marketed but it was reported to have 'received considerable interest' at the time.
(See also Carbodies, Hotchkiss, and Starley.)

HOTCHKISS, 1920 (1919–1926)
Hotchkiss & Co. Ltd, Gosford Street

The long established French munitions firm of Hotchkiss et Cie first arrived in Coventry in 1915 securing old industrial premises on Gosford Street, formerly occupied by the Arno

Motor Company. Also makers of cars from 1903, due to the likelihood that their St Denis factory would fall under the hands of the Germans, by the recommendation of the British government Hotchkiss quickly transferred staff and commenced the manufacture of machine-guns destined for tank and cavalry use during the First World War. To demonstrate the skilled diversity of the Hotchkiss staff at this time, reports also show that the factory also produced field kitchens, ambulances, military cycles, sidecars, and wheels, amongst other items during this period. By the time hostilities had ended, more than 50,000 machineguns were said to have been produced and shipped. Harry Ainsworth, who had worked for Hotchkiss in France since 1904 as a tester, had, by the outbreak of war, progressed to that of chief production engineer and managed the Coventry operation. By late 1918, a new use was needed for the factory and the hundreds of men employed. On hearing that William Morris was on the lookout for an engine manufacturing facility, Ainsworth, along with M. Benet, the MD of Hotchkiss in France, convinced Morris that they could copy or produce any engine to his designs or specifications. After negotiations a contract was agreed, and Ainsworth and his skilled Coventry team began making copies of American 'Continental' engines before full production of Hotchkiss versions commenced in September 1919. By 1920, some 100 units were being made per week; mostly of the 11.9hp variety destined for the Morris Cowley model, and by 1922 they were turning out around sixty-five units per day. Some 20,000 engines had been manufactured at Gosford Street since the Morris contract, meaning that Hotchkiss could claim to be the largest engine-producing factory in Britain at that time. While also making clutches and gearboxes for Morris and engines for B.S.A., Hotchkiss, assisted by Sam Heron and Fred Green of Siddeley-Deasy, also experimented with a light car early on, powered by their own 1080cc air-cooled V-Twin engine. Using a Morris Oxford chassis and a three-speed gearbox, it bore the credentials of a promising vehicle, yet the transition to complete car manufacture was a hefty risk and it never reached production stage. The engine itself, however, was accepted by B.S.A., resulting in the manufacture of B.S.A. TB Ten tourers at the Hotchkiss factory, before production soon moved to Daimler – yet a section of the Gosford Street plant was believed to have been retained by Hotchkiss as a separate concern until 1926. By January 1923, William Morris bought the Hotchkiss operation for £350,000 and retained its workforce, which marked the birth of Morris Motors Limited – Engines Branch. Key employees early on included the likes of Frank G. Wollard, Alfred Wilde, Leonard Lord and Herbert E. Taylor, and, as an engine manufacturing operation, the facility excelled, making 800 units per week. New works were added at Courthouse Green by the Second World War, employing some 4,000 workers. Although partly destroyed during the Blitz, engine manufacture continued and the company remained in Coventry as a large employer until 1984.
(See also B.S.A., and Hollick & Pratt.)

HUBBARD, 1903–1905 (1903–1914)
Hubbard's Motor & Engineering Co. Ltd, 132 Much Park Street

This business began as Hubbard Bros, motor engineers at Much Park Street in early 1903, offering their 3¼hp 'Hubbard' motor engine, stating 'for simplicity, durability and excellence of design it has no equal' offering tri-cars and fore-cars. The company was begun by three brothers from Cambridge – Charles, Edgar and Hubert Hubbard – who were all living in Coventry from the early 1890s. By December 1903 they became Hubbard's Motor & Engineering Company, with a working capital of £1,000, and it would appear that Charles was the leading light. Born in 1867, he was known to have applied for a number of joint patents in relation to pneumatic tyres from 1896 along with Henry Jelley (b. 1863) and William A. Starley (b. 1877), indicating that he was probably working for the cycle manufacturers Dingley Bros at this point. Being listed as 'motorcar manufacturers' in the local trade directories by 1905, there is evidence to suggest that the Hubbard brothers may have been connected in

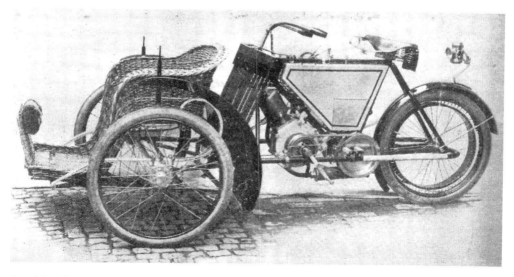

A Hubbard forecar of 1904/5. The outbreak of the First World War appears to have cut this business short.

some way to the Whitley Motor Company, with their engines and motorized vehicles having many similarities. Both businesses made motor fore-carriages using very similar engines and components, and the Whitley engine was also known to have been supplied to other companies with the suppliers name placed on the crankcase instead of their own. Although both Charles and Hubert had moved away from Coventry by 1907, Edgar remained and established Hubbard & Sons at Queen Victoria Road as cycle makers and factors, which appears to have dissolved sometime during the First World War.
(See also Whitley.)

HUMBER, 1895–1976 (1868–1976)
Humber Motor Co. Ltd, Lower Ford Street, Far Gosford Street, Humber Road, & Ryton-on-Dunsmore

Another famous name in the British transport trades, the Humber story began in late 1868, when Sheffield-born Thomas Humber (1841-1910) made a Michaux-type velocipede at a blacksmiths shop in Nottingham. As Humber, Marriott & Copper, cycle manufacturers, in 1878 the company moved to a factory at Beeston, and in 1887 the company was sold. An independent new company called Humber & Company was then formed with factories located at Beeston, Wolverhampton and Coventry. Under the leadership of former Rudge manager Walter Phillips (b. 1855), experimental work had been underway at Lower Ford Street from late 1895 with motors along the lines of the Bollee voiturette, but

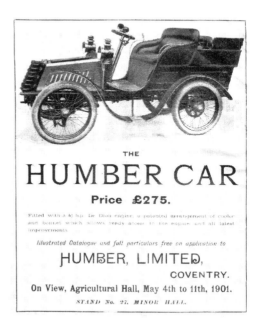

THE
HUMBER CAR
Price £275.

Fitted with a 4½ hp De Dion engine, a patented arrangement of cooler and bonnet which allows ready access to the engine and all latest improvements

Illustrated Catalogue and full particulars free on application to

HUMBER, LIMITED,
COVENTRY.
On View, Agricultural Hall, May 4th to 11th, 1901.
STAND No. 27. MINOR HALL.

An advert showing a 4.5hp Humber model for 1901, exhibited at the Agricultural Hall Exhibition.

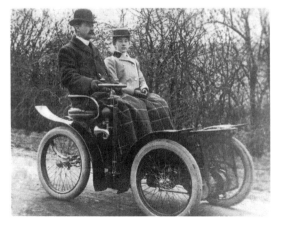

Humber were active in motor production from as early as 1895. Pictured here is a small two-seater model from 1898.

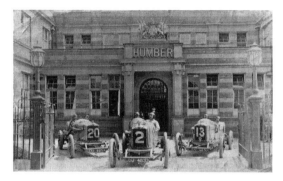

A fine trio of racing Humber motors from around 1910, showing the main office building. Sadly, it was demolished in the 1980s to make way for a car park.

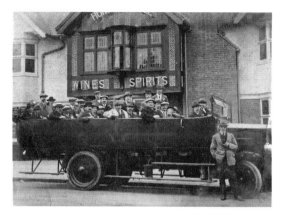

Works away days were rare yet seen as essential to help boost staff morale. Here Humber workers pose in a charabanc outside the Humber Hotel opposite the factory, waiting for the off.

on the 17th of July 1896, a fire destroyed the entire building and, with it, all cycles, motors and blueprints. Humber had also commenced the manufacture of Pennington motors from February 1896 under an agreement with Harry Lawson, who quickly offered some of their workforce space on a floor at the newly acquired 'Motor Mills'. At around the same time, the Humber Motor Company was registered with a huge capital of £500,000 in £1 shares. In 1899 they made their 2¼hp 'MD' voiturette, the first to have mechanically operated inlet valves. It was not until 1900, however, that Humber made their first practical cars, 3-5hp Phaeton-type models, with input from Louis Coatalen as chief engineer. By 1902, they were building a number of motors ranging from 5hp Humberettes to 25hp touring cars from their Beeston and Coventry works. Former Velox man John Budge (b. 1875) joined briefly from 1904 and, soon after, 8.5hp twin-cylinder models and 8-10hp four-cylinder models arrived. In 1906, Humber acquired the former Coronet factory at Far Gosford Street, but by Christmas that too had burnt down, leaving the company short of existing factory space. In March 1907, *The Motor* reported: 'there will be plenty of opportunities for new concerns securing modern factories towards the end of July when Humber Ltd hope to vacate their six Coventry factories for their new Stoke works at present in the course of building'. Completed in 1908, the new site consisted of 29 acres – one of the largest factories in existence at that time. This saw the closure of the Beeston site, and, by focusing all manufacture on the new Coventry factory, the company estimated it would save them £30,000 a year. Joining from Beeston were Arthur H. Niblett (b. 1869), Thomas C. Pullinger (b. 1867) and John S. Napier (b. 1872) as works managers, and Henry Belcher (b. 1866) as sales manager. By 1910, Humber became active in aeroplane construction, joining their wide range of cars including 16hp models, 3.5hp motorcycles, and maintaining the manufacture of their

original product – the bicycle. By now the company were making some 2,000 cars a year and, by the outbreak of the First World War, this figure had reached 2,500. Humber became very busy during the years 1914-1918, producing field kitchens, ambulances, cycles, aero-engine parts, artillery wheels, and machinegun sidecar platforms. On conclusion, production resumed with 10hp and 14hp models. Humber acquired Commer Cars Ltd in 1926 and, in December 1928, Humber Ltd and the nearby Hillman Motor Company amalgamated to form Humber-Hillman Ltd. In 1931, the Rootes Brothers took 60 per cent control of Humber-Hillman, and by the following year had taken complete control. Motorcycle manufacture was phased out while Humber cycles were taken on by Raleigh. The first new Humber cars to commence under Rootes ownership were the 'Twelve' models with design engineers Alfred Wilde, Jack Irving and George Grinham joining around the same time. The Snipe and Pullman models were the main products of the 1930s, and during the Second World War a number of armoured cars were built along with aero-engines. By 1951, Rootes were producing some four models at Ryton under the 'Humber' name – the Hawk, Super Snipe, Pullman, and the Imperial Limousine. Rootes continued to make and sell Humber cars until the Chrysler Corporation took over in 1964, and the last car to carry the Humber name was the Sceptre, until 1976. *(See also Hillman, Hillman-Coatalen, and Pennington.)*

HUMBER-HILLMAN
(See both Humber and Hillman.)

IDEN, 1903–1908
Iden Motorcar Co. Ltd, Fleet Works, Fleet Street, & Parkside

In 1904, Arthur Witherick of the Velox Motor Company was given the responsibility of selling off the assets of the business including the factory on Parkside, its plant and machinery, and even some vehicles in the course of construction. Up stepped George Iden, who had recently formed his own motor company at the Fleet Works, in premises formerly used by Ryley, Ward & Bradford. Iden was born in 1847 at Preston in Lancashire, the son of the engineer Walter Iden. On leaving school George became an office boy in Manchester, working his way up to become an engine fitter by the late 1860s. In 1872 he married Miss Lettice Flitcroft before he and his new wife moved down to Brighton, George securing the position of works foreman in an engineering works. Son Walter arrived in 1874 followed by a daughter, Selina, a year later, the family remaining in the Brighton area until around 1896, when another move was forced. This time Iden and his family arrived in Coventry, where he became engaged in a senior capacity at the Great Horseless Carriage Company, sharing the Motor Mills with the also newly formed Daimler Motor Company. Being appointed the first works manager at the GHCC, Iden was privileged to both witness and be part of the beginnings of the motor indus-try in Great Britain. Of course these times were not without much trials and tribulation and by 1898 the GHCC was no more, yet quickly reinvented itself as

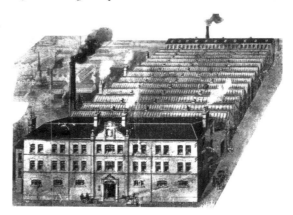

An illustration of the Iden Works at Parkside from 1903. Previous occupants included the Velox Motor Company and the Amalgamated Pneumatic Tyre Company.

the Motor Manufacturing Company on the same site. Iden was retained as works manager and remained in service until resigning his post around 1903, setting himself up in business as the Iden Motorcar Company at a factory at Fleet Street. By this time, his son Walter was also engaged in the Coventry motor industry, but for some unknown reason chose not to work for his father, instead securing a position as chief designer for the Coronet Motor Company. However, as the Iden business progressed, George soon realised that larger works were needed, so when the Velox site became available, he was quick to make the necessary provisions for its purchase, particularly in a growing town where manufacturing premises were very hard to come by. Not many cars were thought to have been built under the Iden name, his first ones being four-cylinder 12-18hp 'Landaulette' models of shaft drive, followed later by a larger 25/25hp variation using his own patented (4978) frictionless radial gearboxes. The company lasted until 1908, and Iden, now nearing retirement, moved to Folkestone – last seen to be working as a 'consulting mechanical engineer' prior to the First World War.
(See also GHCC, MMC, and Velox.)

JAGUAR, 1945–2005 (1922–Present)
Jaguar Cars Ltd, Holbrook Lane, & Browns Lane

It was in 1931 that the Swallow Sidecar Company made its first 'SS' car. Three years later, Swallow changed their business title to that of SS Cars Ltd as a separate operation to sidecar manufacture. In 1935, SS Cars Ltd used the 'Jaguar' name for the first time with the 'SS Jaguar', a 90bhp 2.5litre four-door model selling well in variations up to the outbreak of the Second World War. The manufacture of SS Jaguars continued on a very limited scale into 1940, yet the company transferred most of its production to assist in the war effort, particularly with regard to aircraft repair and component work and more than 100,000 trailers. The 'SS' name was originally chosen by Lyons simply as an abbreviation to the Standard Swallow models being produced, yet during wartime, SS steadily gathered more negative connotations. As Lyons himself put it in 1969:

> After the war the initials SS had acquired a tarnished image, as it was a reminder of the German SS troops, a sector of the community which was not highly regarded, and it was considered to be most desirable to discontinue its use and change the name of the company from SS Cars Ltd to Jaguar Cars Ltd. Our choice of name has proved to be most fortunate for it has helped to build up our world image. There are few places to which one can go where the name 'Jaguar' is not known as a car.

A Jaguar advert promoting the range in December 1946. Few motor manufacturers were as famous as Jaguar.

With William M. Heynes (1904-1989) as chief engineer and Walter Hassan (1905-1996), Harry Mundy (1915-1988) and Claude Bailey in support, Jaguar set about building a new engine, and by 1948 the XK 120 sports was released with its twin-ohc power unit. This model became an instant hit, but soon the company found that their old bomb-damaged factory site had its limitations in terms of expansion, so in 1951 purchased the Daimler shadow factory at

COVENTRY'S MOTORCAR HERITAGE

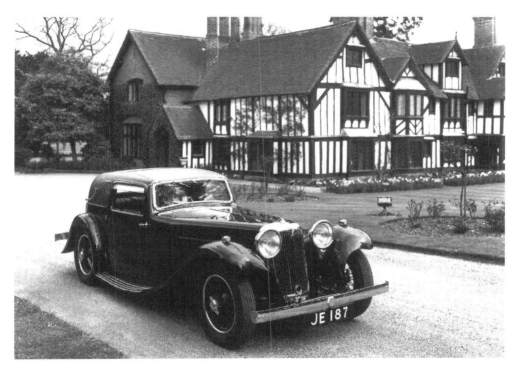

The stunning Jaguar SS1 model pictured at Nailcote Hall, Warwickshire.

Browns Lane with space of over one million square feet, and the Mark VII Saloon, XK 120 and XK 12 models were some of the first built there. The same year saw Jaguar's first Le Mans success when Peter Walker and Peter Whitehead drove their XK 120C model to victory under Frank 'Lofty' England (1911-1995) as competition manager, the first of many more to follow which acted only to increase the company's growing international reputation. 1955 saw the introduction of popular well-designed 2.4litre and 3.4litre saloon cars, and soon after William Lyons was knighted for his services to the British Motor Industry. Sadly, a fire at Browns Lane in 1957 all but destroyed the plant, yet, incredibly, production resumed just nine days later through the hard work and generosity of staff and associates, under temporary tarpaulin structures. In 1960, Jaguar acquired the famous name of Daimler from B.S.A., and the next year saw the introduction of perhaps Jaguar's most celebrated car, the E-Type, of which 70,000 models were sold up to 1975. Guy Motors of Wolverhampton were purchased by the company in 1961, followed by Henry Meadows Ltd soon after, and by 1963, the board also added Coventry Climax Engines Ltd as Jaguar sales began to really soar. In 1966, Lyons joined forces with Sir George Harriman of the British Motor Corporation to form British Motor Holdings, which, two years later, merged with Leyland to form the British Leyland Motor Corporation, whilst in the same year the Jaguar XJ Saloon was born. The Jaguar V12 engine arrived in 1971 as sales reached a record high, and by 1972 Sir William Lyons retired on the fiftieth anniversary of the company he founded in Blackpool, being replaced as Chief Executive by Frank England. Sir William Lyons died at his Wappenbury Hall home in Warwickshire in 1985, and in 1990 Jaguar was bought by Ford Motors, the same year in which two Jaguar XJR-12s gained first and second place at Le Mans. The last Jaguar cars – variations of the XK range – were made at Browns Lane until 2005, yet the company's design and engineering division is still maintained at Whitley, Coventry to this day. In 2008 the company was once again bought, this time by Tata Motors of India, and thankfully, due to their committed investment, the historic Jaguar name has been secured.

(See also Daimler, Lee-Stroyer, and SS.)

JONES, 1914 (1910–1936)
Jones, Gilbert G., Garden Row, rear of 24 Smithford Street

It is believed that Gilbert Gordon Jones first arrived in Coventry as a youth in the 1890s. Born in Dublin in 1885, it is documented that his parents were of independent means, allowing them to settle at Regent Street, a desirable area positioned west of the town centre. On leaving school Jones was known to have worked at the Rover Company in an engineering capacity until around 1910, when he set up on his own account at 'Garden Row' – a small yard behind Smithford Street – as a 'motor engineer'. For the following two years he was listed as a 'motorcycle manufacturer', although full details of these machines have yet to come to light. He was known to have married a Miss Margaret Arnold in 1913 at Warwick, and by 1914 was listed under 'motorcar manufacturers' in the Bennett's Warwickshire Directory, but again it is uncertain whether any complete cars were ever built. Following the war, Jones continued to be listed under 'motor engineers' in the local trade directories until one final listing in 1935/36, and his activities beyond this date are unknown.

KALKER, 1903 (1901–1940)
E. Kalker & Co., Little Park Street

Established in 1901, the firm of Kalker & Co. was first seen under 'motorcar manufacturers' in the 1903 Coventry Trade Directory, yet whether any complete cars were ever realised is so far unknown. The company relates to one Emanuel Kalker (b. 1863) of London, the son of a Dutch diamond cutter. He first arrived in Coventry during the early 1890s and was listed as a manager of an unknown cycle company by the turn of the century. He then set up business on his own at Little Park Street, specialising in the 'manufacture of motor cables' for supply to the trade. By 1908 they had extended output to 'insulated wire flexible, high and low-tension cables, and sparking plugs', with Kalker himself being listed as an 'electric cables merchant' by 1911. Moving the short distance to improved premises at Much Park Street, Kalker extended his business in manufacturing and supplying electric motor cables for both motorcar and aircraft engines. The company was relatively successful, known to have maintained trade throughout the First World War, during which time Kalker was recognised for 'services in connection with war refugees at Coventry'. The business was still seen to be operating in 1940 at 23 Much Park Street and was clearly linked to the Coventry Electric Cable Company of the same address.

LADY, 1899
Henry Cave, Ford Street

The 'Lady' was a seemingly one-off, two-seater voiturette made in 1899 only. It has been written over the years that the vehicle was created by a Mr Henry Cave at Ford Street in the Hillfields area, who powered the car by a 2.25hp De Dion engine. The vehicle had drive to the rear axle by way of a 'Stow' flexible prop-shaft, and was reported to be capable of 16mph. Other notable features included a movable steering column to allow easy access to the seats. In November 1899, the *Automotor Journal* printed a list of recently applied for patents, including one from a Mr H. Cave (22,764) regarding 'improvements relating to motorcars'. Resident directories and census reports of the period do indeed reveal a Henry Cave to be living in Coventry during this time. Born in Edmonton in 1873, Henry Archer Cave's occupation was given as a 'bank clerk' whilst living in the desirable Stoke Park area of the city. If this was indeed the same man, then it would be a greater possibility that Cave wasn't the actual engineer behind the car, but instead may have had the means and interest to make it a reality. As facts or transcriptions can often change over time, then another quite likely possibility could be

William Freestone Cave, known to have applied for a patent (22,882) regarding 'improvements in or relating to the driving gear of velocipedes, motorcars and the like' also in November 1899, whilst living at 5 Avenue Villas, Station Street, Coventry. Born in Leicester in 1870, William F. Cave first arrived in Coventry in the 1890s, was known to have worked in the local motor trade, and was still seen to be living in the city up to 1935.

LANCHESTER, 1931–1956 (1895–1956)
Lanchester Motor Co. Ltd, Radford Works, Sandy Lane

Frederick William Lanchester (1868-1946) produced one of the first experimental British petrol-driven cars in 1895. Establishing the Lanchester Engine Company with his brothers George and Frank in 1899 in Birmingham, he continued his developmental work and the first production cars arrived soon after. After difficulties the business was reconstructed as the Lanchester Motor Company in November 1904, their first offerings being four-cylinder models. By 1909 Frederick was appointed consulting engineer and technical advisor to the Daimler Motor Company in Coventry, and, just prior to the First World War, resigned from the Lanchester Company, the reigns of which were taken over by his brother George. Producing aero engines and armoured vehicles during wartime, after the war the company commenced car manufacture with 40hp six-cylinder model. The 1920s saw a continuation of stylish, luxurious six- and eight-cylinder motors being produced until 1931, when B.S.A., who had acquired control of the Daimler Company twenty years prior, took over the assets of the Lanchester Company. From that point onwards all Lanchester models were produced in Coventry, although these were largely reduced in visual appeal while the Daimler brand won favour in flying the flag in the luxury motor market. By 1933, B.S.A. cars were produced alongside Lanchester variations, the latter consisting

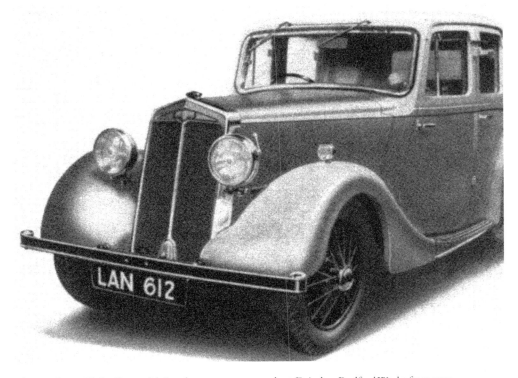

The Lanchester Light-Six model. Lanchester cars were made at Daimlers Radford Works from 1931.

of four- and six-cylinder cars, including the 'Light Six' model. 11hp-18hp Lanchester models were produced up to the war, and by 1951 the company were offering just two 2-litre models – the 'Fourteen' Saloon at £1,533 and the 'De Ville' Convertible at £1,634. Production of the famous Lanchester marque sadly ended in 1956, and likewise the Daimler name was taken over by Jaguar just four years later. The Lanchester name now belongs to Tata Motors of India, yet whether it will ever be reintroduced as a motor manufacturing concern remains to be seen.
(See also B.S.A. and Daimler.)

LAWSON, 1880 (1871–1918)
H.J. Lawson, Warwick Avenue

One of the most significant men concerning the British cycle and motor Industries, Henry John Lawson first arrived in Coventry in 1879, having gained employment at the Tangent & Coventry Tricycle Company. Lawson was born in London in 1852, the son of a mechanical model maker and Calvinistic preacher. Nothing is known of his schooling, yet its believed that young 'Harry' apprenticed at W. Melville, Iron Factors at Islington. He was later to be listed as a 'model engineer' aged 19 by 1871. Soon after, the Lawson family moved to Brighton, where his father had taken up duties at the Providence Chapel, securing a home at Rose Hill Terrace. It was at around this time that Lawson began experimenting with quite radical designs for cycles. It is believed that due to his short stature (about 5ft) the popular 'Ordinary' of 'High-Wheeler' cycles were really of no benefit due to the difficulty in mounting, as they also were to children, many ladies, and the elderly. Lawson designed and made prototypes with the seat, frame and handlebars much lower and positioned in front of rather than over the front wheel. In collaboration with James Likeman, these Brighton-based designs were far safer and by 1876 Lawson had patented the idea whilst also registering the 'Safety' trade name. All Lawson needed now was a company to buy the concept and he found this in George Singer at Coventry, yet the public were not ready for such a design and within a year it was dropped. Undeterred, Lawson made several improvements to the cycle back in Brighton, and established the company of Lawson & Co. at Preston Road with Likeman,

THE FIRST BRITISH MOTOR CAR (Petroleum),

The first ever motorcar design in the country?

yet this partnership had dissolved by October 1878. The following year was the turning point for Harry, marrying Elizabeth Olliver in January, making several changes to his designs – culminating in the 'Bicyclette', selling his Brighton business and moving to Coventry – the principal centre of the world's cycle trade. Appointed by the former Coventry solicitor George Woodcock (1838-1891) at a time of merging several acquired cycle firms, the outcome saw Lawson working for Rudge in a senior capacity. Naturally, he set about making a home and continued his work in cycle development, yet in 1880 he also devised a quite remarkable transport concept several years ahead of its time. The patent (3,913) concerned 'improvements in velocipedes in the application of motive power', regarded by many as the first petrol-powered car for traction purposes in Britain. It is highly likely that an

Lawson's daughters at the helm of his odd-looking 'Motor Wheel' of 1900.

actual prototype was constructed and tested in secrecy in Coventry, perhaps with support from Woodcock and his many cycle manufacturing premises. The end result saw an elaborate enclosed body fixed to the rear axle of a strengthened tricycle frame, the required mechanisms of the engine being crudely attached around it. Unfortunately for Lawson, like his 'Safety' cycle design only a few years earlier, this new design had arrived too soon and was also shelved. Lawson then focused on cycle engineering in Coventry for the next seven years or so, but had begun to take an interest in the promotion of companies and the vast profits that could be made in such ventures, himself being key in the flotation of the Rudge Cycle Company in 1887 with a share capital of £200,000. He then became involved with Ernest Terah Hooley (1859-1947), floating many more companies thereafter and making enormous profits for themselves, Lawson alone making a reputed £500,000 in the floatation of the Dunlop Pneumatic Tyre Company in 1895. By this time Lawson had become increasingly interested in the motoring developments happening in France and Germany. Using his connections and financial clout he formed the British Motor Syndicate, acquiring many manufacturing rights from F.R. Simms, including those of the Daimler concern. On finding suitable premises in Coventry once occupied by the Coventry Cotton & Spinning Company, Lawson refitted the factory and renamed it the Motor Mills – the first motor manufacturing facility in Britain. The Daimler and Great Horseless Carriage Companies were among the first to occupy the space, along with Humber, Beeston, and Pennington. His empire grew dramatically over the following years, yet so did his desire for wealth. In July 1901, he lost a court battle over an alleged infringement of Maybach's carburettor patent, and this decision was the beginning of the end for Lawson, casting doubt over all his so-thought protected patent acquisitions. In November 1904 he was charged, along with Hooley, on the grounds of 'conspiracy to defraud' Alfred J. Paine, and although Hooley was acquitted through expensive legal representation, Lawson saw fit to represent himself. It was an unwise move which saw him shamed and sentenced to one year's hard labour, being imprisoned at Wormwood Scrubs. Whilst incarcerated his health diminished, both his sister and father died, and the Daimler Motor Company reformed without his involvement. On release two days before Christmas in 1905, he tried desperately

to rebuild his career, establishing the Motor Safety Company and selling hundreds of patents to Napier and Edge for just £1,000 in 1907. His mother died in 1909 and by 1915 he began the Bleriot Manufacturing Aircraft Company along with numerous other scrupulous ventures, including the Army & Navy Contract Corporation. This was soon wound up and Lawson was reported to have been physically attacked by shareholders. In March 1916, Lawson was one of 365 passengers aboard the steamship *Sussex*, which was torpedoed by a German U-Boat on return from France, having both his legs broken in the incident where fifty others lost their lives. In January 1918, he was charged once again with conspiracy to defraud, applying for bail as 'being so severely injured in the torpedoing of the Steamship *Sussex*, his legs broken in six places, there was no likelihood of his running away'. He was eventually imprisoned for twenty months, this time losing his wife after a lengthy illness during his sentence. Lawson himself died on the 12th of July 1925, aged 72, leaving just £99 gross and £18 net. He was buried in a modest grave at Hendon cemetery with the inscription *'Exsultanant ossa Humiliata'*, which sadly translates as 'That the bones which thou has broken may rejoice'. This was a tragic end to a man who was a gifted engineer full of enterprise, unfortunately undone by his quest for wealth.

(See also Beeston, British Motor Co., British Motor Traction, Coventry Motor Co., Daimler, GHCC, Humber, MMC and Rudge.)

LEA-FRANCIS, 1903–1906 and 1919–1961 (1895–1966)
Lea & Francis Ltd, Lower Ford Street & Much Park Street

The once well-known name of Lea-Francis began in 1895 at Day's Lane, Coventry through a partnership formed by Richard Henry Lea and Graham Inglesby Francis. Lea, the son of a cabinet-maker, was born in 1858 and raised in Lutterworth, Leicestershire. He was educated at Manchester Grammar School before joining Singer & Company in 1878, staying with the firm until 1895, when he joined Francis. Whilst at Singer, Lea spent a lot of his time abroad drumming up sales in India, the Far East and America, until being appointed works manager at

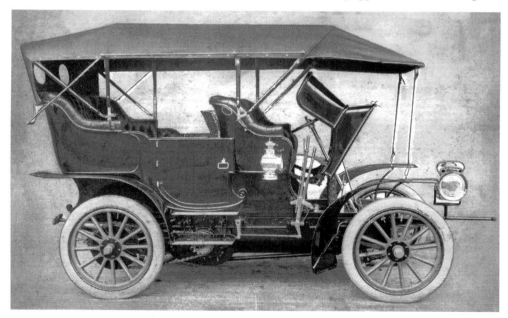

A well-made Lea-Francis of 1904. As a company they began making bicycles in 1895, and made motorcycles also up to 1924.

Lea-Francis cars, seen here exhibited at Olympia in 1926. The company made their final cars in 1961.

Singer's 'New Works' in 1888. Francis also spent much time abroad in his early career. Born in London in 1862, he first found employment at the machine tool makers Ludwig, Loewe & Co. in Berlin, before moving to the USA to take up employment, first with Brown & Sharpe and later with Pratt & Witney. After returning to England, he moved to Coventry in 1891, becoming General Manager of the Auto Machinery Company – suppliers of ball bearings to the cycle trade. By 1895 Lea and Francis had come together, moving to more extensive works at Lower Ford Street the following year, owned by Lord Leigh. James Stone (b. 1857) was appointed the first works manager, John A. Rudd (b. 1874) as secretary, and Francis A. Griffin (b. 1874) became general manager. The company quickly earned a solid reputation for producing quality cycles and gaining many high-profile customers along the way, including Lord Burleigh. By 1900, many of the other cycle manufacturers in Coventry had began experimenting with motorized transport, either by fitting engines to their bicycle frames or were instead developing cars. For some reason, Lea and Francis bypassed motor-bicycle production and decided to build a car instead, establishing the Lea & Francis Motor Syndicate in July 1903 with Lea, Francis, and J.H. Hampson as Directors. Designed by the Scotsman Alexander Craig, a friend of R.H. Lea, this initial attempt consisted of a 15hp model, exhibited at the 1904 Motor Show along with a single chassis. In 1905 they developed this further to a 15-20hp triple-cylinder version, yet by the following year motor activity seemed to have tailed off in favour of the ever-consistent product of bicycles. It wasn't until 1911 that the first motorcycle was built for production and it would be a further decade or so before car manufacture re-emerged. On turning to munitions work during the war, on conclusion Lea appointed former Singer and Calcott designer Arthur Alderson (b. 1875) to the ranks, and, soon after, a 12hp model appeared. After a business partnership being formed with the Vulcan Motor Company, Charles Van Eugen was appointed in late 1922, which proved to be a positive turning point for Lea & Francis. His first offerings were the C-Type and D-Type light cars, available in a variation of engine sizes and body styles, opting for the larger Meadows power-unit over the Coventry-Simplex units. The company's reputa-

tion in the light car market enhanced and sports models began to be developed, culminating in the famous 'Hyper' model by 1928, winning the Tourist Trophy in the same year with Kaye Don at the wheel. By the beginning of the 1930s, however, the company hit severe difficulties due to a split from Vulcan and a global slump, and, in 1931, the receivers were called in. Some of the final seventy-five or so Lea-Francis motors to be built at Lower Ford Street included Van Eugen's promising six-cylinder 'Ace of Spades' model, yet the well-established company name was not quite finished. Former Riley employees Hugh Rose and George Leak purchased the assets of the business whilst Van Eugen departed in the opposite direction, the result of which became Lea-Francis Engineering (1937) Ltd. New works formerly occupied by Triumph were sourced at ancient Much Park Street and a decent range of well-designed medium-sized sports models appeared. Another war saw the firm again switch to munitions work, including making components for Stirling bomber aircraft, yet car production resumed in 1946. Not without further turmoil, Lea-Francis cars continued to be manufactured in Coventry, the last model being the Ford-powered 'Lead-Lynx'. The company was then bought by the motor spares business of Quinton Hazell Ltd, while at around the same time made a number of B.S.A.-powered small tractors called the 'Uni-Horse'. Lea-Francis were last seen at Much Park Street in 1966, but the name was then taken on by Barrie Price of Warwickshire, who, by 1988, released a Lea-Francis 'Ace of Spades' sports saloon using Jaguar components in limited numbers.
(See also Autovia, Calcott, Riley and Singer.)

LEE-EABB, 1926–1934
Lee-Eabb & Co. Ltd, 13 Queen's Road

Of all the companies to be listed in this book, this one is perhaps the most puzzling. The unusual name of Lee-Eabb & Co. Ltd has for many years been listed as a manufacturer of cars at Coventry Transport Museum. On looking at the 1926/27 Coventry Directory, this company is indeed listed under the heading of 'motorcar manufacturers' at 13 Queen's Road, yet in the actual street section it lists them as 'manufacturers of motor conveyors'. By 1929, the address was given as the same but the company name had altered, to that of 'Lu Fabb Co.' – an obvious transcription error one way or another. However, at 13 Queens Road in the street section of the same directory, were listed five separate businesses, only one of which is related to the motor industry – the Hoyal Body Corporation. Two years later, both Lu Fabb and Automobile Conveyors Ltd were separately listed at the same address under 'transport agents' and also as 'manufacturers of motor conveyors'. The final entry for this elusive business is seen in the 1933/34 directory, but only under the title of Automobile Conveyors Ltd at 13 Queens Road, and listed under the headings of both 'transport agents' and 'motor haulage contractors'.

LEE-STROYER, 1903–1907 (1903–1985)
Lee-Stroyer & Co., 63 East Street

The company of Lee-Stroyer began in 1903 at small works to the rear of 63 East Street, for the primary purpose of designing and building engines for supply to the growing motor trade. During four years of production the owners, H. Pelham Lee and Rudolph Stroyer, also briefly delved into complete car manufacture on a limited scale, but ultimately opted to operate as engine suppliers through concerns surrounding spiralling costs. Henry Pelham Lee was born at Putney, London in 1877, the son of an architect. After studying electrical engineering in Kensington he served with the Royal Hussars during the Boer War. On completing his military duties he joined the Daimler Company in Coventry – seemingly a motoring training ground for so many aspiring pioneers. Stroyer was born Jens Peter Rudolph Stroyer-Nielsen in Copenhagen, also in 1877. The son of a cooper, in 1900 he attended Copenhagen Technical

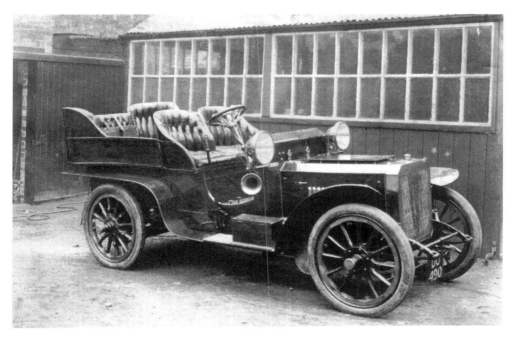

The Lee-Stroyer car of 1904. The partnership only lasted around four years.

A stripped-down version of the same Lee-Stroyer car, most probably pictured in the rear yard of their small East Street address.

University before arriving at Erith in Kent to take up a position at the Schmidt Superheated Steam Company. By 1902 he too was working at Daimler in Coventry, where he and Lee became colleagues and close friends. After their partnership dissolved in 1907, Stroyer returned to Copenhagen to work for the steam locomotive builders Smith, Mygind & Huttemier. After several jobs either side of England, Denmark and Germany, by 1912 he had returned to England full-time and established his own company in London. For H. Pelham Lee, after the

Lee-Stroyer split he established the engine-manufacturing company of Coventry-Simplex at Payne's Lane, suppliers to many car manufacturers, including Abbey of Westminster, Crouch, and GWK, amongst others. In 1917 the company name changed to that of Coventry Climax back at East Street and Friars Road. The business was to become hugely successful, being acquired by Jaguar in 1963. Lee died in 1953, and Stroyer a few years later, in 1957. *(See also Jaguar.)*

LOTIS
(See Sturmey Motors Ltd.)

LTI (London Taxis International)
(See Carbodies.)

MAGUIRE, 1977–1999
John Maguire Racing, Stoney Stanton Road, & Fletchampstead Highway

Born in Coventry in 1949, John Maguire first acquired a small workshop on Stoney Stanton Road in 1977. Over the following six years, Maguire and his skilled team designed and built many modified fibreglass and space-framed racing cars, which drew customers from all around the world. Often finding their way to the British Touring Car Championship circuits, these 'special saloon cars' included Maguire type Minis, Imps, V8 Rovers, Lotus Esprits, and even a few Skoda variations. Maguire also built cars for the OMB Metro series, complete with a three-car capacity transporter – later sold to BMW – and also a Formula Three single-seat 'Le Mans' type racer. A move was made to Fletchampstead Highway in 1983, where Maguire concentrated on Group One and Group A competition cars, including the BMW M3 models. The business remained in Coventry until closure in 1999, yet during twenty-two years of operation more than 100 cars were produced. Maguire, however, was not the only Coventry-based team to have had successes on the racing circuits. Between 1983 and 1997, former Broadspeed employee Andy Rouse (b. 1947) developed and prepared a number of BTCC cars, most notably the Ford Sierra RS500 model. Rouse was an incredibly successful driver, winning some sixty races and four titles during his racing career.

MANLY & BUCKINGHAM, 1911–1912 (1911–1988)
Manly & Buckingham, 159 Spon Street

William George Manly (b. 1875) and James Frank Buckingham (b. 1887) briefly joined forces in 1911 as motor engineers. Manly's early years are difficult to trace, yet he was seen in 1901 to be staying at the Kings Head Hotel in Coventry as a 'visitor'. The entry states that he was from Norfolk and was working as an 'engineer in the motor trade' at this time, but for which company is not known. Buckingham hailed from Kent, and was thought to have arrived in Coventry around 1906 to work for the Riley Motor Company. Six years later, he and Manly had secured works at 159 Spon Street, next door to the builders, Bertram & Son. Before long they set to work, taking out a patent (17,380) concerning improvements in internal combustion engines by July 1912. With the 1912/13 Spennell's Coventry Business Directory listing them under 'motor-car manufacturers', one would assume that a complete car or cycle car was built, but as yet no evidence has been sourced to fully back this up. For whatever reason, this partnership dissolved and Manly's subsequent activities remain a mystery. Buckingham, however, wasted no time in setting up another company, and by doing so found marginal fame and fortune. *(See also Buckingham.)*

MARSEEL/MARSEAL, 1919–1925

Marseal Engineering Company, & Marseel Motors Ltd, Atlantic Works, Harefield Road

Marseel Motors Ltd was formed after the First World War through an agreed partnership between two men – Captain D.M.K. Marendaz and C.A. Seelhoff. Donald Marcus Kelway Marendaz was born in Glamorgan, Wales in 1897 to a Swiss family, and Charles Alexander Seelhoff, of Belgian descent, was born in 1893 at Hednesford, Staffordshire. Before the First World War, both men had found employment at the Coventry car makers Siddeley-Deasy, and on becoming friends decided to form a company of their own. The plans were put on hold though as both served their country during wartime, Marendaz being part of the RAF Royal Flying Corps no. 35 squadron and invalided back to England in 1918. When both had returned, they initially gained employment at the newly formed Alvis Company, specialising in the design and production of gearboxes. On leaving their posts, they combined their surnames to come up with the company name Marseal Engineering Co., locating prem-

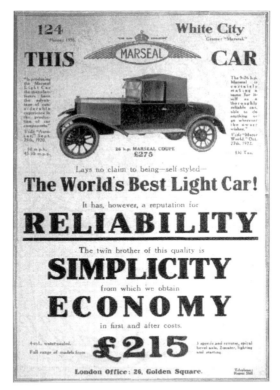

Advert for the Marseal car of November 1922. A few weeks earlier, the car had been known as the 'Marseel', while one of its founder company members, Charles Seelhoff, was still partner.

ises on Harefield Road in Stoke, Coventry. Initially they made gearboxes, which were taken up by firms such as Emscote of Warwick, but also developed a motorised scooter for a brief time. By 1921 they were listed in local trade directories as 'motorcar manufacturers', known to have made a light car powered by a 1.5 litre four-cylinder Coventry-Simplex engine. For unknown reasons, Seelhoff broke the partnership in late 1922, but Marendaz remained, changing the business name to that of Marseal Motors Ltd. An experienced Brooklands racer, he maintained production in Coventry until February 1925, releasing seven different models in total, including most notably the 11/27hp and the 12/40hp models. On closure, the Whitley Manufacturing Company of London Road, Coventry, were seen to be offering 'Marseal' spare parts. Marendaz then set up a new firm as D.M.K. Marendaz Ltd at Brixton Road, London building cars that were deemed by many to appear far too similar to that of Bentley models. Apparently the Bentley Motor Company caught wind of this and considered taking legal action, but backed down when they learned of Marendaz's poor financial position and decided his cars were of no real threat to them. He continued to race with marginal success in cars built by Graham-Paige until 1931, and the following year he started Marendaz Special Cars Ltd at Maidenhead, but this had collapsed by 1936. He then moved to Bedford and started a flying school before establishing Marendaz Aircraft Ltd, building bi-planes, yet none were thought to have made full production. Outside engineering he had become progressively active in politics, following Oswald Moseley and the British fascist movement, and as a result was imprisoned in Brixton Jail in 1940. The Sunday Express newspaper intervened on his behalf due to his heroic efforts during the Great War, and he was subsequently released a

few days later. In 1949, he left for South Africa, where he started a diesel engine business called Marendaz Diesel Tractors. In October 1965, *The Times* reported that he had been accused of fraud, which no doubt tarred his reputation. He ultimately returned to England in 1972 and settled in Asterby, Lincolnshire, where he remained until his death in 1988, aged 91.
(See also Alvis.)

MAUDSLAY, 1902–1954 (1902–1987)
The Maudslay Motor Co. Ltd, Parkside Works, Parkside

The Maudslay Motor Company began at Parkside in 1902. Born in London in 1876, Cyril Charles Maudslay was the son of the engineer, Walter Henry Maudslay (1845-1927) and great-grandson to the famous marine engineer, Henry Maudslay (1771-1831). With backing from his father after the closure of Maudslay Sons & Field, as Managing Director of the new concern Cyril found adequate premises in Coventry and commenced the manufacture of internal combustion engines initially, yet before long began to make complete motorcars. Joined by Alexander Craig (b. 1873) and John Reid (b. 1869), both from nearby Birmingham, Maudslay's debut models were solid 20hp three-cylinder-powered cars of good quality and serviceability. 25hp three-cylinder models followed, largely of the limousine type, as well as 40-60hp six-cylinder versions accompanying a start in the commercial motor side. By March 1907, the business was reformed as The Maudslay Motor Co. (1907) Ltd with a capital of £100,000, the Directors listed as Samuel Sanders, Sir Charles S. Forbes, Alexander Craig, Francis E. Foster, Cyril Maudslay, and John W.C. Seymour, with Lacon Askew Willison (b. 1869) as secretary. Large four-cylinder motors continued to be the main products of the company from 1908, yet a smaller 17hp model did make an appearance a year later and sold in good numbers up to 1914. During the First World War, the Parkside factory produced

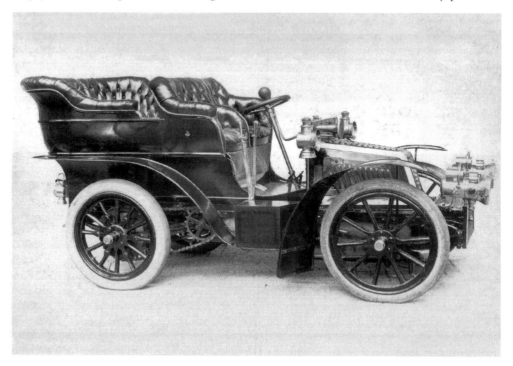

A beautiful Maudslay double-phaeton car of 1902. The Maudslay name has a proud industrial heritage.

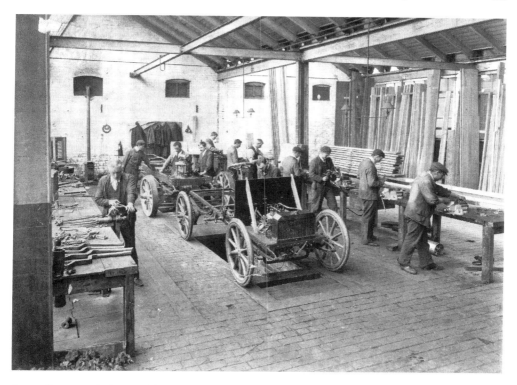

A rare glimpse inside the Maudslay factory at Parkside.

3-ton 'Class A' War Office motor lorries, and this in many ways signalled the end of the mass-production of Maudslay motorcars, the next car (the '15/80' six-cylinder model) not being released until 1923. By 1926, Maudslay completely shelved the manufacture of cars in order to concentrate fully on commercial vehicle production, particularly geared towards the passenger-type vehicle. In 1928, of the 313 vehicles made at Parkside, 263 were of the passenger-designed persuasion. 1928 also saw the erection of a separate factory at a new housing estate off Allesley Old Road, today known as Maudslay Road and marked by the Maudslay public house, the factory itself being taken over in 1940 by Harry Weston's Modern Machine Tool Company. In 1935, the Maudslay Company hit difficulties and was taken over by one of its shareholders, Birmingham builder Oliver Douglas Smith (b. 1908). Smith's initial intentions were to develop the Parkside site, yet instead he chose to continue the business as a commercial motor-manufacturing operation, with Siegfried Sperling (b. 1892) installed as chief engineer. As war drew closer for the second time, Smith and his fellow directors bought land at Great Alne near Alcester in Warwickshire and built a shadow factory, and as Parkside was badly damaged during 1940 and 1941, the new site would later go on to play a big part on the next phase of the business. Maudslay was acquired by former component suppliers the AEC group in 1948, at a time when they were producing one of their most successful coaches – the Maudslay Marathon, of which some 600 were believed to have been sold. Under the Directorship of former Morris and Daimler worker William Lightowler (b. 1903), in 1954, the factory on Parkside was sold to Cornercroft Engineering for £57,000 and all Maudslay production transferred to 'Castle Maudslay' at Great Alne. The manufacture of complete commercial vehicles ended soon after. The company then concentrated on making axles, and, in 1972, was taken over by the American-owned Rockwell Group, producing Rockwell-Maudslay axles until 1987.
(See also Standard.)

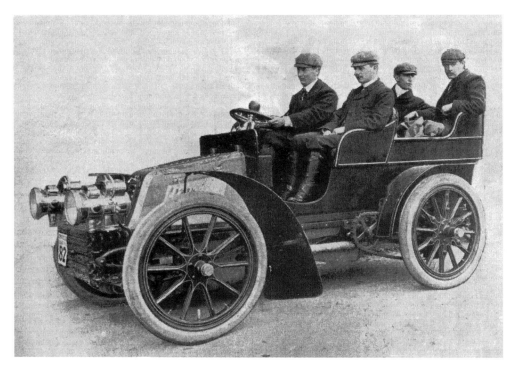

Another view of the 20hp Maudslay car, with four unknown employees sat within.

M.M.C., 1898–1905 (1898–1908)
Motor Manufacturing Co. Ltd, The Motor Mills, Drapers Field, & Parkside

The Motor Manufacturing Company, registered in January 1898, was born out of the misrepresentation of Harry Lawson's earlier firm, the Great Horseless Carriage Company. Before long, the reinvented concern soon began marketing copies of French Werner motor-bicycles, while building and supplying a range of MMC engines under license from the French engineers De Dion Bouton. George Iden, who had been works manager at GHCC, retained his position under the new company name, and was well assisted by Alexander Hamilton, who had also made the simple transfer. Iden became prevalent in all design and engineering work conducted at MMC, their initial offerings being the 'Sandringham' motor Phaeton, the 'Beatrice' motor Victoria, and the 4.5hp 'Princess' carriage models. Most of the company's vehicles incorporated 'Iden's System', and in September 1899 a Princess model was driven from Coventry to London in four hours, averaging 23.5mph, with a consumption of only three gallons of petrol, all done apparently without changing water. Iden was to become President of the Works' Fire Brigade, which was established in October 1898, supported by the engineering clerk Samuel Pilkington (b. 1871) as Vice-President. Also in 1899 the company received a contract from the War Office to supply a number of 2¼hp MMC tricycles for use in the Boer War, this being the very first occasion where motorcycles were used under actual war conditions. The following year the company offered a wide range of motors, including 6bhp Phoenix-powered 'Albany' concave dog-carts, 6hp 'Hampton' chara-bancs and 'Lveagh' phaetons, 'Bedford' and 'Lynton' wagonettes, motor-tricycles, quadricycles, and Werner motorcyclettes. As at Daimler, hundreds of skilled men of all variations were to spend time at MMC before taking their new-found experience elsewhere, including draughtsman Thomas Hyler White (b. 1871), car tester George Harry Ison (b. 1881), and motor fitter Arthur Charles Brown (b. 1882). It wasn't until 1903 that the company issued their first balance sheet to show a profit of £10,000, yet this coincided with the departure of Iden, who went on to set himself up in

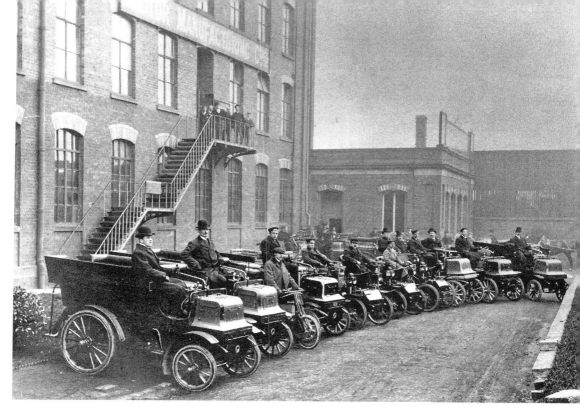

A superb view of the Motor Mills in 1898, when the Motor Manufacturing Company occupied part of the site.

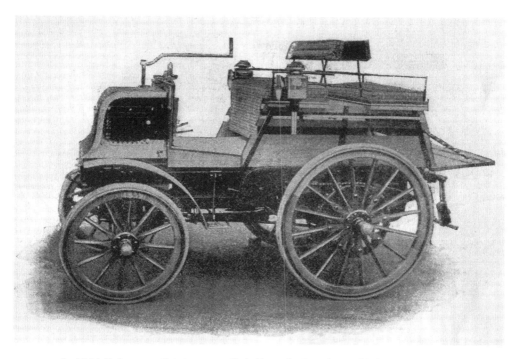

An M.M.C. dog-cart of 1898, not too dissimilar to the Daimler models being built nearby.

business in Coventry. Although eight models were exhibited at Crystal Palace, with prices ranging from £255 for the 8hp Tonneau to as much as £895 for the 20hp Roi Des Belges, years of experimental works had cost them dear and by June 1904 the business was in the hands of the receivers. The company was, however, salvaged and during 1905 a move was made to Parkside while the Draper's Field factories were sold to Daimler. It is believed a limited number of Panhard-type cars were produced under the MMC name at Parkside, yet after a year the business was wound up again. Moving to London, it became the Motor Manufacturing Company (1907) Ltd, yet this too was wound up by December 1908, with G. Ernest Tabor given as Chairman.
(See also Daimler, GHCC, and Iden.)

MONOPOLE, 1900 (1890–1955)
Monopole Cycle & Carriage Co., Union Mills, Foleshill Road
Monopole Cycle & Motor Co. Ltd, 2 St Mary's Street, 6 Little Park Street, & 29 Hertford Street

This company was founded in 1890 in the old Great Heath area of Coventry as 'Cycle and Carriage Manufacturers'. Initially, they sold safety bicycles fitted with 'back pedal friction brakes' before becoming increasingly interested in the development of self-propelled vehicles by the turn of the century. the *Autocar* of the 4th of August 1900 released details of the new 'Monopole' voiturette, stating,

> the car is a light one, constructed to carry two persons and weighs about six hundredweight. It's engine is an air-cooled one on the De Dion principle of three and a quarter horse power, and fitted on the front axle, the car being belt-driven on two speeds. The car was given an exhaustive trial from London to Felixstowe and back, the total distance ridden being 420 miles, and was accomplished without the slightest mishap of any description.

As much as this report appeared favourable, for some reason the company chose not to pursue its manufacture and instead continued with the production of cycles, and motor-bicycles from 1902. Exact details of those who actually founded the company have yet to be finalised, although a number of individuals are now known to have been heavily associated with the firm, having a distinctly part Midlands, part Yorkshire involvement. Included is Thomas Law Husselby, who was known to have been Monopole secretary until his death in 1911. Husselby was born in Coventry in 1868, the son of a shoemaker. During the early 1890s he worked as a clerk in a Bradford worsted wool mill, before arriving back in Coventry to take up his administrative post with Monopole. Much of the motor engineering input appears to have come from Joseph Bush, born in Coventry in 1853. Bush worked as a gas and steam engineer prior

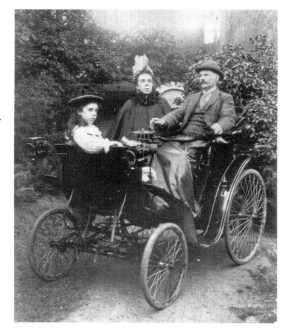

Thomas Law Husselby, Secretary to the Monopole Company, sitting inside a copy of the Benz car with his wife and child.

to working for Monopole, but was listed in the 1901 census as a 'motor engineer', and later became a consulting engineer, having works at Hertford Place. Whilst in Bradford, evidence suggests that Husselby worked alongside John Clough (b. 1847) and Joseph William Maude (b. 1851). Clough, who was a manager at a worsted mill, applied for four patents between 1895 and 1897, along with Joseph Bush, relating to speed gears. Also involved on each occasion was Rochester Illingworth, born at Bradford in 1853. By the early 1890s, Illingworth was seen to be living at Hill Street, Coventry, employed as a worsted mill manager, almost certainly at the Leigh Mills. Lastly, Joseph Maude too hailed from Bradford, but by the turn of the century was also in Coventry working as a commercial traveller. However, existing Monopole share certificates reveal that both he and Rochester Illingworth were company Directors around the same period. By 1911, Maude was still in Coventry with family, listed as a 'manager of a cycle company', while Herbert James Skipp (b. 1881) took over as secretary. As a business, Monopole ran into difficulties in 1913, but did survive, taking government contracts during the Great War. They appear to have ceased motorcycle manufacture around 1924, yet continued the production of cycles and carrier cycles up to 1940, with Herbert Skipp by this point as Director. Incredibly, their last known entry appeared in the 1955 Coventry & District Directory at 29 Hertford Street, amassing some sixty-five years in the trade.

MOORE & OWEN, 1904 (1900–1914)
Moore & Owen Ltd, 4 Much Park Street

The company of Moore & Owen Ltd began in December 1900 at 24 Bishop Street with a working capital of £5,000 in £1 shares. The first Directors were given simply as H. Moore and C. Owen and their business activities listed as 'manufacturers, sellers, factors of bicycles, tricycles, motor-propelled cycles, carriages, vehicles, gas and other engines'. Although the true identity of Mr H. Moore has so far proved inconclusive, Mr C. Owen surely relates to Cyril Owen, born in 1876 in Liverpool. By 1901 he was seen to be lodging at the home of Rachel Sidwell, the Headmistress of a girl's private school in the Stoke Knob area of Coventry, his occupation shown to be a 'cycle manufacturer'. By 1904, the company were listed as 'motor factors' at Much Park Street in the local trade directory, but as yet no further evidence has been sourced to support this. The following year, however, they were listed as 'wholesale factors and cycle accessories dealers'. Owen's younger brother Bertram (b. 1883) later moved to Coventry and was working as a 'motorcar salesman' by 1911, yet whether he had any involvement in the Moore & Owen concern is unknown. Although seemingly absent for a while, the company were last seen listed in 1914 as 'wholesale factors' at Earl Street before war intervened. Cyril Owen then moved to Tanworth-in-Arden, becoming a company director. He died in Birmingham in 1945.

MORRIS ENGINES
(See Hotchkiss.)

MOTOR AGENCY, 1899–1900
The Motor Agency Co., Ryley Street

The Motor Agency Company was seen for the first time in March 1899, offering '1hp De Dion motor castings' out of premises at Ryley Street opposite the huge Leigh Mills factory. The following year, they were seen in the Kelly's Warwickshire Directory under 'motorcar manufacturers' with a Mr John Crouch listed as manager. This can only relate to John Crouch, born at Stratton in Dorset in 1856, who, by 1901, was living at Barras Lane, Coventry and occupier of a haulage contracting company. It is believed that he was a keen owner and driver of an imported Leon

Bollee tri-car during the mid-1890s, so whether his business interests only related to haulage, or extended to that of motor agents or actual motor production, is unknown. By 1911 he had all but retired from manufacturing, yet within a year, he, along with his son John W.F. Crouch, went on to establish a known motor manufacturing company – that of Crouch Motors Ltd. (*See also Crouch.*)

MOTORIES, 1912–1920
Motories (Coventry) Ltd, 132 Much Park Street

This business was first seen in both the Kelly's and Spennell's Coventry trade directories for 1912/13, yet the former listed them as 'motorcar manufacturers' whilst the latter as 'manufacturers agents'. Their address was at 132 Much Park Street, sharing the same premises and telephone number as the North British Rubber Company, which must be linked in some way. The Bennett's Warwickshire Business Directory of 1914 then just listed them as 'agents', which rings true, particularly as no evidence has so far come to light to support any motor manufacturing activities. *The London Gazette* later revealed that the company dissolved in March 1920, and, although the individuals behind Motories (Coventry) Ltd remain unknown, there may be links to Sidney Hill. In 1919 he established the firm of Hill & Co., Sidney Motore (Coventry) Ltd at Godiva Street, and was also known to have worked as a 'purchasing agent'. (*See also Hill & Co.*)

MOTOR BODIES, 1905
Motor Bodies Co., Chapel Street

Apart from being seen in the 1905 Coventry Directory under 'motorcar manufacturers and factors' at Chapel Street, absolutely nothing else is known about the Motor Bodies Company, or the individuals behind it. As their business title would imply, chances are that it was with the production of motor bodies that the company was concerned. Even this though would have been very brief, as they are not seen listed by 1907. In 1894, Thomas S. Hobley (b. 1867) was trading as a 'body builder' at Chapel Street, which may have a connection. Another could be that of the Scotsman James Muir (b. 1871), seen to be a 'cab proprietor' at 17 Chapel Street in 1901, and as a 'motor mechanic' at the same address ten years later.

MOTOR PANELS, 1960–1962 (c. 1920–2000)
Motor Panels (Coventry) Ltd, Dunlop Road, Holbrook Lane

The once familiar name of Motor Panels was thought to have begun soon after the First World War in Coventry. As their company title would suggest, their main operational focus surrounded the manufacture and supply of automotive steel pressings, located at industrial works at Holbrook Lane. Motor Panels progressively established a healthy supply trade to the British motor industry, boasting an impressive line of local companies during their peak, which included the likes of Alvis, Armstrong-Siddeley, Daimler, the cars of the Rootes Group, and Standard. However, whilst under the leadership of Alfred G.B. Owen (1909-1975) and James M. Phillips (1905-1974), the company was to play an integral part in a historic motoring feat during the early 1960s, when it was chosen to construct the Bluebird-Proteus CN7. Designed by the Norris brothers, it was powered by a Bristol-Siddeley Proteus gas-turbine engine of 4,000hp, the completed vehicle made with the intention to break the then existing Land Speed Record of 394mph set by John Cobb in 1947. Although Bluebird was completed in the spring of 1960, due to unprecedented heavy rain it was not until July 1964 that the record was broken at Lake Eyre, South Australia.

A nice interior image of Bluebird after completion at the Motor Panels factory.

Driven by Donald Campbell, Bluebird attained a new 'Wheel-Driven' Land Speed Record of 403.10mph, yet he was disappointed not to have reached a far greater speed due to the potential of Bluebird itself. By November 1965, the record was once again taken by the American Bob Sumner. Bluebird now forms part of the National Motor Museum collection at Beaulieu.

MOTOR RADIATOR, 1912–1913 (1907–1968)
Motor Radiator Manufacturing Co., Arno Works, Dale Street, & Parkside

Another motor related firm to have graced Parkside, the Motor Radiator Manufacturing Company initially began at Bermondsey in London in 1907. Its founder was Peter Oscar Serck, born in St Petersburg, Russia in 1882 but of Norwegian descent. Although born in Russia, he retained his Norwegian citizenship through Russian law, yet his parents were of Norwegian origin, and his grandfather had, for many years, been a ship owner and Consul-General of Sweden and Norway in St Petersburg. He received an education at St Anne's College and in 1902, at just 20 years of age, left for America. There, like so many others, he hoped to find his fortune, but after two years he had returned home, all but penniless. In Germany he met an engineer called Hans Zimmermann who had invented a 'Honey Comb' motor radiator. They formed a partnership and in 1907 Serck opened up a branch in London, but two years later moved the operation to Coventry, initially at the shared 'Arno Works' on Dale Street, before settling at larger premises on Parkside, opposite the Swift Motor Company. Serck himself found a home at 49 Park Road and lived there with his older sister Alice. She married Sydney Nelson Purchase (b. 1881) of Kings Norton, who had become Serck's works manager in Coventry from 1910. Others known to have worked for the company at this time were John 'Jack' Millward (b. 1889), Arthur J.G. Golder (b. 1888), Edwin James Bowman (b. 1880), and the

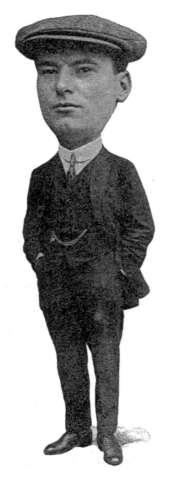

Caricature of Peter Oscar Serk, one of the founders of the Motor Radiator Company.

German Ernst Tiator (b. 1878). In Coventry they commenced the manufacture of Zimmermann's patented radiators for the motor and aviation industries, including Italian airships. From 1912 to 1913, however, local trade directories listed them as 'radiator, accessories, and motorcar manufacturers' but details of any complete cars have not been traced and would appear doubtful. Also in 1913, Zimmermann and Serck dissolved their partnership, each retaining their share in both Germany and England respectively. The Motor Radiator Manufacturing Co. remained in Coventry until 1914 when the business moved once again, this time to Greet in Birmingham, where a new factory was built. The factory was taken over by the Ministry of Munitions during the war, and on conclusion the company title was changed to that of Serck Radiators Ltd, manufacturing motor radiators until 1968, when the company concentrated on other engineering matters. Peter Oscar Serck died in Torquay in 1924 at the young age of 41, but led a very eventful life with a number of reported incidents. Whilst in America in the early 1900s he often had no money and was forced to sleep rough, and, on one occasion, he was robbed at gunpoint. Although he managed to grab and retain the firearm it went off, damaging his finger. On another occasion he was walking along a railway bridge to Brooklyn at night when a train caught him out halfway across. In order to avoid certain death he hung from the sleepers whilst the train passed over him. During the First World War, he spent much of the time in Russia at his works situated at St Petersburg. In 1917, during the revolt, he reportedly walked the shop floor, a revolver in each hand, to cover his workforce. On a lighter note, he was also a keen sportsman, most notably regarding swimming, yachting and football. He played for Victoria St Petersburg from 1901 and has been suggested to have been the first Norwegian to play football outside his own country of citizenship..
(See also Arno.)

NEVILLE-SINCLAIR, 1904–1906
Sinclair, Neville & Co. Ltd, Fleet Works, 4a Fleet Street

The firm of Sinclair, Neville & Company were first seen listed as 'tyre manufacturers' and 'pneumatic-tyre experts' in the 1904 Coventry Directory. Positioned at the Fleet Works next door to the Iden Motor Co., the owners are believed by some to have also developed a car called the 'Neville-Sinclair' but, as yet, no evidence has been found to support this. Although the individuals behind this elusive business have yet to be confirmed, there have been a few possibilities dated around the existence of this firm whilst in Coventry that have connections to the cycle and motor tyre trades. The first two relate to the brothers David (b. 1862) and Finlay Sinclair (b. 1858) of County Antrim, Northern Ireland. David was first seen in Coventry at the turn of the century at Gosford Terrace working as a 'cycle tyre maker', yet he had married Harriet Hopkins in the city earlier in 1894. By 1911 he was listed as a self-employed cycle agent and the following year as a 'pneumatic tyre manufacturer' at Victoria Street, Hillfields. Older brother Finlay arrived in Coventry around 1890, listed initially as a cycle manufacturer

whilst living at Priory House, Cox Street with his family. At this point he would have been employed by the Pneumatic Tyre & Booths Cycle Agency at Dale Street, yet, prior to this, he was part of the cycle company Edlin & Sinclair at Belfast, most notably involved with John Boyd Dunlop regarding fitting the first pneumatic tyre to a bicycle. By 1901, he was Managing Director of the Preston-Davies Tyre Company in Coventry, but by 1907 had relocated to Birmingham. Regarding the Neville side of the partnership, the 1904 Kelly's Warwickshire Directory revealed 'John Neville, cycle accessories factor – see Sinclair, Neville & Co.' which at least offers some certainty. Unfortunately though, no men by this name appear in the census in relation to Coventry so the likelihood is that he too was Irish by origin.

NEWSOME, 1939 (1919–1968)
S.H. Newsome & Co. Ltd, Corporation Street

In May 1939, S.H. Newsome & Company announced that they would be releasing the 'Newsome' Drop-Head Coupe. In an arrangement with SS Cars Ltd, the company purchased SS Jaguar '100' chassis' to be fitted to an all-new weather-protected body, built by Avon Bodies of Warwick and designed by Sammy Newsome himself. The modified cars were offered from £485 for a 2.5 litre model and £535 for the 3.5 litre version, but it is believed that only a very small number were actually ordered. Newsome knew the SS 100 model well, having raced them competitively on many occasions whilst also being a registered distributor of SS cars. The outbreak of war clearly hampered the hopes for this model, and S.H. Newsome & Co. continued to operate as motor agents and engineers until 1968.
(See also Cooper, and Warwick.)

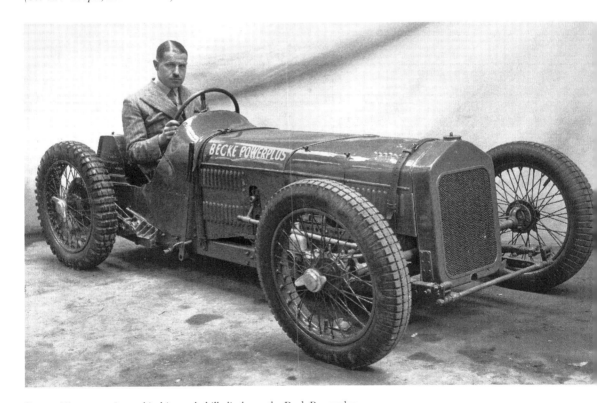

Sammy Newsome pictured in his sturdy hill climber – the Beck Powerplus.

NEW BEESTON
(See Beeston.)

NOBLE, 1911–1912 (1911–1925)
Noble, A. & Co. Ltd, Stoneleigh Works, Hill Street

Alfred Harry Noble was born in Coventry in 1883, the son of a commercial clerk. On leaving school Alfred became a clerk for the railways, probably based at Coventry's station, then a modest Victorian building at the end of Eaton Road. In 1911 he set himself up as 'cycle & motorcycle manufacturers' at an address known as Stoneleigh Works at Hill Street. These 'Noble-Precision' named motorcycles were belt-driven machines using Druid forks and powered by 3½hp Precision Engines, but it is not believed too many were sold. In the same directory, Noble was also listed as a 'motorcar manufacturer' at the same address, but no details have yet been sourced to support this. His younger brothers John and Frank were both listed as motor draughtsmen in 1911 and may have played a role in Alfred's business activities, although Frank Noble was also known to have worked for the Riley Engine Company. It is thought that motorcycle manufacture phased out in 1913 and instead Noble concentrated on general mechanical engineering and repair until around 1925.

NORTON, 1904–1905 (1904–1913)
Norton Cycle & Motor Co., 3 Binley Road

Not to be confused with James Norton's famous Norton motorcycles of Birmingham, the Norton Cycle & Motor Company were first seen in the *Applications for Registration of Trade Marks* at 3 Binley Road in January 1904, as 'manufacturers of cycles, motor cycles and motorcars'. This was supported by the company also being listed in the 1905 Coventry Trade Directory as 'motorcar manufacturers and factors' but, as yet, no details of such vehicles have come to light. The man responsible was Stephen Herbert Norton (b. 1864) of Coventry, who had previously worked as a secretary for William Hillman's Premier Cycle Company. The son of a Northamptonshire baker, by 1905 Norton also went into partnership with Jonathan Stillwell at Earl Street as engravers and printers, so as to further his investments. Known to have resided with his wife Ellen at 'Ashlea' on Binley Road, it is thought that if any existed at all, his manufacturing premises would have been situated elsewhere in the city. Listed as a 'manufacturers commission agent' by 1911, the Norton Cycle & Motor Company made one last appearance, in the 1912/12 Coventry Spennell Directory, but after that the trail runs dry.

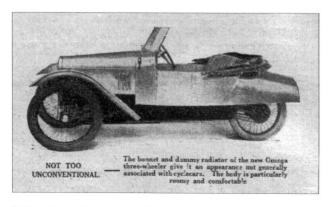

NOT TOO UNCONVENTIONAL. The bonnet and dummy radiator of the new Omega three-wheeler give it an appearance not generally associated with cyclecars. The body is particularly roomy and comfortable

William James Green ventured into the cyclecar market only briefly.

OMEGA, 1925–1927 (1913–1927)
W.J. Green Ltd, Omega Works, Swan Lane

The 'Omega' name was first introduced by William James Green after the First World War, when he began the manufacture of motorcycles at Croft Road. Born at Nottingham in 1876, it is believed he first worked for the Humber Company at nearby Beeston before moving

to Coventry, becoming secretary of the Premier Cycle Company by 1907 at a salary of £450 per year plus commission. By 1913 he decided to go it alone, finding initial premises at Little Park Street, yet as war broke out the following year this venture was cut short and Green was fortunate enough to regain his old position back at Premier. From 1919 he tried again, this time more successfully and after some six years of marketing his JAP, Barr & Stroud and in-house-powered motorcycles, added a three-wheeled car to his output whilst at Swan Lane. Chain-driven by a single rear-wheel, this Omega was powered by a 980cc twin-cylinder JAP engine, making its debut at the 1925 Olympia Motor Show, with prices ranging from £95 to £120 plus an additionaal £3 for optional front-wheel brakes. Limited production lasted just two years as the entire business was wound up.
(See also Coventry Premier.)

PAYNE & BATES, 1898–1902 (1890–1934)
Payne & Bates Ltd, Foleshill Road

Walter Samuel Payne and George Bates first joined forces in 1890 as gas and oil engineers. George Bates (b. 1847) was the uncle of Walter Payne's wife, Harriett, and following the sale of his hotel in London, offered to set Walter on his way in business. Terms were agreed and new works were constructed for him at Godiva Street, where he established the Godiva Engineering Company. Joined by his brothers, George, Frederick and Matthew Payne, it was here that Walter developed the first petrol engine in the city, in 1895. With the solicitor Sylvester Masser (b. 1849) installed as Chairman, George Bates began to steadily take a silent

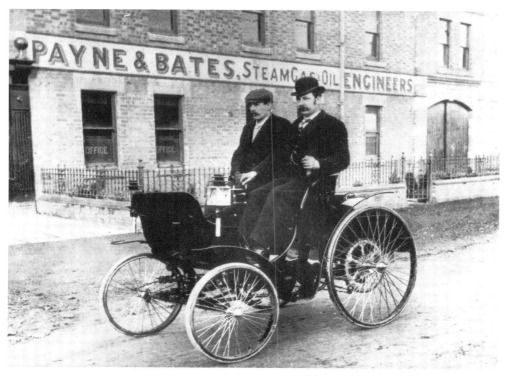

Walter Payne and Henry Bates pose briefly whilst driving the 'International' Benz type vehicle outside their Foleshill Road works.

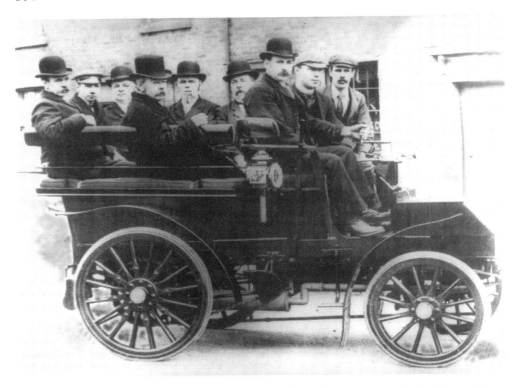

Charles Hamilton sits between Payne and Bates at the front of this vehicle – quite possibly the 'Shamrock' model with its financiers as passengers.

interest in affairs yet remained the majority shareholder. However, his son, Henry Bates (b. 1869), kept him informed of developments as he began to work more closely alongside the Payne brothers. By 1898 business was booming, and George Bates had a house built for Payne and his growing family on the Foleshill Road for them to rent. The house was quite impressive, complete with servants quarters, and was constructed by builders John and Edmond Broad of Coventry, who had also built the works for Bates on Godiva Street and, later, Foleshill Road. First making copies of the Benz model under the name of 'International' from 1898, Payne & Bates made their own 'Godiva' car from 1900, the 'Stonebow' for R.M. Wright of Lincoln, and were later approached by Charles Hamilton to build a car to his design, the result of which was the 'Shamrock'. After the death of Payne's wife Harriett in 1901, disaster struck again soon after with the death of George Bates. It was reported that in the winter of 1901, Henry Bates took his father and a Daimler employee out for a test drive in one of the latest Payne & Bates cars, yet took a corner too fast, which threw George from the vehicle and, tragically, he died as a result of the injuries he sustained. A consequence, the Bates family sold all related assets, including the Godiva Street and Foleshill Road works and the adjoining house, leaving Payne effectively unemployed and homeless. Fortunately, Payne and his brothers did own some small works, which they were able to sell, enabling them to re-establish themselves at Castle Street by 1902. From here on in Walter Payne seems to have recovered quite well and by 1905 was still in business as Payne & Company at 21 Castle Street, and still listed as a 'motorcar manu-facturer and factor' in the Coventry Trade Directory, yet details of any cars made at this time have yet to be found. Payne continued building and supplying engines until his death in 1934. Interestingly, both Walter Payne and George Bates are buried on the same plot near the gate-house at St Paul's cemetery in Holbrooks, Coventry.
(See also Cromwell, Godiva, Hamilton and Stonebow.)

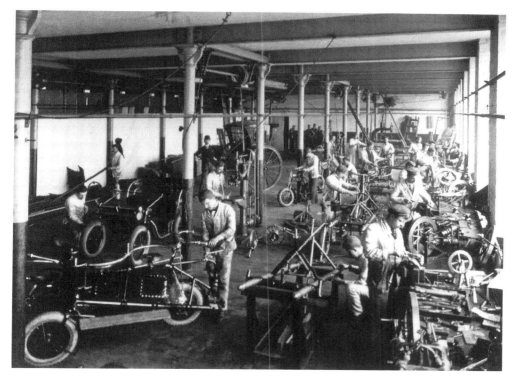

A variety of Pennington motors being built at the Motor Mills about 1897.

PENNINGTON, 1896–1898 (1895–1901)
Great Horseless Carriage Co., The Motor Mills, Drapers Field

Edward Joel Pennington was perhaps, along with Harry Lawson, one of the most notorious of individuals to have been involved in the pioneering years of the British motor industry, and his story is a fascinating one. Born at Franklin Township, Ripley County in Indiana, America, in 1858, at the age of thirteen he became apprenticed at the woodworking machinery makers J.A. Fay & Co. in Cincinnati. It was whilst here that Pennington took out the first of many patents – some eighty during the course of his eventful career, and by the early 1880s he began to display for the first time the artistry, showmanship and gab that he would become renowned for. In 1883, he was reported to have 'transformed Circleville, Ohio, into a centre of industry, on paper' – a clue to the kind of person Pennington was. For the following twelve years, he moved quickly from town to town across several states, taking out numerous patents ranging from turning lathes, pulleys and even airships, whilst forming a number of brief, if not fabricated, companies along the way. Impeccably dressed to present himself as a man of considerable wealth, it was a trick of his to embark upon a town, book several suites at the best hotel, meet with the bank manager and persuade the release of a large deposit. On producing a portfolio of patents and the promise of much-needed industrial investment, Pennington often won them over due to his confidence, charm and appearance. In reality, however, he would soon disappear with the money after little progress and without settling his hotel bills. Naturally, as the years rolled by, he struggled to keep up his act due to increased publicity. He therefore needed new ground to work on, and by 1895 he had made his way to England, and as the motor industry was only just beginning there, for Pennington it was exactly the right time. Enter Harry Lawson. After a meeting at Pennington's plush hotel, Lawson, like so many before him, had been sold a classic story, and by the time he left had parted

with an astonishing £100,000 'all in hard cash'. This time, however, there was no disappearance on Pennington's part, instead taking floor-space at the Motor Mills in Coventry. From 1896 to 1898, several Pennington motor designs actually made production, including a motor-bicycle and motor-tandem fitted with his 'long mingling spark' ignition, an armoured car and fire engine, the tubular-framed 'Torpedo', and the three-wheeled 'Victoria' model. Unfortunately for Lawson, most of these vehicles were mechanically flawed and none were sold in great numbers. Pennington was seemingly finished in Britain by early 1901, after being found out too many times. On returning to America, his past exploits began to catch up with him, being arrested in New York for unpaid hotel bills six years earlier, and by 1903 he had put up his clothes for sale in Racine, Wisconsin to settle yet another unpaid bill. As much as he repeatedly tried thereafter, he never regained the ease of fortune that he had so mastered during the 1880s and 1890s. In March 1911, whilst in Springfield, Massachusetts, he collapsed in the street and broke his nose in two places. He died three days later due to cerebral meningitis and pneumonia and was buried in a $12 grave at Oak Grove cemetery. What happened to his vast fortune remains a mystery, but, like Lawson, Pennington was actually quite a gifted engineer, but driven by wealth over natural talent. Ernest Courtis (b. 1876), who worked with Pennington at the Motor Mills, stated in 1911, 'I might say that E.J. Pennington was a good man to his workpeople, and highly respected by all of them, and undoubtedly was a first-class mechanic.'
(See also Billing, British Motor Company, GHCC, Humber, and Lawson.)

A Pennington four-wheeler vis-a-vis motor being tested at the Butts cycle track.

Another example of Pennington's varied range of motors.

PEUGEOT
(See Peugeot-Talbot.)

PEUGEOT-TALBOT, 1979–1986
Peugeot-Talbot Motor Co., Ryton-on-Dunsmore, & Humber Road

The Frenchman Armand Peugeot (1849-1915) first entered the motor market in 1889 with an experimental three-wheeled steam-powered car. By 1896 he had established the motor manufacturing company of Société Anonyme des Automobiles Peugeot at Audincourt, France. Steadily, Peugeot cars became very well known and respected throughout Europe,

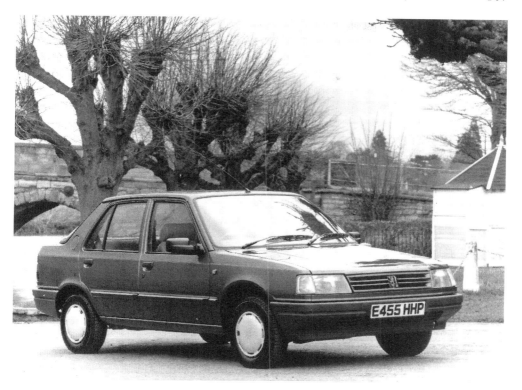

A Peugeot 309 GL model of 1988. The 309 was built at Ryton until 1993.

and by the outbreak of the First World War were the largest car manufacturers in France. Turning to arms manufacture during the war, by 1927 they took over the De Dion Company whilst continuing a string of racing successes. Following the Second World War they recommenced production of their '202' model and by the late 1950s began to try their luck in the difficult American market, whilst also sourcing new manufacturing sites in Australia. In 1975, Peugeot took over complete control of the Citroen Company, and then, in August 1978, Peugeot-Citroen bought out Chrysler's operations in Britain and France for £230m, thus providing them at that point with an 18 per cent share of the European motor manufacturing market. Unsurprisingly, the Coventry workforce were concerned regarding Peugeot's initial intentions, yet car manufacture thankfully remained, but under the new title of the Talbot Motor Company, a reassuring reintroduction of an almost forgotten Rootes acquisition some forty years earlier. As the Peugeot-Talbot Motor Company a year later, Ryton-built models included the Horizon, Solaras and the Alpine, employing some 1,350 staff at the factory by 1984. At around the same time, Peugeot proved their long-term commitment to Coventry when they announced that they were to invest some £20m into the Ryton site in preparation for the assembly of the 309 model. Becoming the Peugeot Motor Company in 1986, production at Ryton saw the arrival of the successful 405 family model, which remained in production until 1995. The 306 model succeeded the 309 in 1993, and the smaller 206 arrived in 1998, being the final Peugeot model made in Coventry before closure in January 2007. However, although Peugeot's manufacturing plants now exist outside Britain, their UK headquarters still remain in the city, located at new offices built just south of their former Humber Road site, originally the premises of the Hillman and Humber motor companies.

(See also Chrysler.)

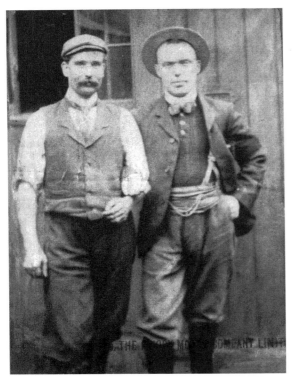

Charles Alexander Hamilton (right) is seen here whilst employed at the Priory Motor Company. Could the other man be Arthur Hallett?

PILOT
(See West.)

PREMIER
(See Coventry Premier.)

PRIORY, 1901–1905
Priory Motor Co. Ltd, 18 Dale Street & Cope Street

Established with a working capital of £5,000 in June 1901, the Priory Motor Company was yet another relatively short-lived business hoping to come good off the back of Coventry's fast-growing motor industry. Until recently, uncertainty once again surrounded those behind the origins of the firm; yet a select few can now be named. One is Arthur Hallett, born in Bedford in 1875, the son of commercial traveller in engineering. It is not exactly certain when he arrived in Coventry, but after marrying Katie Judkins in Bedford in 1898, they set up home at 20 Chester Street, Coventry. On forming his own business at Fleet Street under the title of Arthur Hallett & Company, he also joined forces briefly with Eardley D. Billing under the title of the Endurance Motor Company. After this business collapsed, some early extracts from the *English Mechanic and World of Science* confirmed his involvement in early motor production. In October 1900, he was seen to be advertising 'motorcar frames, complete with axles, springs – all ready for motors', and by February 1901 sent in particulars of a 'three-wheeler Bollee type car' that he claimed to have built for his own personal use in 1897. Also in 1900, the Coventry Trade Directory listed the Priory Motor Company for the first time, giving Arthur Hallett as secretary, and by June 1901, Middleton Crawford was seen to be Managing Director. Others known to have been connected were Charles L. Loveridge (b. 1856), and Charles A. Hamilton, whose 'Shamrock' car of 1900 was believed to have been part-constructed at Hallett's Fleet Street Works. Separately, the same 1900 directory also revealed that a Mr Henry Shaw, of Bayley Lane Chambers, Coventry, was an agent for the Priory Motor Co. Ltd in respect of their 'motor vehicles'. This relates to Henry Shaw (b. 1876), the son of John Shaw, the well-known Coventry hollow tube manufacturer. On leaving school he became a 'clerk in the cycle trade', and by 1901 was listed as a 'general manager to an engineering and cycle parts firm' residing at, interestingly, Priory House on Dale Street. It is believed that the Priory Motor Company closed around 1905 and Arthur Hallett and his wife moved to Brentford, where he became a manager of a 'taxi-cab' garage. Shaw also left Coventry and settled in Tonbridge, Kent, with his wife Emily (Roberts), securing the position of 'accountant for a firm of automobile engineers'. His older brother, James, was thought to have been behind the Cunard Motor & Engineering Company in Coventry, of which Henry was also an agent.
(See also Billing, Crawford, Cunard, Endurance, Force, and Hamilton.)

PROGRESS, 1897–1903 (1888–1915)
Progress Cycle Co. Ltd, 412–420 Stoney Stanton Road, Foleshill Road, Bishopgate Green

The Progress name began in April 1897, when Enoch John West established the Progress Cycle Company with a nominal capital of £50,000. West was born at Exhall near Coventry in 1864, the son of a silk weaver, and after serving his apprenticeship at the Singer Cycle Company joined forces with William and James Calcott in 1888 to form Calcott Brothers & West – makers of 'XL' bicycles and tricycles. After five years West broke from the partnership, and with himself as Managing Director and James George Morgan (b. 1859) as works manager, they commenced the manufacture of 'Royal Progress' cycles at their factory at Stoney Stanton Road. By this time, motor production was becoming ever more prevalent in Britain and, eager to keep up, West began the development of a small voiturette, yet it would be a further two years before he would be satisfied enough to place them on the market. When the car did make an official appearance, the Chairman of Progress Mr William Newton anticipated 'great results from this new departure'. Along with the development of motor-bicycles and quad-ricycles, these first tubular-framed two-seater vis-à-vis motors were of 2.5hp single-cylinder engines with two forward gears, of which two larger powered versions had followed by April 1900. Further works were secured to meet demand at Bishopgate Green – just a stone's throw (across the canal) from the huge Motor Mills, and on presenting four models at that year's National Motor & Cycle Show, the *Autocar* reported 'the four Progress Voiturettes exhibited are amongst the gems of the exhibition'. By 1901, seven or eight cars were being turned out per month, yet the public demand for forward-facing seats saw Progress respond by making larger two- and three-speed front-engine Tonneaus and Phaeton models ranging from 6hp-12hp. The manufacture and sale of cycles had always provided West with the means to develop the motoring side, yet a global slump in the cycle trade saw the business in dire straits, and by late 1903 further investment failed to be secured. Incredibly, some 500 variations of motors were manufactured under the Progress name, a name which Edward O'Brien, the nearby cycle and motor manufacturer, wasted little time in obtaining for 10 guineas. The Stoney Stanton Road works were later taken over by the Humber Company and the Bishopgate Green Works by the Standard Motor Company, yet this was by no means the end of Enoch John West, who, within a matter of weeks, had formed yet another company as E.J. West & Co.
(See also Academy, Calcott, Ranger and West.)

QUADRANT, 1909 (1883–1949)
Quadrant Motor Co. Ltd, Moor Street, Earlsdon

Beginning at Sheepcote Street, Birmingham in 1883, brothers Walter and William Lloyd first started out with the design and manufacture of tricycles. In the early 1900s they were joined by Tom Silver and William Priest, who possessed the mechanical engineering qualities needed to drive the business forward, resulting in the manufacture of motorcycles, initially using Minerva engines. Unfortunately the investment needed to do this was all but drained, and by 1907 the company fell into financial difficulties and the receivers were called in. A new enterprise was formed by Silver, William Priest and H.P. Priest under the new title of the Quadrant Motor Company Ltd, and, for some reason, in July production was transferred first to Meriden Street, Coventry, and then to Moor Street in the Earlsdon area of the city. At their new premises they continued to manufacture both cycles and motorcycles, and in 1909 they may also have built a lightweight cycle car. If true, then this was most probably a continuation of their belt-driven 'Pyramid' model, begun back in Birmingham in 1906, which was powered by an 8hp V-Twin JAP engine. In 1911 they opted to return to Birmingham at works at Lawley Street, yet cycle production remained in Coventry at Foleshill Road, the manufacturing rights thought to have been purchased by the established cycle agent and manufacturer Francis S. O'Brien.

nullnullnullnullnullnullnullnullnullnullnullnullnullnullnullnullnull

The Quadrant name was eventually dropped in the late 1940s, seemingly under the Directorship of Gerald Paine.

(See also Challenge and Remington.)

RAGLAN, 1899 (1889–1921)
Raglan Cycle Co., Raglan Works, Raglan Street

Established in 1889 as Taylor, Cooper & Bednell, this cycle company started out making their celebrated 'Raglan' safety bicycles at the imposing Raglan Works in Hillfields. From 1894, George Taylor, Caleb Thomas Cooper and Alfred Bednell were also instrumental in developing an electric car to the design of Charles Garrard and Thomas Blumfield. In 1896 they changed the company name to that of the Raglan Cycle Company, whilst also combining their other business of the Anti-Friction Ball Company. In 1899, they developed a prototype motorcarriage of their own, being a modified version of the International Benz motorcar, with an announcement that twelve would be made initially, yet it is believed that the 'Raglan' never made full-scale production. Always keen to have a hand in motoring developments, in 1902, the Raglan Cycle Co. also developed a motor-bicycle fitted with a 2hp Clement-Garrard engine and a forecar powered by a 3¾hp motor – both being exhibited at the Stanley Show of that year. Once again, these did not prove to be a commercial success, and Taylor, Cooper and Bednell resorted back to the manufacture of cycles, which as a business continued through to the early 1920s.

(See also Garrard & Blumfield.)

RANGER, 1913–1915 (1888–1915)
Ranger Cycle Car Co. Ltd, West Orchard

During late 1912, Enoch John West had developed a 'West' cycle car at Lower Ford Street powered by an 8hp Chater-Lea air-cooled twin engine. By April 1913, West had formed the Ranger Cycle Car Company and secured works in West Orchard, formerly used by the Centaur Cycle Company. The 'Ranger' was a chain-driven lightweight model powered by a two-cylinder 8hp Precision engine, fitted with a two-speed gearbox. West unveiled the car at the International Cycle, Motorcycle and Accessories Exhibition at Olympia in London, and although there were many similar variations of cycle car on the market during this time, reports testify that it was well received both by the public and motoring press of the time. Later models used Blumfield power units while light delivery vans also appeared under the Ranger name in 1914. No doubt the outbreak of war impacted on further production and no more were made after 1915. West, who had been working on his own 'Progress' motors from as early as 1897, was by this time aged 51, and, rather than attempting yet again to manage his own affairs, decided instead to take up a managerial post at the engine makers White & Poppe. With a career in the cycle and motor trades spanning over forty years, Enoch John West was a true pioneer of early British motoring. He died at Kenilworth in 1937.

(See also Academy, Progress, and West.)

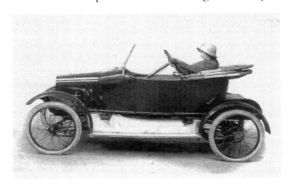

The Ranger Cyclecar of 1912. The driver is Enoch J. West's daughter, Maud.

RECORD, 1904–1905
Record Motor Co., 585 Stoney Stanton Road

Another early company lacking details is that of the Record Motor Company, thought to have been makers of cars at Stoney Stanton Road on the corner of Awson Street for a brief period at the beginning of the twentieth century. Listed under 'motor manufacturers' in the 1904 Coventry Trade Directory, no details exist regarding any actual complete car production, yet what is known is that the company did supply De Dion engines for both 'small and large makers' whilst also offering 'repairs and accessories'. It has been suggested that the manager of the company was a Mr W.H. Thomas, who rented the Stoney Stanton Road premises from the cycle manufacturers Drakeford, Randle & Cooke. On viewing the census reports, there is indeed a William Henry Thomas born at Neath, Port Talbot in 1858 that may just fit the bill. The son of a railway station superintendent, Thomas first trained as an accountant before arriving in Coventry in the late 1890s. There he found lodgings at Cox Street together with his wife Rose, gaining employment as a 'managing clerk' for a local motor company by 1901. This initial company may well have been the Motor Manufacturing Co., as the *English Mechanic and World of Science* of August 1901 reported on a Mr Thomas of MMC, relating to the impact of the growing motor industry. By 1905, Thomas was listed as living at 585 Stoney Stanton Road. It is uncertain as to when he departed the Midlands but he was known to have moved to Wembley, becoming a 'manager of a motor works' shortly afterwards. Prior to the First World War, a Record Motor Co. was seen to have operated in Manchester and made the 'Record' cycle car, yet it is unlikely that it was related to the earlier Coventry concern.

REMINGTON, 1919–1939 (1909–1949)
Remington Motor Co. Ltd, 201 Foleshill Road

This company began life as cycle manufacturers at an address known as 'Trinity Churchyard' around 1909. This location could only refer to the area around Holy Trinity Church in the very centre of Coventry, yet where the actual factory was is open for debate. Sometime later, the business moved to units at 201 Foleshill Road, an area heavily populated by similar interests. By 1919 the company had become more of a general motor engineering concern and was thought to have had an involvement in the manufacture of cars and motorcycles on a limited scale, with local trade directories consistently listing them as 'motorcar manufacturers' year after year. With regards to the name Remington, it is a complete mystery whether any individual using that name was behind the actual company. One possibility could be that of James Spencer Remington (b. 1861) of Derby, and his son Harold, who were both living and working in Coventry by 1911, James as a 'cycle clerk' and Harold as a 'motor clerk'. However, when the Remington Motor Company was wound up in 1949, it was done so along with a number of other Coventry-based companies. These included the Remington Cycle Company, the Quadrant Cycle Company, the Coventry Ensign Cycle & Motor Company, and the Coventry Mercantile Association Ltd, and in every case the Director was given as G.A. Paine. This relates to Gerald Arthur Paine, born at Ashby-de-la-Zouch in 1886. By 1911 he was seen to be living at Yew Tree House on Lythalls Lane, Coventry, employed as a 'department manager' for an unknown cycle company. Whether he had any early involvement with the origins of the Remington cycle and motor companies has yet to be confirmed.

(See also Quadrant.)

REX, 1902–1914 (1898–1936)
Rex Motor Manufacturing Co., Earlsdon Works, 222 Osborne Road

The Rex story began in 1902, when the Birmingham Motor Manufacturing & Supply Company merged with one of their suppliers, Coventry-based Allard, establishing a new enterprise called the Rex Motor Manufacturing Company at works in Osborne Road. Rex derived from the Latin word for 'King' and was chosen by its founders, brothers Alfred, Arthur, George and William Pilkington – four Birmingham engineers who had previously managed a tube metal business. It was William Pilkington (1857-1928) who instigated the merger, as he was known to have been interested in the development of the British motor industry, and purchased his first car, a Coventry-built 'Allard' in 1899. Advertising themselves as 'the king of British motors', in 1902 Rex enlarged their works and set about building a variety of three- and four-wheeled cars while also introducing their first motorcycle, a 247cc four-stroke machine. Their first cars, called the 'Charette', were built under contract for Oscar Seyd's (b. 1863) International Motorcar Company of Great Portland Street, London, and were 3.5-5hp models sold as 'British made throughout'. The company soon added former work colleagues Harold and Billy Williamson to the ranks, and, along with William Pilkington junior, Richard Lord (b. 1888), and Herbert Sarginson (b. 1874), they combined their skills to design and build quality machines of various capacities. Under their own Rex brand name, the company soon produced 10hp Broughams from 350 guineas, and 10-16hp Tonneaus from 265-385 guineas from 1903, along with a range of no less than twelve motor-bicycles. 'Rexette' tri-cars were also added from 1903, and the following year, 'Rex-Simplex' 12hp double-cylinder models were added. The popular 'Rex-Remo' arrived from 1905 – large and handsome 16-20hp cars which were sold in decent numbers until 1910. 1906 saw the introduction of the 'Ast-Rex' and 'Airex' models, and in 1909 came the 3.5-5hp 'Rex Triette' tri-car priced from 60 guineas. Among all these models, however, it had always been the motorcycles that Rex had manufactured and sold in great numbers, and with the exception of a short-lived Rex cycle car in 1912, and a Dorman-powered light car in early 1914, all later Rex motors came in the form of two wheels only. Production of cars ceased by the outbreak of war and also signalled the end of the Pilkington's involvement with the company, all assets being taken on by Coventry Acme engineer George Henry Hemingway. It

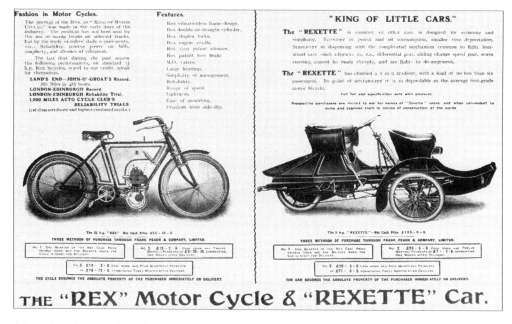

A Rex advert for 1903. Alongside motorcycles, other products such as the Rexette were offered during the early years.

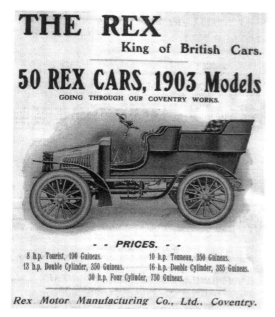

THE REX
King of British Cars.

50 REX CARS, 1903 Models
GOING THROUGH OUR COVENTRY WORKS.

- - PRICES. - -

8 h.p. Tourist, 190 Guineas. 10 h.p. Tonneau, 250 Guineas.
13 h.p. Double Cylinder, 350 Guineas. 16 h.p. Double Cylinder, 385 Guineas.
30 h.p. Four Cylinder, 750 Guineas.

Rex Motor Manufacturing Co., Ltd., Coventry.

Another Rex advert for November 1902, promoting 1903 models. The company chose to focus on motorcycle manufacture as time went on.

is unsure whether Hemmingway's new business took on any government contracts during the war, yet from 1919 motorcycle manufacture resumed and continued to be the mainstay of Rex production until their merge with the Coventry Acme Company in 1922 to form Rex-Acme – manufacturers of motorcycles themselves until 1933. However, for some unknown reason the Rex Motor Manufacturing Company were also seen listed from the mid-1920s at 287-295 Stoney Stanton Road. Categorised as 'motorcar manufacturers' there until 1936, Rex also appeared to share the address alongside the former cycle manufacturing firms of Hobart, Fulwell, and Maxim, as well as the sidecar makers Mills-Fulford. Clearly, another individual or company had been building a portfolio of wound-up company names, and the manufacture of any 'Rex' cars after the war would appear highly unlikely.
(See also Allard, Acme, Bayliss, and Williamson.)

RIDLEY, 1901–1904 (1900–1917)
Ridley Autocar Co. Ltd, Upper Well Street

The origins of this company began around 1900, with John Ridley, George Gibson and Craigie Gyle Borthwick listed as 'engineers and machinists' at Upper Well Street, Coventry. Gibson was born in Scotland in 1858, and was most probably a distant partner, as a joint patent (14,979) with Ridley in 1900 concerning 'improvements in autocars' shows Ridley to be living in Coventry, and Gibson in Birkenhead, a 'manager of a motor woks'. Borthwick also hailed from Scotland, born in Edinburgh in 1873, and by 1901 was seen to be lodging at 22 Ellys Road, Coventry, working as a 'mechanical

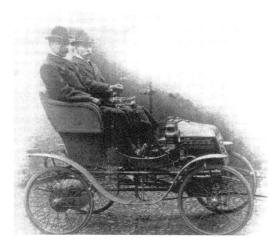

A Ridley voiturette of 1902, with Cragie Borthwick and John Ridley in the seats.

engineer – motorcar' on his own account. Ridley originally hailed from Durham, born in 1855, and was the son of a farm bailiff. After apprenticing as an engine fitter in London, he later became a draughtsman, arriving in Coventry around 1897. By the turn of the century, he and family came to be residing at 18 Ellys Road, with Ridley listed as a 'motorcar manufacturer'. Considering that he lived just two doors up from Borthwick, combined with the fact that Ridley's wife was also Scottish, would suggest that they knew one another prior to moving to Coventry. In 1901 he formed the Ridley Autocar Company at the same Upper Well Street premises, where they set about the development of driving gears, whilst perfecting their 'Ridley' Voiturette. Available

in both 3.5hp and 4.5hp De Dion or Buchet engines, the light two-seater car had a two-speed rear axle incorporating the company's own reverse gear. Production lasted until late 1904, when Ridley was thought to have found alternative work, first at Horsfall & Bickham in Manchester and then at Arrol-Johnston at Paisley. Having made the move with his family, it is then understood that Ridley commenced making his own 4-7hp cars using 'Horbick' chassis. However, by the summer of 1907 he was back in Coventry, residing at Moor Street in Earlsdon, where he was known to have developed a 'self-locking cap' for use on motor radiators and tanks. His activities for the following decade are somewhat obscure, but by August 1917 he appears in Coventry yet again, this time at Belvedere Road, where he and Alfred Herbert (later of machine tool fame) applied for a joint patent application (117,585) relating to 'rotary pumps', and, a short time after, from Glasgow with a patent application (114,337) relating to the 'propulsion of tractors'.

RILEY, 1898–1948 (1890–1969)
Riley Cycle Co. Ltd, St Nicholas Street
Riley Motor Co. Ltd, Riley (Coventry) Ltd, Castle Works, Cook Street, City Works,
St Nicholas Street, Cunard Works, Aldbourne Road, & Durbar Avenue, Foleshill

The son of a Coventry weaver, William Riley was born at Foleshill in 1851 and on leaving school became an apprentice at his father's mill, where he remained for a good number of years. In 1890, Riley, aware that the weaving trade was all but finished, bought the assets of the Bonnick Cycle Company (est. 1885) at King Street, retaining the services of Arthur Bonnick as works manager and Edward Bakewell as sales manager. When Bonnick left in 1896, the company became the Riley Cycle Company Limited, with brothers Herbert and Basil Riley joining the family business, Herbert as general manager. William was also joined by his sons Victor (1876-1958), Allan (1881-1963) and Percy (1883-1941), with Stanley (1885-1952) and Cecil (1895-1961) coming in later. In 1898, Percy and Stanley Riley took the lead in developing motorized transport for the company in the form of a De Dion Bouton type car, which was initially tested by a journey from Coventry to Stratford-upon-Avon – a test which, on completion, was deemed 'quicker than on a cycle'. The Riley Engine Company was established independently from the cycle side in 1903, and Riley motor-bicycles and tri-cars became a main concern, alongside a range of cycles. It was not until 1907 that the company really took to motorcar manufacture with a 9hp model with detachable wheels, sold through the London agents Simpson & Co. Both Aster and White & Poppe two-cylinder engines were adopted, the Aster Engineering Company offering to supply fifty of their 10/12hp 26K engines at the much-reduced price of £40. By 1911, the Riley family had well and truly left behind their weaving and cycling days, as the census reports them all to be living at 'Holly Bank' on the Radford Road and engaged fully in the motor industry. Motorcycle and cycle production phased out at around the same time, and in 1912 the company signalled its future business intentions by changing their name to Riley (Coventry) Limited, supported by the introduction of the Nero Engine Company, the '17/30' model following soon after. During the First World War, Riley assisted the war effort by making 'gearboxes, ambulance axles, and aero-engine parts', and, joined by the car designer Harry Rush (b. 1884) on conclusion of the war, the 11hp was unveiled in 1919 – the first Riley model to adorn the V-Shape radiator and the now famous blue diamond trademark. By this time located at the 'Cunard Works' at Aldbourne Road, the 1920s saw the emergence of many competition successes for the company, most notably with the 1100cc four-cylinder sports model the 'Brooklands Nine' in 1927, soon after joined by a touring version. A host of Riley models continued through to the 1930s, including as the 'Kestrel', the 'Monaco' and the 14-6, plus the introductions of the 'Falcon', 'Lynx' and 'Merlin' models, among many others. In 1936, an unsuccessful attempt was made to break into the luxury market with the 'Autovia', and by 1938 the company's resources were all but drained, being privately purchased by William Morris soon after. Fortunately, car production remained in Coventry but the factory did not escape the severe air raids of the early 1940s. Sadly, the founder of this hugely successful

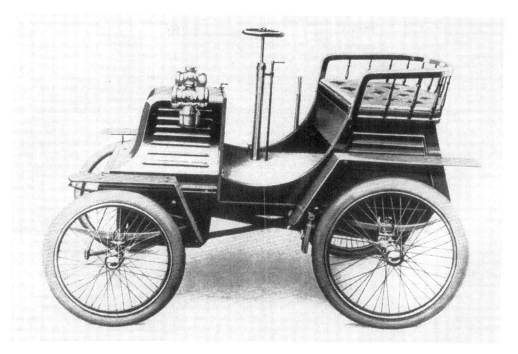

An early Riley model developed by Percy Riley between 1896 and 1898.

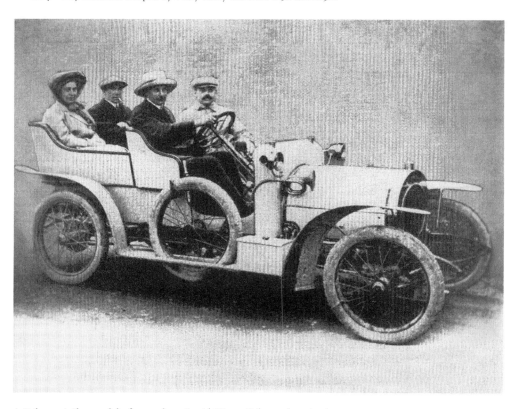

A Riley 12/18hp model of around 1908, with Victor Riley at the wheel.

company, William Riley, died on the 17th of January 1944 at Kenilworth, at the age of 93. Such was his dedication to the Riley concern that it wasn't until he was 86 that he finally retired from the board. Although from 1946 the popular 1.5 and 2.5 litre Riley models appeared, as far as production in Coventry was concerned, their final year was 1948 with the 100hp 2.5 litre drop head coupe, the three-seater Sports, and the 1.5 litre LHD saloon. The company was soon after transferred to Abingdon-on-Thames, where car production remained for the following two decades. In July 1969, it was announced that all Riley models produced at British Leyland's Austin-Morris Division would be discontinued after very poor sales of the Riley Elf, 1300, and 4/72 models. The Riley trade name is now believed to be the property of BMW.
(See also Autovia, Buckingham, and CMS.)

ROVER, 1899–1945 (1877–2000)
The Rover Cycle Co. Ltd, Meteor Works, West Orchard
The Rover Motor Co. Ltd, Meteor Works, Rover Road
New Meteor Works, Helen Street
Clay Lane Works, Stoke Row

A long-established name in motoring, the name 'Rover' in road transport terms goes back to 1885, when it was applied to a revolutionary bicycle design evolved in Coventry. James Starley (1831-1881) had been involved with the Coventry cycle industry from the very beginnings, along with the likes of Josiah Turner, William Hillman and George Singer. His early pioneering work earned him the title of 'the father of the cycle trade' and this was continued by his nephew, John Kemp Starley (b. 1855). In 1877, John established the firm of Starley & Sutton along with William Sutton (b. 1844), building 'Ordinary' cycles as well as tricycles at

One of the first 6hp Rover cars made, pictured in 1904 outside the entrance to the Meteor Works on Rover Road, leading to Queen Victoria Road.

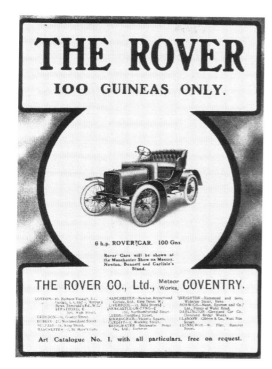

THE ROVER

100 GUINEAS ONLY.

6 h.p. ROVER CAR. 100 Gns.

Rover Cars will be shown at
the Manchester Show on Messrs.
Newton, Bennett and Carlisle's
Stand.

THE ROVER CO., Ltd., Meteor Works, COVENTRY.

LONDON—10, Holborn Viaduct, E.C.
Garage, 4, 6, and 8, Warren |
Mews, Tottenham's Rd., W.C.|
STRATFORD, E
309, High Street.
CROYDON—14, George Street.
DUBLIN—23, Westmoreland Street
BELFAST—34, King Street.
MANCHESTER—7, St. Mary's Gate.

MANCHESTER—Newton Bennett and Sons,
Carlisle, Ltd., King Street W.
LIVERPOOL—33, Bold Street
NEWCASTLE-ON-TYNE—
45, Northumberland Street.
LEEDS—Guildford Street.
BIRMINGHAM—Victoria Square,
CARDIFF—9, Working Street.
BRIDGWATER—Bridgwater Motor
Co., Ltd., Eastover.

BRIGHTON—Hammond and Sons,
Waterloo Street, Hove.
NORWICH—Mann, Egerton and Co.,
Ltd., Prince of Wales Road.
DARLINGTON—Cleveland Car Co.
Cleveland Bridge Works.
GLASGOW—Gibson & Co., West Nile
Street.
EDINBURGH—W. Flett, Hanover
Street.

Art Catalogue No. 1. with all particulars, free on request.

Advert for the little 6hp Rover of 1904.

West Orchard. By 1885, four years after his uncle's death, Starley used the 'Rover' name for the very first time with the invention of his Rover 'Safety' bicycle. This revolutionary diamond-framed design allowed cycling to become accessible to millions of people worldwide, and this style of bicycle is, by-and-large, the one still in use today. In 1888, Starley & Sutton experimented with motorized transport for the first time with an electric car, but because of British restrictions and a general lack of interest, this type of developmental work was unfortunately cut short. In 1896, the company became the Rover Cycle Company with a capital of £150,000, and under Harry Smith (b. 1863) as Managing Director, moved into new and larger premises at Garfield Road, and, two years later, began developing their first experimental motorcycles. At this time, Smith also lured designer Edmund Woodward Lewis (b. 1871) away from the Daimler Company and appointed former Pennington and MMC employee Ernest Courtis (b. 1876) as chief tester, and, in 1899,

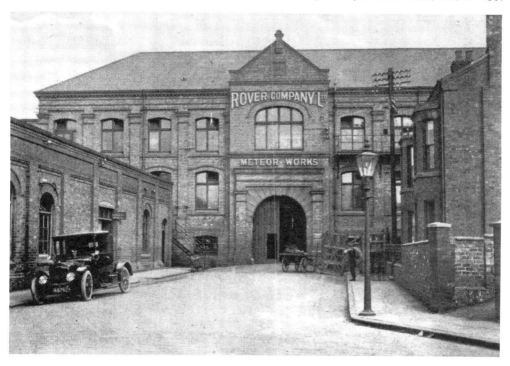

The Meteor Works of the Rover Company on Rover Road.

Rover exhibited their 'Coventry Chair' at Richmond – a De Dion-powered three-wheeler driven and steered from the rear. Sadly, John Kemp Starley died suddenly at his Barrs Hill Home in 1901, and it wasn't until 1904 that Rover began to enter full car production. This arrived in the form of a 6hp Lewis-designed model at 100 guineas, with bodies made by Hawkins & Peake under the supervision of Leonard Jackman (b. 1879). A year later the company title changed to the Rover Motor Company with a capital of £100,000, while Lewis jumped ship to work for the Deasy Motor Manufacturing Company at Parkside. Undeterred, Harry Smith pushed on with motor production with 6-8hp single-cylinder and 16/20hp four-cylinder models, making some 750 6hp cars alone, alongside 15,000 cycles. In 1907, two 16/20hp Rover cars were entered in the Tourist Trophy race driven by Edgar R. Folker (b. 1885) and Ernest Courtis, with the latter racing to victory. Motorcycle manufacture rested in 1902 but was resumed in 1911, whilst the Rover '12' car was introduced with Owen Clegg (b. 1877) as works manager. During the First World War, the factory and its 2,000 workforce were placed at the disposal of the government, making motorcycles for the Russian army, bicycles, gas shells, whilst adapting 16hp Sunbeam ambulances and 3-ton Maudslay lorries. Edward 'Ted' Commander (b. 1881), who began at Rover as a boy in 1896 rose to chief buyer by the early 1920s, whilst car production recommenced with the 'Eight' model until 1925 with over 17,000 being sold. Yet the company was struggling and shareholders were becoming restless, so in 1929, after the Rootes amalgamation of the Humber and Hillman companies, Spencer Wilks (b. 1892) became engaged at Rover as Managing Director, and through his reorganisation of the ailing business, the proud name of Rover soon became a force to be reckoned with. Before long, brother Maurice Wilks (b. 1892) also joined, and a new range of Rover models were made available. Meanwhile, the original Meteor Works were sold in 1932 and production continued at Helen Street in Coventry and Tyseley in Birmingham. By the end of the decade, Rover were selling some 10,000 cars a year, whilst in anticipation of war the government began their 'Shadow Factory' scheme, resulting in two new Rover factories being erected at Acocks Green and Solihull. Over four sites, Rover employed some 21,000 staff during wartime, mostly in the production of aero and tank engines. From October 1941, Rover also made history when they became involved in the development and production of Frank Whittle's jet propulsion gas turbines, resulting in the WB2. Rover's Coventry works at Helen Street were all but obliterated during the Blitz, yet smaller works had been retained in the city at Stoke Row. From 1945, the Solihull factory became the main site of which all future Rover cars would be assembled until the BMW takeover in 2000, yet the company continued to be listed as 'car manufacturers' in local trade directories at Stoke Row also until 1970.
(See also Deasy and Starley.)

RUDGE, 1912–1913 (1869–1940)
Rudge Whitworth Ltd, Crow Lane & 34 Spon Street

Pub landlord and engineer Dan Rudge (b. 1841) first began making bicycles in 1869 at small works in Wolverhampton, but when he died in 1880, his cycle business was bought by George Woodcock (1836-1891) and was swiftly transferred, along with a selected few of his staff, to Coventry. Woodcock had for many years been a successful partner in the solicitors Woodcock & Twist, but retired a wealthy man in 1874 and embarked on the emerging cycle trade. He did so by acquiring the early Coventry cycle firms of Haynes & Jefferis and the Tangent & Coventry Tricycle Company, combining them with the Rudge concern six years later. Involved around this time were Walter Phillips, later the MD of Humber, and Harry Lawson, later instrumental in the beginnings of the British Motor Industry. From 1880 onwards, Rudge, with all their combined expertise in the field, commenced the manufacture of cycles and tricycles, developing a great reputation over the following years due to their high quality. Becoming Rudge-Whitworth Ltd in 1894 under the leadership of Charles

Above: The imposing works of Rudge-Whitworth. The factory was cleared in the 1990s.

Right: Advert for the Rudge Cyclecar of 1912. As a company, Rudge did not seriously attempt to break into the car market.

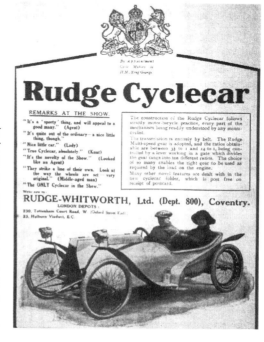

Vernon Pugh (b. 1869), unlike many of their local rivals, including the likes of Humber, Rover, and Singer, it wasn't until 1910 that Rudge entered the motor market with a 3.5hp chain-driven motorcycle, quickly succeeded by their celebrated 'Rudge-Multi' model the following year. It would be with the manufacture of cycles and motorcycles that the company largely concentrated for the next thirty years, until much of the factory was devastated during the Coventry Blitz of November 1940. However, in 1912 they did venture briefly into the light car market with a low-positioned 750cc belt-driven cycle car. With space for just two persons, the sporty-looking vehicle used many features existing on their motorcycles, including variable gears by expanding pulley, and incorporated their celebrated 'detachable wire wheels'. Prices began from £142 and although the vehicle was originally well received by the motoring press, few were sold and the project was abandoned within a year in favour of cycle and motorcycle production.

(See also Humber and Lawson.)

RYLEY, 1901–1902 (1896–1939)
Ryley, Ward & Bradford Ltd, Fleet Works, 4 Fleet Street

Messrs Ryley, Ward and Bradford joined forces in 1896 at Fleet Street, when Coventry's cycle trade was at its most prominent. There they began marketing their 'Tribune' safety cycles, over-looked by both the Royal Prince Cycle Company and the Clipper Tyre Company. Backed by the watch manufacturer Thomas J. Mercer (b. 1853), in September 1901 the company entered the motor market with a light tubular-framed shaft-driven two-speed 'Ryley' Voiturette, powered by a 2.75hp single-cylinder MMC engine. A 3.5hp MMC version followed soon after, their final three-speed model being powered by a 5hp Aster engine by late 1902. Little is known

about Bradford except that early in 1897 he became manager of their Scottish depot. Ryley, however, relates to John Albert Ryley, born in Fillongley, Warwickshire in 1861 and the son of the watch manufacturer John Ryley. By the mid-1860s the Ryley family had made the short move to Coventry, no doubt to be closer to one of the chief centres of watch manufacturing in the country. Interestingly, one of their lodgers early on was William Borthwick Smith, whose patented watch-making products were marketed by John Ryley & Co., of the Butts, Coventry. Smith later formed a partnership with James Starley and William Hillman around 1871 as sewing machine and bicycle manufacturers, working on the very significant 'Ariel' bicycle. John Ryley junior probably apprenticed in the watch trade under his father, but then chose to switch to the more promising cycle industry by the late 1880s, becoming manager of the Singer Cycle Company's depot in Glasgow, reportedly being a cyclist of some note. After the break up of Ryley, Ward & Bradford in 1904, he moved to Martineau Street, Birmingham and set up business on his own account, offering sparkplugs and carburettors among other related items. He was known to have released a 'Ryley' 6hp cycle car in 1913, and by the 1920s he had teamed up with Lionel Stapleton Lee, and, although Ryley himself died in 1931, a company called J.A. Ryley Ltd was known to have existed in Birmingham up to 1939. William Edward Ward was born 1864 in Coventry, the son of watch finisher Benjamin Ward. After finishing his education, William became an 'assistant schoolmaster' at just 18. For some reason he did not pursue a teaching career, instead becoming a clerk for the cycle makers Calcott Bros, and eventually teaming up with Ryley and Bradford in 1896. In 1903, he invented a device to display 'rotating advertisements' yet it did not reach commercial success. Unlike Ryley, Ward chose to remain in Coventry after the collapse of the partnership, and was employed as a 'manager of an iron foundry' in the city by 1911, residing with his family at Palmerston Road.

SAXON, 1902
Brandes & Perkins, St John's Street

According to the *Motor Cycling Magazine* of late 1902, Messrs Brandes and Perkins of Coventry had been '*making a feature of their Saxon light-car at popular prices*'. Possibly under the guise of the Victorian Motor Co., they provided the consumer with the opportunity of having their 'Saxon' model tailor-made to order, with an option of 6hp De Dion, Aster or Buchet engines, Crypto or Panhard gears, wood or wire wheels, and even number of seats, with competitive prices from £150 to £165. Further research into the owners first reveals Louis Brandes, born in Germany in 1872. The *London Gazette* shows that in November 1903, he and Frank Johnstone (b. 1879) had dissolved their partnership of Brandes & Johnstone – motor Engineers of St. John's Street, Coventry. It's not known exactly when Brandes arrived or departed Coventry, but a business going by the name of the Saxon Motor Company was known to have dissolved in London in 1905 which may be connected. By 1911, Brandes was indeed seen living in London, at Pimlico with his wife and family, employed as a 'salesman for motor lorries for commercial vehicle manufacturers'. Johnstone was known to have been involved in the Vernon Cycle & Motor Company, established in 1898 at Earl Street through a partnership with Brandes, Oliver Perkins established the Invicta Motor Accessories Co. in Coventry which was active until the outbreak of the First World War.
(See also Coronet and Vernon.)

SHAMROCK
(See Hamilton and Payne & Bates.)

SIDDELEY, 1902–1905
Siddeley Autocar Co. Ltd, Garfield Road, Coventry, & York Street, Westminster

John Davenport Siddeley was born at Longsight, Manchester in 1866, the son of a hosier. He was educated at the Beumaris Grammar School in Anglesey, and on completion, briefly worked for his father as a shirt cutter. A keen cyclist, he became employed by the Humber Company in 1892 as a draughtsman, until Harvey Du Cros persuaded him to take up a senior position at his Dunlop factory in Belfast. He married Sara Mabel Goodier in Manchester in 1893, and, as Dunlop expanded in England, Siddeley arrived back in Coventry to help manage the factory. Sons Cyril and Ernest arrived during 1895-96, and after gaining much experience in the growing pneumatic tyre industry, in 1898 Siddeley started up his own business at Fleet Street, under the title of the Clipper Tyre Company. To prove the quality and durability of his tyres, he personally cycled from John O'Groats to Land's End without mishap. In 1900, he competed in the 'Thousand Mile Trial' fitted again with his 'Clipper' Tyres, and in 1901 he resigned his Managing Directorship at Clipper, the business being absorbed by his former employers the Dunlop Company. The proceeds of the sale enabled Siddeley to form another enterprise, this time under the title of the Siddeley Autocar Company, at premises at York Street, Westminster, and also at Garfield Road, Coventry, overlooked by the large Rover works. Initially, he became an importer and agent of Peugeot cars, but by 1902 began to make part-British copies, using French chassis and engines completed by British-made bodies. Four 'Siddeley' models were exhibited at the Crystal Palace Show of 1903, ranging from a single-cylinder 6hp to larger four-cylinder 18/24hp versions. The 'Little Siddeley' model of 1904 was to become one of his most celebrated creations years later. It is believed that only six 'Siddeley' cars were ever built, and, not being a great commercial success at the time, in 1905 Siddeley joined the Wolseley Tool & Motorcar Company at their Crayford factory in Kent, the models being sold as both Wolseley and Siddeley autocars. He remained at Wolseley until 1909, when he once again returned to Coventry, this time to take up a new challenge with the struggling Deasy Motorcar Manufacturing Company.
(See also Armstrong-Siddeley, Deasy, and Siddeley-Deasy.)

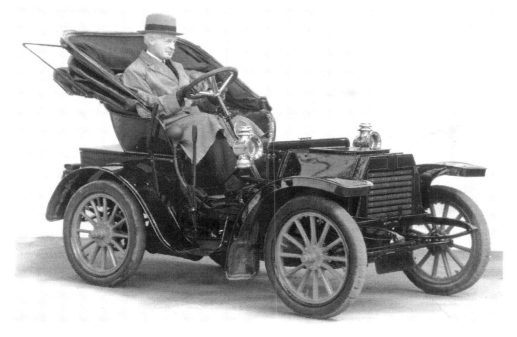

John Davenport Siddeley sits behind the wheel of one of his earlier 'little Siddeley' autocars.

SIDDELEY-DEASY, 1911–1919
Siddeley-Deasy Motor Manufacturing Co. Ltd, 51 Parkside

In 1911, with support from the board, John Davenport Siddeley transferred the name of the Deasy Motorcar Manufacturing Company to that of the Siddeley-Deasy Motor Manufacturing Company. Captain Henry Deasy had resigned in 1908 through clashes with Edmund W. Lewis, and Siddeley took over as Managing Director in 1909, quickly making his mark with the introduction of his 'J.D.S. Type' Deasy cars. From 1911, Siddeley and his growing workforce of around 500 continued to take a stronghold in the luxury car market, promoting their vehicles as 'Motorcarriages of perfect comfort'. Two prominent models stood out at this time, being the 30-36hp six-cylinder, and the 18-24hp four-cylinder, which *The Motor* recalled in 1946, 'afforded proof that luxurious motoring could be had without resorting to an excessively large engine'. Their distinctive dashboard-mounted radiators and coffin-like bonnets continued to be a trademark design feature, and, in 1912, Siddeley adopted the 'Silent Knight' sleeve-valve engines for his larger four and six cylinder models. 1912 also saw the introduction of the 'Stoneleigh' light car, a 'no-frills' economical model that sold for a number of years, and later, the commercial vehicle arm of the business. The Siddeley-Deasy model 12 was dropped in 1913, but the 14/20, 18/24 and 24/30 models were to be the most successful throughout. At the outbreak of war, it has been reported that Siddeley rounded up his workforce and encouraged every single man amongst them to stand up and be counted and enlist, his own sons Cyril and Ernest also signing up. However, when, a few days later, he received an unexpected yet lucrative order from Russia for 'Stoneleigh' Lorries, he immediately called his workforce back. From 1915 the company began making engines, ambulances and field kitchens under contract. Thomas G. John (later of Alvis) came in as works manager at this time, while the company also began to engage in the manufacture of aero engines and aeroplanes. It is also said that during the war, Siddeley employed a group of Belgian refugees, as well as a number of women in the factory, yet when the war ended, he immediately laid off his female workers. As involvement with aero engines and complete aircraft manufacture had been so prevalent

Siddeley-Deasy sales brochure, detailing the 'Althorp Special' of 1913.

during the war years, in 1919, Siddeley negotiated with the well-established Newcastle firm Armstrong-Whitworth with a view to a merger, soon becoming Armstrong-Siddeley. Overall there appears to have been two sides to John Davenport Siddeley, known by his staff as the 'Old Man'. On the one hand he was a brilliant engineer and natural leader, but on the other, he could be quite ruthless. A 1964 *Bristol Siddeley News* account described him as 'a master, leader, friend, terror, a bit of a slave driver, a very fair man, but a perfect gentleman. If you met him outside the factory with your wife he would raise his hat and know your name. He would pick up nuts, washers, and paper clips off the floor for the sake of economy, but he was a genius'. *(See also Armstrong-Siddeley, Deasy, and Stoneleigh.)*

SINGER, 1905–1945 and 1956–1970 (1874–1970)
Singer & Co. Ltd, & Singer Motor Co. Ltd, 50–54 Canterbury Street, & Ryton-on-Dunsmore

George Singer, the son of a farm bailiff, was born in Kingston, Dorset in January 1847. On leaving school he gained an apprenticeship at the marine engineers John Penn & Sons of Greenwich before moving to Coventry in the late 1860s. Along with the likes of William Hillman, John Thomas and John Icely Warman, Singer was one of the first men to be employed at the Coventry Machinists Company when they first commenced the manufacture of cycles, under the skilled guidance of Josiah Turner and James Starley. In 1873, he resigned his position of foreman and instead became works manager for the relatively small concern of Charles D.

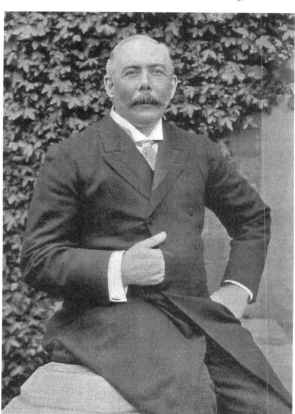

Roberts' Paragon Cycle Company. The following year, Singer married his Paradise Street neighbour Elizabeth Stringer and in partnership with his new father-in-law, James Stringer, founded their own cycle company at Leicester Street building 'Challenge' cycles. By 1883, the reputation of the company had grown, becoming one of the largest cycle firms in the country, supplying cycles to many people of note including the Queen of Portugal – Maria Pia of Savoy. As a result of such success, more production space was needed, so Singer & Co. acquired additional buildings once used by the celebrated craftsman and metal worker, Francis Skidmore at Alma Street. In the same year, the Singer workforce founded the city's first football team as Singers FC, which later became Coventry City Football Club in 1889. In 1890, Singer commissioned Charles Gray Hill to build him and wife a large house on the outskirts of Coventry, the result of which was Coundon Court, completed in 1891 and neighbouring one of the company Directors, A.E. Jagger.

George Singer, sitting on the entrance steps to his Coundon Court home.

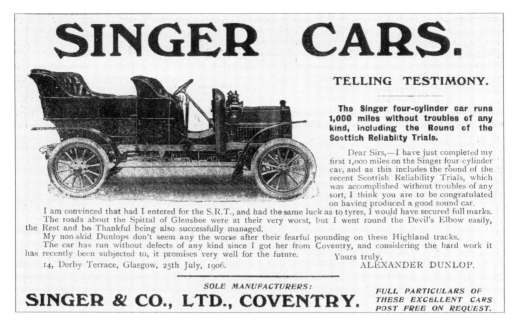

SINGER CARS.

TELLING TESTIMONY.

The Singer four-cylinder car runs 1,000 miles without troubles of any kind, including the Round of the Scottish Reliability Trials.

Dear Sirs,—I have just completed my first 1,000 miles on the Singer four-cylinder car, and as this includes the round of the recent Scottish Reliability Trials, which was accomplished without troubles of any sort, I think you are to be congratulated on having produced a good sound car.

I am convinced that had I entered for the S.R.T., and had the same luck as to tyres, I would have secured full marks. The roads about the Spittal of Glenshee were at their very worst, but I went round the Devil's Elbow easily, the Rest and be Thankful being also successfully managed.

My non-skid Dunlops don't seem any the worse after their fearful pounding on these Highland tracks.

The car has run without defects of any kind since I got her from Coventry, and considering the hard work it has recently been subjected to, it promises very well for the future. Yours truly,

14, Derby Terrace, Glasgow, 25th July, 1906. ALEXANDER DUNLOP.

SOLE MANUFACTURERS:

SINGER & CO., LTD., COVENTRY.

FULL PARTICULARS OF THESE EXCELLENT CARS POST FREE ON REQUEST.

Advert for Singer motors of 1906. The inclusion of customer letters of testimony is nothing new these days.

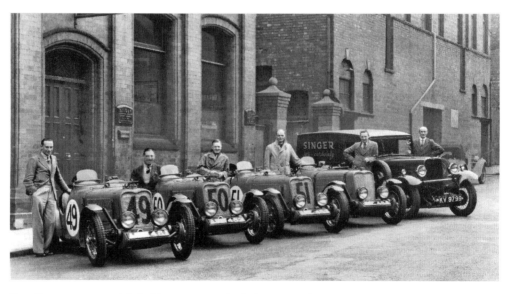

Four Singer race cars and their drivers pose outside the large Canterbury Street Works in the 1930s. Only part of the original factory exists today.

Also in 1891, Singer was elected Mayor of Coventry, a position he kept until 1894. In 1899, Edwin Perks (b. 1867) and Frank Birch (b. 1871), unveiled a unique design they called the 'Compact', by which a small engine was fitted within the confines of a wheel. This was taken up by Singer the following year as the 'Motor Wheel' and employed in the form of a motorized tricycle and bicycle, along with the services of Perks and Birch themselves. Herbert Duret (b. 1869) also joined the ranks, while variations of such motor-bicycles and tricycles continued until 1906, yet a year earlier their first four-wheeled car was marketed – a three-cylinder model

made under license from Lea & Francis. Many models followed for the next two years before the White & Poppe engine was favoured by 1909, sadly the same year in which the company founder, George Singer, died suddenly at his Coundon Court home. Two years later the small but successful Singer 'Ten' model appeared and sold in great numbers up to the outbreak of the First World War. War production then transferred to the manufacture of high explosive shells, gun sights, axles, and military light cars. The early 1920s saw the acquisition of the Coventry Premier light car along with the Read Street premises, while Singer motorcycle production was phased out. At this point, William E. Bullock (b. 1877) was works manager, while six-cylinder models were added to the range. Acquiring the Sparkbrook and Calcott businesses in Coventry, by 1927, Singer occupied five sites in the city covering 16 acres, employed some 2,600 people, and were ranked only third behind Morris and Austin as private car manufacturers in Britain. Such growth saw the opening of another factory in Birmingham, while the Coventry sites covered main car production, testing, cycle production, repair and service, coach building, and showrooms. The first half of the 1930s saw Singer produce 25-45cwt commercial vehicles and smaller cars ranging from 850-1500cc in power, until sales began to decline and the company was reformed by 1936. War then once again intervened, yet from 1945 main car production was taken up at the Small Heath works, which included the stylish but expensive 'SM 1500' from 1948. By 1951, with A.E. Hunt as MD, Singer offered three models – the 'Nine Roadster 4AB', the 'SM Roadster' for export, and the 'SM 1500' Saloon, but at a little over £1,000 it was deemed too expensive. In 1956, the Singer name was absorbed by the Rootes Group and production returned to Coventry at Ryton with the introduction of the Singer 'Gazelle', later followed by the badge-engineered 'Vogue' model. Falling under part control of the Chrysler Corporation from 1964, the final car to carry the Singer name was a sporty variation of the Hillman 'Imp', known as the Singer 'Chamois' up to 1970.
(See also Calcott and Coventry Premier.)

SPEEDAUK, 1923
The Speedauk Cycle Company, 3, Melville Road

A dubious entry, in October 1923 a Mr John William Jones appeared in the *Applications for the Registration of Trade Marks* trading as The Speedauk Cycle Company at 3 Melville Road, Coventry. Registering the 'Speedauk' trade name, his business activities were stated as concerning 'cycles, motor cycles and motorcars' yet it is unknown if any of this was actually realised, particularly considering that Melville Road is purely a residential area. Jones' origins are far from clear, yet a man of the same name from New Zealand did take out a patent in May 1921 regarding 'an improved splash guard for motor vehicles'.

SS / SS JAGUAR, 1928–1945 (1922–Present)
Swallow Coach Building Co., SS Cars Ltd, Holbrook Lane

The origins of the world-famous Jaguar name began at Blackpool in 1922, when motorcycle enthusiasts William Lyons and William Walmsley formed a partnership to manufacture sidecars as the Swallow Sidecar Company. Having secured premises at Bloomfield Road and £500 from each of their parents they began making motorcycle sidecars soon after with an initial workforce of just eight, most of whom were just boys. These early sidecars were fitted to chassis made by Montgomery's of Coventry, while extended works were found close by at Woodfield Road and John Street as business quickly grew. By 1926, a further move to Cocker Street was made as Swallow also took the decision to commence coachwork for motorcars as their workforce swelled to some thirty staff. Later that year they began building bodies for the Austin 7 chassis, an open-sports two-seater to be known as the 'Austin Swallow'. By early 1928 a saloon

Swallow 'model four' sidecars being made at Foleshill in 1929, shortly after the move from Blackpool.

An Austin Swallow car of the late 1920s. Swallow used both Standard and Fiat chassis for a time.

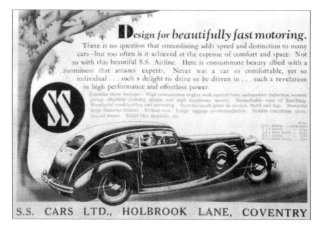

Advert for SS Cars Ltd, showing prices for the SS range prior to becoming Jaguar.

model was added, and when Lyons took one of these to the car dealer Henly's in London, he returned amazed, having agreed to supply them with 500 units. On recognising that their current factory would not be able to meet such an order, Lyons went to Coventry to find larger works, of which he did at Holbrook Lane, formerly occupied by White & Poppe. In September 1928, the company moved 'lock, stock and barrel' to Coventry, led by one of the firm's founder employees Arthur Whittaker (b. 1906). Around thirty staff were believed to have taken the brave decision to move, including Harry Teather (b. 1909), Cyril Marshall (b. 1907), Cyril Holland, Jack Beardsley (b. 1905), Harry Gill (b. 1907), Richard Binns (b. 1905), Arnold Hollis (b. 1896), Jim Greenwood (b. 1903), Joe Yates, Fred Gibson (b. 1907), Wilfred Webb, Jack Chandler, and the Marshall brothers of Wolverhampton. Working all hours, by December 1928 they were producing some fifty bodies per week, and by the following year had acquired further space on site and added 9hp Standard, Swift, and Wolseley Hornet Swallows to a production of some 100 per week, whilst over fifty obsolete Fiat chassis were likewise utilized. During the early 1930s, Lyons designed a new chassis built by the Standard Motor Company using 16-20hp Standard engines, complemented with a low, elegant, stylish body, which was to become the 'SS1' model. Unveiled at Olympia in 1931, the *Daily Express* reported, 'the car with the £1,000 look for £310.' Changing the company title slightly to the Swallow Coach Building Company, Lyons persuaded former Humber man William Heynes to join as chief designer, supported by Harry

Westlake, while the SS1 became an instant hit with the buying public. Several variations of the SS marque followed and by late 1934, SS Cars Ltd was formed as a separate concern to the coach building side. 1935 became a significant year, as not only did founder partner William Walmsley retire, but it was also the year the 'Jaguar' name was used by the company for the first time as the 'SS Jaguar'. Variations of this sensational car continued up to the outbreak of war, when the factory became busy transferring production to that of making fuselages for Stirling bombers and the first Meteor jets, as well as general repair work to Whitley bombers. On conclusion, the coach building business was sold and SS Cars Ltd became Jaguar Cars Ltd in 1945.
(See also Jaguar.)

STANDARD, 1903–1963 (1903–1963)
Standard Motor Co. Ltd, Conduit Yard, 128–129 Much Park Street, Foleshill Road, Canley, & Banner Lane

Following on from the foundation of his cousin's Maudslay Motor Company in 1902, a few months later the engineer Reginald Walter Maudslay was able to purchase some modest works off Fleet Street in Coventry, after being backed by the celebrated engineer Sir John Wolfe Barry (1836-1918). Reginald Maudslay was born in London in 1872 of wealthy stock, his father, Athol Edward Maudslay (1846-1923), being a landowner and author, and grandson of the machine-tool engineer Henry Maudslay (1771-1831), while his mother Kate was the daughter of Sir Thomas Lucas, a successful building contractor. He was educated at Moffat in Scotland and Marlborough College in Wiltshire, and on completion he trained as an engineer under Wolfe-Barry, famed for many civil engineering projects including Tower Bridge in London. On moving to Coventry, the initial purpose of the operation was to purchase and examine foreign-made one and two cylinder cars, and, soon after, more substantial factory accommodation was sourced at Much Park Street, a street with several hundred years of history and adorned with many timber-framed buildings. Registering the Standard Motor Company in March 1903 with a nominal capital of £5,000, production commenced with an initial workforce of just six but with input from the Maudslay Motor Company's Alexander Craig (b. 1873). Also joined by former Velox and Humber designer John Budge (b. 1875), early models consisted of single-cylinder engines with three-speed gearboxes, and within the first year six cars were produced. Two, three and four-cylinder models soon followed, and, by 1905, the first six-cylinder model was offered. Charles Friswell (b. 1872), the London-based engineer and motor agent, was so impressed by Standard models as seen at Crystal Palace that he agreed to represent them, becoming Chairman two years later. In December 1906, the company moved to better-equipped premises on Foleshill Road, formerly occupied by Enoch J. West, and began making 16-20hp, 24-30hp four-cylinder cars, and a limited number of six-cylinder 50hp versions. The well-known Standard 'British-Ensign' appeared on all models from 1908, while Friswell's input helped broaden the appeal of Standard models, and, in 1911, they supplied seventy cars to King George V for a state visit. Friswell sold his shares in the company soon after, being replaced by Siegfried Bettmann of Triumph and the solicitor Charles J. Band. Between 1914 and 1918 Standard were engaged in the production of 'airplane parts, drag washers, artillery wheel hubs, water pumps, gearboxes and steering gear units' as well as over 1,000 aircraft, and, following the war, saw a move to open space at Canley, which they had developed from 1916. The first cars to be produced following the hostilities were 1.3 litre versions of the 'SLS' model, initially introduced in 1913, and by 1922 an Americanised assembly track was incorporated at the Canley plant as the company grew stronger, making 10,000 cars per year by 1924. By 1927, former Morris Engines employee Alfred Wilde joined the company to work on the successful Standard Nine model, and two years later saw the appointment of Captain John Black from the Hillman Motor Company to drive the business forward through the difficult times of the early 1930s. Standard's founder, Reginald Maudslay, died in 1934, but the enterprise he created prospered and in 1936 the *Autocar* reported that over £350,000 was being invested to enlarge the

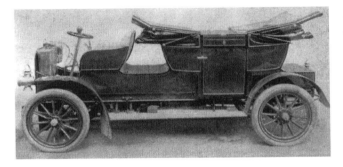

An early Standard Brougham model, powered by a 3-cylinder water-cooled engine.

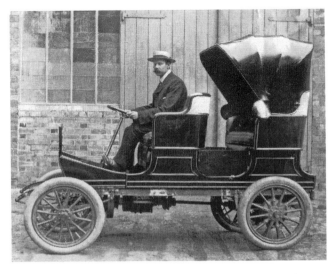

Another early Standard model of 1903, this time only part complete.

An excellent image from 1925, showing staff from Standard's Dispatch Department while at Canley.

Canley site, while the company were producing an incredible 34,000 cars per year. Between 1939 and 1945, war production once again resumed in the form of armoured vehicles, aero-engines and fuselages, and, perhaps most famously, over 1,100 Mosquito aircraft. Following the war, Standard acquired the Triumph Motor Company as a subsidiary concern and also began the production of Ferguson tractors at their Banner Lane works from 1946. By 1951, Standard employed a workforce of over 12,000 at three sites and was producing an incredible 112,000 cars a year, mostly down to the enormous success of the 'Vanguard' saloon, introduced in 1947. In 1961 the company, by this time known as Standard–Triumph International Ltd, was purchased by Leyland and in May 1963 the last car to carry the famous Standard name, the Ensign, rolled off the Canley production line. Under Leyland, and subsequently British–Leyland, Triumph cars continued to be built in Coventry until 1980, when taken over by Austin-Rover, and today both the 'Standard' and 'Triumph' names are owned by BMW.

As a point of special interest, one particular early employee of Standard is still celebrated by a famous English football team to this day. The Scotsman David Danskin (1863-1948) first became engaged at the Standard Motor Company in 1907 and remained there for the rest of his working life. However, back in late 1886, while working as a fitter at the Woolwich Arsenal Munitions

Factory, Danskin instigated a collection amongst workmates in order to purchase a football. The money was raised and the Woolwich Arsenal Football Club was formed, with Danskin himself as Captain. Arsenal went on to win their first league title in 1936, and Danskin retired from Standard soon after.
(See also Ferguson and Triumph.)

STANDARD-TRIUMPH
(See Standard and Triumph.)

STARLEY, 1888
J.K. Starley & Co., Meteor Works, West Orchard

John Kemp Starley was born at Walthamstow, Essex in 1856. He was sent to Coventry by his father at the age of 17 in 1872 and given employment at his uncle James Starley's cycle works, working on the manufacture of the significant 'Ariel' cycle, among other things. By 1878, he had joined forces with William Sutton, forming the partnership of Starley & Sutton at the Meteor Works at West Orchard as 'machinists and cycle manufacturers'. In 1885, J.K. Starley began developing his 'Rover' Safety bicycle, which he had all but perfected by 1888. This style of bicycle steadily phased out the popular 'Ordinary' bicycle and was soon copied by all future cycle manufacturers the world over. Also in 1888, Starley developed a three-wheeled tri-car powered by electricity, steered through a spade-handled bathchair lever. The motor and accumulators were supplied by Elwell-Parker of Wolverhampton and the carriage itself built by Henry Hollick of Coventry. Unfortunately for Starley and his team, the carriage was built at a time when motorized vehicles were not allowed to be driven in England at more than four miles an hour. To counter this, Starley shipped it across the Channel to be tested at Deauville, France, where it was said to have 'proved satisfactory and averaged about 8mph'. For some

John Kemp Starley was famed for his involvement in the development of the safety cycle.

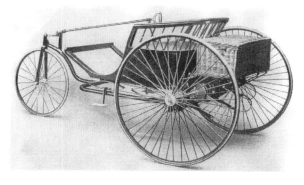

The Starley Electric Tricar of 1888. Due to British restrictions, this machine had to be tested in France.

unknown reason though, Starley never pursued the idea. Although it was with the manufacture of cycles that he ultimately sought to perfect, Starley still maintained an interest in motorized transport and was Managing Director of the Rover Cycle Company when they first commenced manufacture of motor-bicycles in 1898. In the same year he applied for the patent (25,807) relating to the 'driving gear of auto cars'. Sadly, John Kemp Starley never saw the first 'Rover' badged cars of 1904, as he died suddenly at his 'Barrs Hill' home three years earlier.
(See also Hollick & Pratt, and Rover.)

STONEBOW, 1900–1901
Payne & Bates Ltd, Foleshill Road
R.M. Wright & Co., Guildhall Street & Newland Lane, Lincoln

Walter Samuel Payne and Henry Bates made a number of experimental motors around the turn of the century at their Foleshill-based factory. One was given the name of 'Stonebow' by the company of R.M. Wright of Lincoln, and sold through their cycle and motor agency at Guildhall Street. The name was chosen after the Stonebow, an ancient gateway to the Guildhall which happily still stands in Lincoln to this day. Incidentally, R.M. Wright as a person was thought not to exist, but was a title used by a Mr Albert Dyke for cycle racing purposes as well as for his agency, apparently because some members of his family frowned upon such activities. Albert George Dyke originally hailed from Penkridge in Staffordshire, and trained as a baker and confectioner on leaving school. He moved to Lincoln with his parents during the 1880s, where his father found work in a brewery as a labourer. Albert worked initially as a confectioner at Lincoln but began to take up more of an interest in cycling, opening up his own cycle sales agency by the mid-1890s. By the late 1890s his business also began to sell motors and he became a founder member of the Lincolnshire Automobile Club. One

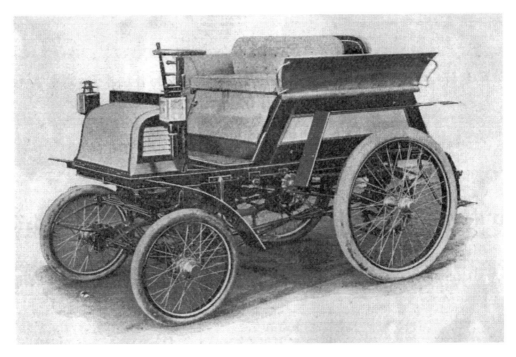

The Stonebow dogcart of 1900, as made by Payne & Bates for R.M. Wright & Co. of Lincoln.

such motor sold at R.M.Wright's was Dyke's self-labelled 'Stonebow' by 1900. This Coventry-made, four-seated dos-a-dos type was powered by either 5 or 7hp front-mounted two-cylinder engines, with double chain drive. It is thought that very few were actually sold on, but R.M. Wright & Co., 'Motor Pioneers', were still seen to be in full operation ten years later, offering 'Stonebow' cycles among many other cycle and motor makes, and having the 'largest garage and best equipped works in the county'. Records show the company was wound up in 1931. *(See also Payne & Bates.)*

STONELEIGH, 1912–1932
Siddeley-Deasy Motorcar Co. Ltd, Parkside
Stoneleigh Motors Ltd, Parkside

The 'Stoneleigh' name was first introduced in 1912 as a sister company to Siddeley-Deasy at Parkside, at that time under the supervision of John Davenport Siddeley. Designed by Deasy draughtsman Bernard W. Shilson (b. 1883) of Guernsey, the initial intention was for the Stoneleigh to become the light and commercial motor manufacturing arm of the business, and a number of experimental commercial versions were known to have been developed particularly during the First World War, many of which found their way to Russia. However the first Stoneleigh light cars consisted of 12hp models at the rather expensive price of £350, and were reported to have been 'almost identical to the BSA cars being assembled by Daimler around the same time'. Following the War, Stoneleigh Motors fell under the control of the Armstrong Siddeley Company and commenced production of even more basic two and three-seated versions powered by small 998cc V-Twin engines at the cheaper prices of £155-£165. It would appear that the Stoneleigh was a product not very highly regarded by those who were involved, being labelled a 'wash tub' and even 'sack of potatoes car' by some. However, Harry Crook (b. 1896) recalled in 1956 that one was driven up Mount Snowden –

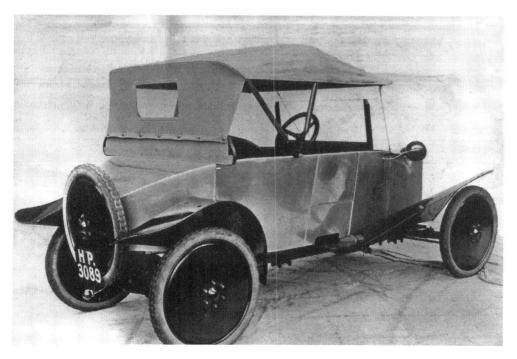

A near-complete Stoneleigh model of 1922.

the first car to do so, while another completed the 1923 Lands End Trial. Others known to have been involved included William Green (b. 1903) and later, Bernard G. Chatwin (b. 1908). Considering the fact that these Stoneleigh light cars were never built or sold in great numbers, makes it all the more surprising that as an operational business it lasted until 1932. After this time Armstrong-Siddeley concentrated their efforts firmly on larger, more powerful and stylistic cars.
(See also Armstrong-Siddeley, B.S.A., and Siddeley-Deasy.)

STURMEY, 1907–1912
Sturmey Motors Ltd, 230–250 Widdrington Road

After taking the decision to close the Duryea Company in January 1907, Henry Sturmey began Sturmey Motors Ltd with a nominal capital of £60,000. Managed by Ernest Groves, one of their first offerings was the 'Napier-Parsons' light delivery van, before establishing the 'Lotis' marque around 1908. Groves, born at Weymouth in 1864, apprenticed as an engineer in Richmond before later taking over the brewery of his father, Sir John Groves – the last man to receive a Knighthood from Queen Victoria in 1900. After a slump in the brewery trade, it is thought that Sturmey offered him the managerial position in Coventry, and by 1907 he was known to be living in the city at Manor Road with his family. The 'Lotis' was to become the main product of Sturmey motors, appearing in many private and commercial guises over the following four or five years of production. Initially these models were powered by 10/12hp and 12/18hp two-cylinder engines as supplied by the nearby Riley Engine Company, but from around 1910, White & Poppe motors were preferred, ranging from 18/21hp to 25/32hp. In January 1911 a new Lotis model was announced, again using a four-cylinder White & Poppe engine upon the usual chassis, Bosch magneto ignition, automatic pump lubrication, and patent 'everlasting gear'. Many of these models were uniquely designed and sold around the world as taxi-cabs, a service that was quickly growing by the day. Other Sturmey Motors commercial

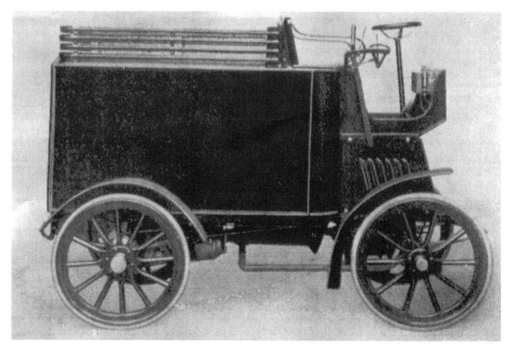

The 'Napier-Parsons' 8hp van of 1907, as offered by Sturmey Motors.

products found their way to the Australian out-
back, Brazil and South Africa, while Sturmey
also introduced a special motor hearse. From
the beginning, in 1907, all bodywork had been
built and supplied by Hewers Bodies Ltd, yet
another Sturmey controlled company managed
by Edward Hewer (b. 1867), a vastly expe-
rienced coachbuilder formerly employed at
Daimler. In October 1911, Groves left the com-
pany and along with his family made a new start
in Canada, his daughter Winifred going on to
marry the Bishop of Calgary – Harry Richard
Ragg – in 1914. Sturmey Motors continued
to trade until they ran into difficulties in 1912,
and was reinvented as British Business Motors
soon after. Sturmey then concentrated on his
Bramco business until closure in 1923, but the
contribution he made to the British motor
industry should not be underestimated. Born
John James Henry Sturmey in 1857 at Norton-
sub-Hamdon in Somerset, he was educated at
Weymouth College. Specialising in both sci-
ence and mathematics, he first became master at
Brynavvor Hall College in Towyn, Wales before
being appointed at Coventry College School at

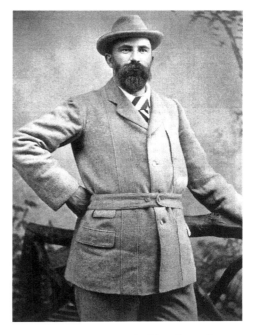

Henry Sturmey was highly influential
in both the cycle and motor trades.

King Street in the mid-1870s. A keen cyclist, in 1877 he published the *Indispensible Bicyclists
Handbook* and through this became associates with William Illiffe – a Coventry printer and pub-
lisher. In 1879, the two joined forces with the creation of the popular magazine *The Cyclist*, and,
by 1881, Sturmey was listed as 'schoolmaster, author and editor'. In 1889 he became first editor of
Photography magazine, and by 1895 established the *Autocar* – the first journal of its type devoted
to the advancements in motor-powered vehicles. At around the same time he came into con-
tact with the likes of Harry Lawson and Edward Joel Pennington, becoming a shareholder and
promoter of both the Daimler and Great Horseless Carriage companies, eventually succeeding
Lawson to the position of Daimler Chairman. Accompanied by the works mechanic Richard
Ashley, in October 1897 he set out on a 1,600-mile journey from John O'Groats to Land's End
in a Daimler, the body of which was designed by Sturmey himself. After many months of board-
room struggles he resigned his position from Daimler, and from 1902, with the inception of his
Duryea and British American Components businesses, he concentrated thereafter on managing
his own affairs until the early 1920s. When appointed as columnist to *The Motor* in 1904, he
had taken out over thirty motor-related patents, and was described by the editor as 'one of the
foremost pioneers of the motor movement' and that 'few men connected with automobiles have
had more practical experience or gained a more extensive knowledge of the industry'. He died
at his home in Quarry Close, Coventry in 1930 having never married.
(See also Bramco, British Business Motors, Daimler and Duryea.)

SUNBEAM-TALBOT, 1946–1956 (1901–1956)
Sunbeam-Talbot Ltd, Ryton-on-Dunsmore

The Sunbeam name was founded in 1888 in Wolverhampton by the cycle manufacturer John
Marston (b. 1836). The first production 'Sunbeam' car came about in 1901 in conjunction with
Maxwell Maberley-Smith (b. 1869), and four years later the Sunbeam Motorcar Company was

formed. In late 1908, Louis Coatalen joined the company as chief designer, having spent the previous two years working for William Hillman in Coventry. Coatalen quickly stamped his mark on the business, making profitable changes to in-house production techniques, whilst designing the shaft-driven 14/20 model and spearheading Sunbeam's racing obligations. During the First World War, the company adapted production to that of military motorcycles, ambulances and trucks, and by 1920 had merged with the French motor firm Darracq, who only the year before had acquired the Clement-Talbot brand. The result saw the new name of STD Motors (Sunbeam-Talbot-Darracq) being formed. After some fifteen years covering the production of several popular sports models, by 1935 STD Motors went into receivership. The Rootes brothers, who were busy building their British motoring empire, bought both the Talbot and Sunbeam assets, creating the new company of Sunbeam-Talbot by 1938. The first Sunbeam-Talbot models were made in London, but the arrival of the Second World War delayed progress until 1946, when full production commenced in a section of the Ryton factory. Within two years, seven Sunbeam-Talbot models were available, mostly derivatives of the existing Hillman and Humber range. The 1950s saw many motor racing successes for the Sunbeam-Talbot name, particularly the Monte Carlo Rally of 1955, in which a Sunbeam-Talbot 90 model was the outright winner. Racing driver Michael Parkes (b. 1931), the son of Alvis MD John J. Parkes, worked on such cars as well as the 'Imp' model, until joining Ferrari in 1963. The Talbot name was dropped in 1956, but popular Sunbeam cars such as the 'Rapier' were built at Ryton through the Rootes Group and their successors until the early 1980s, the final offering being the Sunbeam Lotus-Horizon.
(See also Chrysler, Hillman-Coatalen, and Peugeot.)

SUPERCAR, 1937–1940 (1923–1950)
Supercar Co., Progress Works, Stoney Stanton Road

To date, very little is known about the Supercar Company, listed in local trade directories as 'manufacturers of small motorcars' at the Progress Works in Stoney Stanton Road from 1937 to 1940. It would appear that this business was a continuation of the Coventry Babycar Company, who were known to have also been at the Progress Works from 1923 as 'manufacturers of baby carriages, invalid carriages and bath chairs'. The Progress Works were significant in that some forty years earlier, Enoch John West had been making pioneering examples of motor-

A simple yet interesting advert for the Supercar Company of Coventry in 1937.

ized road transport there. However, concerning Supercar, small may have been really small, as an existing 1950 photograph of a car made by the Supercar Co. (Coventry) Ltd, of Gunnery Lane, Leamington shows a child's pedal-type vehicle. Whether these were motorized is so far unknown, but it appears to be of the racing type that young boys would have found extremely appealing. The Coventry address was later taken up by the well-known magneto makers British Thompson Houston before they relocated to Rugby. The Progress Works was situated at the end of Causeway Terrace, seemingly sharing premises with the Winfray Engineering Company and the machine tool makers Donald Hinton Limited during the three years of supposed car production in Coventry, which may suggest a possible connection.
(See also Progress.)

SWALLOW
(See SS/Jaguar.)

SWIFT, 1898–1931 (1868–1955)
Swift Motor Co. Ltd,
Swift of Coventry Ltd, 15 Cheylesmore, & Quinton Works, Parkside

The Swift name is one that can not only lay claim to being associated with the first cycle manufacturers in Coventry, but also arguably in Britain, directly descending from the Coventry Machinists Company which began making velocipedes in late 1868. Of that claim, many great names in the field of cycling and motoring were born as some of the company's early employees included James Starley, George Singer, William Hillman, Thomas Bayliss and a host of others. After nearly thirty years of reputable cycle making, in 1897, Birmingham-based Dunlop took over the Coventry Machinists with a principal capital of £370,000, re-establishing the business as the Swift Cycle Company Limited on their original Cheylesmore site. Lord Randolph Churchill was appointed Chairman of this new concern, while the Irish brothers Harvey and Arthur Du Cros were placed as Directors, along with the Coventry watch manufacturer Joseph White. Closely connected to the Ariel firm of Birmingham, Swift's first motorised machine of 1898 took the form of a De Dion Bouton-type tricycle powered by a 1¾hp engine mounted ahead of the rear axle. Becoming the Swift Motor Company in 1902, the first full-production cars were single-cylinder models along with a line of motor-bicycles and cycles, all exhibited at the 8th Motorcar Exhibition at the Agricultural Hall, London. Former Rudge foreman William Radford (b. 1873) was at this time works manager, and was well assisted by the likes of Robert Burns (b. 1869) and Arthur E. Tomlinson (b. 1874), among others. From 1904, Radford took the lead in designing 7-10hp twin-cylinder models using the company's own engines, and between 1906 and 1912 produced a variety of two-, three- and four-cylinder cars of different sizes. As well as continuing a range of cycles and motorcycles, the company's concentration on car production intensified and by 1913 they also released a 3½hp water-cooled cycle-car as well as the large 3-litre '15' model. Motorcycle production ceased during the First World War and Swift adapted manufacture to that of making 'belt filling machines, pipe boxes, flanges, drag washers, and axle caps for gun carriages'. In 1919 the company name changed once more, this time to Swift of Coventry Limited in order to merge cycle and car production, with Charles Sangster (b. 1873) installed as Chairman soon after. Car production resumed with the '10' model, and for the rest of the decade Swift created a number of well-built variations, yet found it increasingly difficult to compete with the cheaper and more popular motoring names of Austin, Ford and Morris. In 1930, their last gasp attempt was the 850cc Coventry-Climax-powered 'Cadet' model priced at £150, but it was too little too late and the company was forced to close soon after. The famous 'Swift' name was quickly acquired by the Birmingham cycle makers Kirk & Merrifield, who continued to make and sell bicycles at Ballsall Heath under the brand until

Swift cars being tested on a bleak day outside the company's Parkside factory.

Sales material from Frank Peach & Co., detailing Singer cars of 1905.

the 1960s. After the devastation suffered during the Coventry Blitz, very few central factories survived the intense bombardment not to mention the following clearances through redevelopment, yet, incredibly, the frontage of the Swift Works survives to this day as a hotel.
(*See also Ariel and White & Poppe.*)

TALBOT
(*See Peugeot-Talbot.*)

TAYLOR-SWETNAM, 1912–1913
Taylor-Swetnam & Co., Albert Street

This very short-lived company existed at Albert Street in the Hillfields area of Coventry prior to the First World War, where they produced and marketed their 'Taylor-Swetnam' light car. The two-seater vehicle was said to have been powered by a twin-cylinder engine of the company's own make and capable of 50mph, with shaft-drive and a three-speed gearbox. At £140 it wasn't too badly priced, and although a four-cylinder French-powered version was intended for 1914, the impending outbreak of war no doubt quashed all plans. The founders of the business were Frank Taylor and George Swetnam, and although Taylor's background is not certain, there is one man in the census reports that very likely fits the bill – Frank Taylor, born in Coventry in 1872 and the son of a West Bromwich blacksmith. By the mid to late 1880s, Taylor found work at one of Coventry's many cycle companies and remained in the trade for more than twenty years. By 1911, he was living with his wife and family at Freehold Street in Hillfields and working as a 'mechanic at motor works'. The other half of the partnership is confirmed as George Rupert Swetnam, born in Coventry in 1880, the son of another Staffordshire blacksmith. Again, it is likely that George too gained experience in the cycle industry, but by the turn of the century was listed as a 'mechanical motor draughtsman' and living at Canterbury Street. Considering this, perhaps Swetnam devised the ideas and Taylor made them happen. Which motor company Swetnam was working for at this point is not known, but in 1908 he teamed up with Frank Egerton Walker (b. 1882) and they took out a patent (17,490) regarding 'improvements in carburettors for internal combustion engines'. It is thought that Swetnam went into partnership with Taylor around 1912, yet chances are they had been acquainted with each other at a Coventry motor works long before.

T.G. JOHN LTD
(See Alvis.)

TITAN, 1910–1913
Titan Motor Wheel Co. Ltd, Court 33, Gosford Street

Another short-lived pre-war entry, the Titan Motor Wheel Company was thought to have begun around 1910 in Coventry. The man behind the business was John Archibald Forrester, born in Keswick, Cumbria in 1874. After completing his schooling, he apprenticed under his father as a coach builder, the family having by this time moved the twelve miles to Crown Street, Cockermouth. Forrester clearly took his occupation seriously, as at the young age of 23 he applied for a patent (27,096) concerning 'improvements relating to wheel hubs for chain driving vehicles'. The following year, in 1897, he married Caroline Marsh in South Shields, having two children in quick succession before the turn of the century. The family then moved to the Midlands, settling first at Stetchford, where John was seen to be working as a 'commercial traveller in timber'. A third child arrived in 1903 and, at some point soon after, Forrester took the decision to make the short move to Coventry, where the motor trade was quickly growing both in size and reputation. He most probably found work at one of the city's many motor or coach building firms initially, but by 1910, with the family settled at 27 Carmelite Road, he gambled on starting his own business. This he called the Titan Motor Wheel Company, finding adequate premises at Gosford Street and sharing the same court with both the Arno Motor Company and the Regent Motor Side Car Company. There he set about making a three-wheeled ash-framed model, powered by a 5¼hp single-cylinder Fafnir engine. It had a three-speed epicyclical gear with final chain-drive to the rear wheel, and was priced relatively cheaply at £78. No doubt Forrester, with his experience in coach building, made the body

himself, with the remaining mechanical parts being sourced elsewhere, but, unfortunately, the venture was not to be as the Titan business closed around 1913. Forrester must have gone on to work for another Coventry related company, as he and family were still seen to be living at his Carmelite Road address by 1919/20, and residing at 55 St Patrick's Road by 1934. He died at Nuneaton, Warwickshire in 1959, aged 85.

TRIUMPH, 1923–1980 (1885–1984)
Triumph Motor Co. Ltd, Clay Lane, Holbrook Lane, Priory Street, & Canley

The Triumph story began in England in 1885, when Siegfried Bettmann started export-ing British-built bicycles using the 'Triumph' name under the business title of Bettmann & Company. Born in Germany in 1863, Bettmann moved to England at the age of 20, and within three years formed a partnership with Mauritz Johann Schulte (b. 1858), a friend and fellow German who had recently trained at William Andrews' cycle factory in Birmingham, the source of their previous export business. At this time, Coventry was very much the centre of British cycle production, so Bettmann and Schulte wasted little time in moving there, finding suitable premises to rent at Much Park Street. By 1894, Bettmann and Schulte had built a much larger factory at Priory Street as the cycle business rapidly expanded, yet keen to keep up with the very latest motoring developments, in 1895 Schulte had a German-built Hildebrand-Wolfmuller 2½hp motorcycle shipped to Coventry and studied its make-up in great detail. This was the world's first motorcycle to be produced and sold commercially and it created quite a stir in the city. Although at this point Triumph were arguably the largest cycle firm in the country, they also quietly experimented in motorcycle production, yet waited patiently until they were satisfied with a quality product. This came about in 1902 with the release of a suitably modified bicycle frame fitted with a 2¼hp Minerva engine, the overall finish of which was of very high quality, yet the machinery itself unreliable. However, this was all but perfected soon after, and Triumph went on to become one of the greatest names in motorcycle manufacture. Regarding the pro-duction of cars, however, although Schulte had been eager to make a start, Bettmann refused to do so whilst cycle and motorcycle production continued to prosper. Instead, Bettmann became involved in a separate motoring enterprise called Climax Motors in Coventry from 1904, yet after heavy personal investment the company was scrapped just three years later. His next involvement in car manufacture came in 1912, when he became a board member of the grow-ing Standard Motor Company, yet, although holding the highly respectable position of Mayor of Coventry, due to his German roots he was voted off the board during the early stages of the First World War. In 1917 Schulte resigned from Triumph and was succeeded two years later by Captain Claude Vivian Holbrook (b. 1886) who, by 1922, eventually instigated the production of cars in works formerly occupied by the Dawson Car Company at Clay Lane. A few months later the Triumph 10/20 appeared, a 1393cc Ricardo-powered car designed by Arthur Alderson, not too dissimilar to the failed Dawson model. Several variations followed, but it wasn't until 1927 that the company released a really marketable product – the 'Super Seven' model, a popular 832cc light car for £150. Before long, Triumph were making around 100 Super Seven cars per week, and the number of staff was increased to about 1,850. The company struggled through the Depression of the 1930s, and after some forty-seven years leading the Triumph brand, Siegfried Bettmann resigned from the company on his 70th birthday in April 1933, yet remained on the board for a further six years. Although experiencing severe financial hardships, Triumph pro-duced some of their greatest cars of the 1930s, most notably the superb Gloria range through the design skills of Walter Belgrove and Donald Healy. Triumph's motorcycle division was acquired by Ariel's Jack Sangster (b. 1896) in 1935, as the company continued to struggle. The company went into receivership in July 1939, being put up for sale as a 'going concern'. It was bought by the Sheffield engineering company Thomas Ward & Co. as the Second World War got under-way, Donald Healey appointed as general manager. It is believed that around thirty-five 12hp

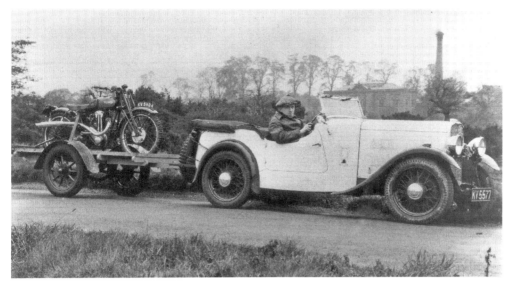

A good advert for the Triumph company – one of their trials motorcycles being towed by a Triumph Super Nine model.

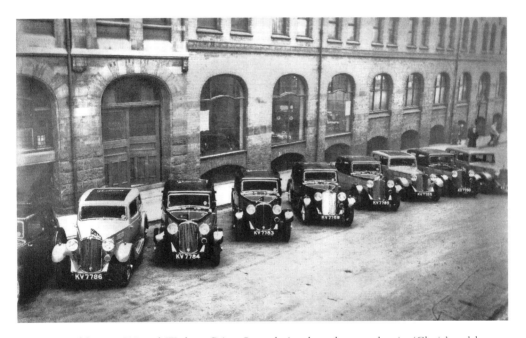

A rare view of the great Triumph Works on Priory Street during the early 1930s, showing 'Gloria' models.

Triumphs were made before the war would impact upon the fortunes of the Triumph name, as much of the Priory Street and Clay Lane factories were destroyed during the air raids of 1940/41, the Gloria Works fairing no better. In 1945, Sir John Black of the Standard Motor Company purchased what remained of Triumph's assets for £75,000, and, as a subsidiary concern, the new business was renamed the Triumph Motor Company (1945) Ltd. The first Triumph cars produced under Standard control were the '1800' Roadster models, soon followed by the Renown

range. The American-styled 'Mayflower' arrived in 1949, and by 1952 the Triumph name was chosen to represent Standard's sports ambitions with the release of the TR2, the following series of which were to become a great success for the company. The Triumph Herald arrived in 1959, the same year that the entire business became Standard-Triumph International Ltd, but within two years was taken over by Leyland Motors, with Stanley Markland as Managing Director. The last car to carry the Standard name was the 'Ensign' in 1963, yet the Triumph brand became ever stronger with the release of famous models including the '2000', the 'Stag', 'Spitfire', 'TR7' and 'Dolomite' cars until 1980 at Coventry. The last car to carry the name was the re-badged Honda model called the 'Acclaim', which was built at Cowley until 1984.
(See also Climax, Donald Healey, and Standard.)

VELOX, 1902–1904 (1897–1904)
Velox Motor Co. Ltd, Parkside

The origins of Velox began as the Amalgamated Pneumatic Tyre Company in 1897 at a new factory at Parkside, said to have been formed to take over a host of existing tyre companies, including Beeston and Scott's. The Directors at this time were Earl De La Warr, James Bradshaw, Henry Jelley, Basil Gee, Albert Gamage, Edward Rawlings and Herbert E. Cohen. They began by promoting their 'A.B. non-puncturable' tyres, but by early 1902, started marketing 'A.B. Velox' tyres, now under the title of the New Amalgamated Tyre Company. Soon afterwards they became the Velox Motor Company, with a working capital of £50,000 under the Directorship of George H. Dive (b. 1872) and A.G. Harris. Initially they offered three models ranging from the 'Miniature' Aster-powered 4hp single-cylinder two-seater model from £125, to the large 20hp four-cylinder at £750. These vehicles included a number of interesting yet complex features, including an additional transmission brake and an adjustable steering column. With

Advert showing a 12hp Velox model for 1904.

regards to their late Victorian works, one report stated, 'It [Velox] has very fine premises well adapted for the manufacture of cars and their directors consider that, situated as they are in the centre of the motor industry, they would be wasting their opportunities if they were not to avail themselves to the full use of the fine modern factory'. The running of the company was probably managed by Arthur Witherick, while the cars themselves were known to have been designed by John Budge. Arthur Ernest Witherick was born at Bethnal Green in 1868, the son of a boot maker. On leaving school he became a ledger clerk and stamp dealer before entering Coventry's cycle industry around 1897. Living at nearby 49 Cheylesmore with his wife and children, in 1901 Witherick was seen listed as a 'sales manager at a tyre company', and, in 1904, he was left the responsibility of acting as receiver when Velox was wound up. John Budge was born in India in 1875, the son of the Scot, James M. Budge, a locomotive engineering foreman. He was educated at Barton School, Wisbech in Cambridgeshire, before apprenticing at Richard Hornsby & Sons' engineering works at Grantham, Lincolnshire. By 1901 he was lodging at Cox Street, Coventry, working as a 'mechanical draughtsman' for the Humber Company, but a year later he was appointed by Velox, placed in charge of the design and build of their motors. Only twenty-one cars were said to have been completed; the remaining ones in the course of construction were offered along with plant and machinery by Witherick. Budge went on to become a manager at the Standard Motor Company, while the Velox works, and no doubt all its trappings, were taken on by George Iden. In March 1904, a company called the Velox Engineering & Autocar Company began in London, which may well have been connected. *(See also Iden.)*

VERNON, 1905–1910 (1898–1930)
Vernon Cycle & Motor Co. Ltd, Star Yard, 32 Earl Street

The Vernon Cycle Company was founded in 1898 at Earl Street through an interesting partnership that existed between Oliver Perkins and Eliza Cleaver. Oliver Charles Perkins (b. 1880) was the son of William Perkins and grandson of Joshua Perkins, two Coventry coach lace manufacturers. Oliver himself first ventured into the coach lace industry before being gifted a share of a cycle company. Eliza Cleaver (b. 1847) was the widow of William Johnstone, a watchmaker and landlord of the Smithfield Hotel in Hales Street. When he died in 1890, Eliza continued in the pub trade and was known to have run the White Swan on Hill Street, yet she also had the foresight to buy into the cycle trade, forming an unusual partnership with the much younger Oliver Perkins at premises to the rear of the Old Star Inn. As the Vernon Cycle Company, this was known to have dissolved in 1905, and it was probably at this point that the name was changed to that of the Vernon Cycle & Motor Company at the same address. Under the management of Eliza's son, Frank Johnstone (b. 1879), it is uncertain how far exactly the company went in terms of actual motor production. However, considering that Frank Johnson had been in partnership with Louis Brandes as 'motor engineers' in Coventry until 1903, one would assume that, at best, some experimental work occurred. Motors aside, it was with the manufacture of cycles that the company was most renowned. Seen listed as 'gas lamp manufacturers' prior to the First World War, the business ran into difficulties in the early 1920s, but struggled on until closure in around 1930. Why the name Vernon was used in the title of this cycle and motor firm has yet to be established. *(See also Saxon.)*

VIKING, 1914 (1911–1922)
Viking Motor Body Co., Viking Motor Body Works, Warwick Street, & King William Street

The Viking Motor Body Company was thought to have begun in 1911 for the purpose of, as their title would imply, manufacturing motor bodies. Indeed this is confirmed by an advert

VIKING MOTOR BODY C°

Open or Closed Bodies of every description for the Trade and private use. COACH-BUILT SIDECARS—lighter and stronger than Wicker or Cane bodies. Price List and Illustrations on application.

WARWICK STREET, EARLSDON
COVENTRY. Telephone 135y.

A 1912/13 trade directory advert for the Viking Motor Body Company. Did they ever make complete cars?

placed in the 1912/13 Coventry Spennell Directory showing the company to be at Warwick Street offering 'Open and closed bodies of every description for the trade and private use', and 'Coach-built sidecars – lighter and stronger than wicker or cane bodies'. However, in 1914, a company called Viking Motors Limited released a shaft-driven light car at King William Street, Coventry, powered by a four-cylinder Mathis engine and priced at £160 for a two-seater. One source names James Thrift as owner, and census reports of the period do indeed show a James Thrift (b. 1842) of Wolverhampton to be living at 34 Warwick Street. Although his occupation of 'farm labourer' falls well off the mark, his two sons, Herbert and Harold, are recorded as 'motor body mounter' and 'motor trade tool maker' respectively, which may hold some substance. If the Thrift family were connected to actual car production at King William Street, then this may have been in the same premises that John and Ernest Twigg's Broadway company used – known to have made cycle cars there from 1913. Viking's Motor Body Works are believed to have closed by 1922 and the premises were later taken over by the Coventry Gauge & Small Tool Company. (See also Broadway.)

WARWICK, 1923 (1919–1968)
S.H. Newsome, Walsgrave Road & Lythalls Lane

At around the same time that Sammy Newsome was developing his 'Cooper' light car whilst forming his garage and car dealership business; he also built a race car called the 'Warwick'. This took the form of a 1.5 litre Janvier-powered car which was entered into the 1923 Brooklands 200-mile race. Newsome had held a fascination with competitive motor racing from an early age, making his Shesley Walsh hill climb debut in 1921 and not missing a year thereafter. In addition to this, he raced regularly at Brooklands, in cars that he himself had primed to high-powered Jaguar models later on. Newsome's determination on the race circuit was echoed in his business activities. He began in a modest way, paying himself just £5 a week from the payroll, to amassing a self-made fortune. However, it was not just the motor trade that he

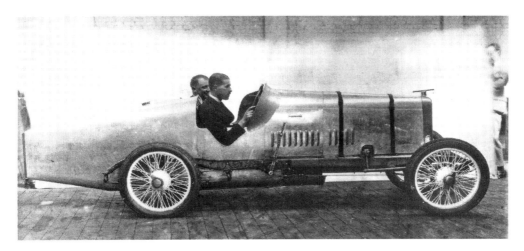

Sammy Newsome pictured at the wheel of his 'Warwick' racer in 1923.

found himself involved in. His father, Samuel Thomas Newsome (1869-1930), was a watch manufacturer by profession, but had acquired an interest in the theatre around 1910, becoming a Director on the board of both the Coventry and Aston Hippodromes. When he died in 1930, Sammy, having no experience or even interest in the stage, took his place on the board. Over time he created a new theatre in Coventry and arranged with Emile Littler to show matinee performances there. In 1942, Newsome joined the board of the London Theatre Group – Stoll Theatres Corporation. Over time he became a big name in the field, holding managing directorships at three of the largest Midland theatres, and directorships of world-famous London venues including the Stoll, Phoenix, Adelphi, the Theatre Royal and Drury Lane.
(See also Cooper and Newsome.)

WEST, 1904–1913 (1888–1915)
E.J. West & Co. Ltd, Canal Bridge Motor Works, Foleshill Road
West Ltd, Canal Bridge Motor Works, Foleshill Road, & Lower Ford Street

Enoch John West's Progress Company had gone into liquidation in late 1903, but, not being a man to give up easily, by January 1904 he was back in business, this time under the title of E.J. West & Co. at new purpose-built premises on Foleshill Road. A number of former Progress employees were thought to have transferred to the new venture at this time, including James George Morgan (b. 1859), Thomas Harrison (b. 1859), George Caulton (b. 1861), John Liggins (b. 1864), and George Perkins (b. 1873). Initially, West began making 10hp and 12hp chassis using double-cylinder

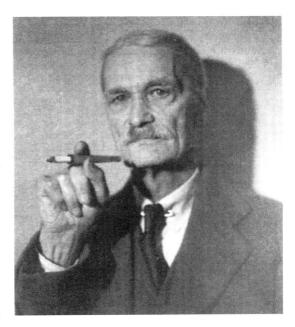

A photograph of Enoch J. West, taken in his later years.

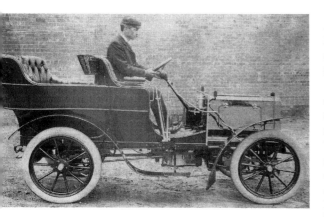

1904 image of a 10/12hp West car, with Enoch J. West at the wheel.

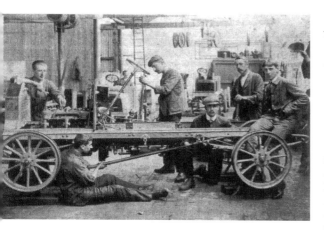

est employees are seen here working on a 'West' chassis of 1905/06.

Aster engines, most notably for the Heron Motor Company of Birmingham, later known as 'Heron-Aster' cars, and also for Turberville Smith's driving school 'Academy' models from 1905. Other firms known to have been customers of West chassis and components at around this time included the likes of Scout, Singer, and Calthorpe. From July 1905, however, E.J. West & Company became West Ltd, and recommenced manufacture of complete cars as well as supplying chassis to the trade. On the Board of Directors at this time was Sydney Dawson Begbie (b. 1865) of Aster Ltd, and one of West Ltd's first appointments was that of Percy Lamb, formerly of Lamb Bros & Garnett of London, as 'sales manager'. Among others known to have joined the ranks was West's own son, Arthur J. West (b. 1892). Five 'West' models appeared in 1905, ranging from 10hp to 22hp, succeeded by seven models the following year in preparation for the 1907 season of 10hp to 30hp. From February 1907, future cars produced by West Ltd would be known as 'West-Aster', consisting of no less than thirteen Tourers and Landaulettes of 15hp-30hp. The latter was a six-cylinder limousine sold at £620, yet production ended in 1908 due, once again, to operational costs and West himself was later to have remarked, 'I sold more cars off the doorstep in Coventry than ever went through the London showroom'. Reverting back to E.J. West & Company, a move to Lower Ford Street followed and chassis production resumed once more. In 1910 he released his 'West' light car, which later was adapted to the 'Pilot' light car, once again for supply to Turbeville Smith of Motor Schools Ltd. West and Pilot cars continued to be built until late 1913, when, once again, finances were stretched. Still not ready to stand down, Enoch John West concentrated on another enterprise he had established earlier in the year at West Orchard, going on to sell cycle cars under the 'West' and 'Ranger' trade names. (See also Academy, Progress, and Ranger.)

WEST-ASTER
(See West.)

WHITEHOUSE, 1914 (1914–1922)
W.H. Whitehouse, 16 Friar's Road

In March 1914, Walter Henry Whitehouse appeared in the *Applications for Registration of Trade Marks* at his home address of 4 Spencer Avenue, Coventry, listed as a 'manufacturer of velocipedes, motor cycles, cycle cars and motorcars', yet whether any complete cars were made is so far unknown. Whitehouse was known to have been works manager at the Premier Cycle Company

from around 1905, taking out a patent (18,987) in that year concerning 'improvements in gear cases for cycles'. In November 1913, still as works manager, he applied for a second patent (26,689) along with works foreman Peter Moss and Managing Director Alexander Rotherham, relating to variable speed gearing. Although the precise origins of Whitehouse are not yet clear, evidence suggests that he was American by birth. The 1911 census shows his wife, Louise, living at Spencer Avenue, but three of their four children were seen to have been born in the USA between 1897 and 1902, proving that at very least they lived there for a time. Also at Spencer Avenue is another Louise Whitehouse, a 'visitor' aged 18 of America, who is listed as 'niece'. Walter himself is not found on the 1911 census, indicating that he was most probably overseas at that time. What is known for certain is that in 1915, Whitehouse began marketing his 'Revere' motorcycles at an address at Friar's Road, assembled by the Sparkbrook Manufacturing Company of Coventry, and in 1919 added Villiers-powered motorcycles, this time under the 'Whitehouse' name, again built by Sparkbrook. It was with cycle manufacture that he ultimately continued after the war, but by 1922 the company was wound up and his subsequent activities are so far unknown.

WHITE & POPPE, 1899–1933
White & Poppe Ltd, 4 Drake Street, Lockhurst Lane & Holbrook Lane, Foleshill

The company of White & Poppe Ltd began in October 1899 with a capital of £4,000 in £1 shares through a partnership incorporating Alfred James White and Peter August Poppe. Poppe, born in 1870, was of Norwegian origin and a highly skilled civil engineer. White was born in Earlsdon, Coventry also in 1870, the son of Joseph N. White, the former watch manufacturer and Director at both the Singer and Swift cycle companies. They first met while visiting the Steyr small arms factory in Austria in the early 1890s, and, after a few meetings, White suggested that Poppe should move to England. After some deliberation he agreed and by September 1899 they joined forces, specialising in engine making for supply. On moving to Coventry, Poppe brought with him a De Dion tricycle that he had purchased in Austria, no doubt using it to commute to work. White's family invested the majority into the new venture with White himself personally taking over the responsibility of accounts as 'general manager of mechanical engineers'. Poppe, on the other hand, took control of the design side. By 1902, the company were thought to have begun building their own complete motorcycles using 5hp vertical-twin engines. Although this was to continue on a very limited scale for the next twenty years, the company concentrated their efforts more on engine supply, gaining lucrative contracts with companies such as Ariel, Swift, and, later, the Morris Motor Company. The First World War was to prove instrumental in White & Poppe's future success. At the outbreak of war in 1914, the company employed around 350 workers, yet by 1918 this had reached 12,000. This was due to the large contracts agreed by the company to build millions of munitions components, mostly made up of aluminium fuse bodies and shell-sockets. Much of this skilled work was undertaken by women, who were drafted into Coventry in their thousands from all over the British Isles and beyond. These women became known locally as the 'W & P Canaries' because the explosives used in their work stained their hands, faces and clothes yellow. Between 1912 and 1927, the company were often listed under 'motorcar manufacturers' in local trade directories, yet whether any complete vehicles were ever produced by White & Poppe at Holbrook Lane would appear unlikely. In 1920, White, the principal shareholder, sold his interest to the Dennis Company. Poppe stayed on for a further two years before joining Rover as chief engineer, where three of his sons already worked, including Olaf Poppe as works manager. In 1925, Peter Poppe designed the Rover 14/45, which unfortunately proved to be a commercial disaster for the company. By 1930 Colonel Searle was drafted in to streamline departments and, as a result, Poppe was sacked and his son Olaf given six months notice. Many thought that this was a direct result of Poppe's earlier miscalculations, which the board members had not forgotten. The White & Poppe Company ceased all business in 1933.
(See also Rover and Swift.)

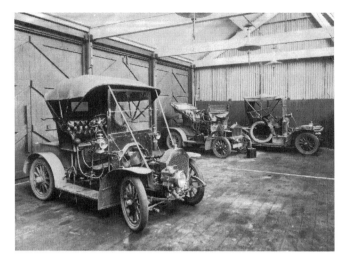

Cars pictured minus their power units at the White & Poppe factory.

A superb image taken within the stores department at White & Poppe.

WHITLEY, 1903–1905 (1902–1909)
Whitley Motor & Engineering Co. Ltd, Whitley Works, Cow Lane, & Fleet Street

The Whitley Motor Company was yet another firm established in Coventry on the back of the fast-growing motor industry, their factory being located in Cow Lane, an ancient street once crammed with timber-framed buildings. They began in September 1902 with a working capital of just £500, and were first seen listed in the 1903 Coventry Directory as 'motorcar manufacturers', yet predominately, Whitley's main purpose involved the production and supply of a range of proprietary engines, carburettors and tanks, but also motor-bicycles and fore-cars. These belt-driven machines were fitted with their own engines hung from the underside of the down-tube, the overall finish of which was of a very high standard. Once again, the exact details of the individuals behind the firm are not fully known, yet there are some useful clues. The *Motor Cycle* of July 1903 reviewed the 'Whitley' motor-bicycle and fore-carriage in relation to its fitted 'Air Scoops', stating, 'The combination first attracted our attention as it was climbing a stiff hill near Coventry, without the slightest sign of flagging, and on interrogating Mr Hubbard of the Whitley Motor Co., he assured us that the draught induced by the scoops was very considerable, and kept the motor completely cool'. In view of this, there are a number of men with the Hubbard surname who may be linked here. One is that of William Sammons Hubbard, who, in the late 1880s, formed a partnership with Alfred Herbert in Coventry. By the turn of the century, however, he was in partnership with William Taylor in Leicester as 'engineers and crane makers', so unless he was a distant owner, then this would seem improbable. Another more likely possibility is three brothers from Cambridge: Charles, Edgar and Hubert Hubbard, all seen to be living and working in Coventry at this time. A joint patent (2830) of 1896 with Henry Jelley regarding pneumatic tyres shows that Charles Hubbard was residing at 'Whitley Villa' in the Whitley area of Coventry at that time, and could be a possible reason for naming his motor business that of the Whitley Motor

Company. The business was wound up in 1909, with Charles already having moved north to Lancashire, finding employment with the India rubber manufacturers, Charles Macintosh & Company. Another enterprise later using the Whitley name came about in 1919, with the sidecar makers The Whitley Manufacturing Company Ltd at London Road, yet it is unlikely to bear any relation.
(See also Hubbard.)

WIGAN-BARLOW, 1922–1923 (1921–1923)
Wigan-Barlow Motors Ltd, Lowther Street & David Road

Wigan-Barlow Motors Ltd made a very brief entry as 'motor manufacturers' in the early 1920s in Coventry. Beginning in 1921, the partnership was formed by Aubrey John Graham Wigan and Captain Ashworth Barlow. Wigan was born in 1897 at Aylesford, Kent, the son of a wealthy banker and had a private education in Eastbourne from a very early age. Apart from hailing from Hartlepool and spending time in Scarborough, little is known about Barlow's early life, yet due to his military title, one would assume he experienced some service during the First World War. It is not known when or where the two men met, but in December 1921 they registered Wigan-Barlow Motors Ltd at Rotherham's solicitors' office in Bayley Lane, Coventry, securing new premises at Lowther Street soon after. Here they developed motorcycles assembled from outsourced components incorporating 293cc JAP and 346cc Barr & Stroud engines. In early 1922 they also began making light cars powered by 1368cc Coventry-Simplex engines, followed by two larger Meadows-powered models designed by the consulting engineer Frank Carey, one being known as the '11/40 Sports'. As well as being shareholders in the Lewis Ordnance Manufacturing Company of London, Wigan and Barlow had their sights set on exhibiting their products at the Olympia Show in December 1922, yet the idea was shelved when the business ran into difficulties and ceased all trading only a few weeks later.

WILLIAMSON, 1913–1916 (1911–1920)
Williamson Motor Co. Ltd, Cromwell Works, Cromwell Street, & Moor Street

William Williamson was born in Coventry in 1873, one of five children born to parents William and Emma. William senior was a 'gold watch case manufacturer' by profession, and his three sons naturally apprenticed under their vastly experienced father. One by one,

A rare image of a Williamson three-wheeler. Billy Williamson had previously been manager at the Rex Company.

however, all three departed the steeply declining watch industry and transferred their skills to the booming cycle trade, possibly encouraged and influenced by their uncle, Frederick Williamson, who worked as a 'commercial traveller of bicycles and tricycles'. William and his younger brother Harold made the biggest steps into the cycle trade, William becoming a mechanic and Harold a clerk, most probably at Allard & Company. By 1902, both were employed at

the newly formed Rex Motor Manufacturing Company at Earlsdon, an offshoot of the Allard firm and keen to make a stake in the fast developing local motor industry. At Rex, both brothers rose to quite senior positions, with William becoming Managing Director, but an apparent boardroom bust-up in 1911 saw both walk out. Harold took a sales manager job at the Singer Motor Company, but William decided to set up on his own account at Cromwell Street, a stone's throw from his former employees. Here, Williamson and his skeleton staff commenced manufacture of their 864cc Douglas-powered 'Williamson' motorcycles, the choice of engine down to the fact that William was in fact a cousin of Willy Douglas (b. 1859) of the Bristol-based Douglas Motor Company. By 1913, a small two-cylinder 8hp Douglas-powered three-wheeler was introduced, and, rather like a Morgan in appearance, was chain-driven to a single rear wheel. The outbreak of war clearly hampered this production when the company transferred its manufacture to aid the war effort, but motorcycles and sidecars continued to be built until closure in 1920, when Billy Williamson died, aged 48.

(See also Rex.)

WILLIS, 1914 (1907–1914)
Willis, F., 333 Foleshill Road

Frank Willis was born just outside Belfast, Northern Ireland in 1877. Towards the end of the 1890s he moved to Coventry and found work as a 'cycle brazier', lodging at the house of schoolmaster Charles Rogers on the Foleshill Road. After marrying local woman Annie Hackett from Longford in 1901, Willis had started working on his own account as a 'cycle and motorcycle manufacturer' at number 333 Foleshill Road by 1907. This appears to have been Willis' staple trade activity over the following years, yet by 1911 he was just listed as a 'cycle agent and repairer', indicating that the manufacturing side of things had not been too successful. However, the 1914 Bennett's Business Directory of Warwickshire had Willis listed under three separate entries: a cycle manufacturer, motor accessories manufacturer, and motorcar manufacturer. The motoring element supposedly related to his involvement with the production of a very short-lived 8hp cycle car fitted with 'many notable features', but to what extent will probably never be fully known.

WOOLLISCROFT, 1903
Woolliscroft Motor Company, 177–179 Foleshill Road

A recently discovered name, the *Automotor Journal* of April 1903 showed that a business going by the name of the Woolliscroft Motor Company had been registered at 177-179 Foleshill Road. With a considerable working capital of £30,000 in £1 shares, its first Directors were given as W.A. Taylor, W.W. Woolliscroft and F.C. Colliard. Further research reveals that William W. Woolliscroft (b. 1872) was actually a registered medical practitioner of Chelsea, while Francis Cecil Colliard (b. 1882) was simply a fortunate young man of considerable independent means. The only Director with any motor engineering experience therefore was William Allen Taylor, a former works manager of the British Motor Company. Taylor was also instrumental in the formation of the Force Motor Syndicate, of which Woolliscroft's brother, Frederick E. Woolliscroft, was also Director. Whether any complete vehicles were ever developed under the 'Woolliscroft' name is not known but would appear doubtful.

(See also British Motor Company, and Force.)

MOTORCAR MANUFACTURERS WITH CLOSE LINKS TO COVENTRY

A.B.F., 1918–1923
All British Ford, Ford Motor Works, Kenilworth

Kenilworth garage owner Albert Owen Ford made a brief entry into car manufacture in 1918 with his 'A.B.F.' light car. 'Bertie' Ford, as he was more commonly known, was born in 1887 at Exeter, and by 1911 was seen to be working in Grantham, Lincolnshire, as a 'motor engineer'. During the First World War, it is believed that he joined the RAF, being stationed in Canada. Whilst there he was reportedly involved in a flying accident, and on returning home took to building cars on a very limited scale. A.B.F. stood for 'All British Ford' so as not to tread on the toes of the American giant, the Ford Motor Company of Detroit, yet it is highly unlikely that Henry Ford ever caught wind of it. These small cars took the form of a 1216cc V4 Two-stroke engine of three speeds under the body of a 10/30 Alvis shell. Ford sold up his Kenilworth business during the mid-1920s and is known to have married a Miss Mabel Lillian Sadler at Shipston-on-Stour in 1929. Settling at Worcester Road at nearby Moreton-in-Marsh, Ford is believed to have opened up a motor garage that he ran for many years. In 1934, he invented a surgical device to assist in the healing of fractures, a concept that may well have stemmed from his earlier flying mishap.

ARDEN, 1912–1916 (1912–1924)
Arden Motor Co. Ltd, Kenilworth Road, Balsall Common, & Blacksmith Corner, Berkswell

Named after the ancient Forest of Arden, which once covered much of Warwickshire, the Arden Motor Company was set up in 1912 in rural Berkswell, a picturesque village just west of Coventry. It is believed that the company was part-financed by two unknown wealthy engineers from Worcestershire, and a builder's foreman called Ernest Alfred Isherwood (b. 1875). Isherwood hailed from Cleckheaton in Yorkshire and apprenticed as a joiner before moving to Berkswell in the late 1890s, becoming a builders manager for the building contractor Charles Hope (b. 1864). By 1912 the Arden Motor Company was formed, offering a V-Twin air-cooled JAP-powered cycle car initially. This was followed by an Alpha-powered two-cylinder model, the engine being supplied by Daniel Hurley of Coventry. By 1914 they were selling two-cylinder cars from £145 and four-cylinder models from £160, before the small factory was turned over to the production of artillery shells for much of the First World War. Isherwood died at the young age of 44 in 1918, but the company continued trading under the name of the Arden Motor Company at Berkswell until 1924, but under whose supervision is unclear.
(See also Alpha.)

CROWDEN, 1898–1904
Crowden, C.T., Leamington Motor Works, Packington Place, Leamington Spa

The son of a schoolmaster, Charles Thomas Crowden was born in 1859 at Halesworth, Suffolk. The family moved to Bath during the 1860s, where young Thomas attended the Blue Coat School, governed by his grandfather. In 1869 he became a pupil at the Bath Grammar School, where he became 'instructed in natural science, chemistry, drawing, and applied mechanics, in which he excelled'. Even at a young age he was said to have had a small workshop fitted with lathes and tools, where he constructed many things of his own design, ranging from velocipedes to canoes. He also frequented the Pickwick Iron Works on Wednesday afternoons, where he was reported to have had 'a free run of the place, working the lathes, using the tools, and watching the blacksmith, wheelwright and others at work'. Against his grandfather's wishes (who hoped he would work in banking), he was first employed at Stothert & Pitts Newark Foundry at Lower Bristol Road, Bath, where he remained for a number of years engaged in the manufacture of dock cranes. He then secured a position at Merryweather & Sons in London, the makers of steam fire engines, becoming one of their chief designers. Always keeping an eye on cycling developments, in 1884, together with Herbert James Pausey, he developed a rear-driven safety bicycle, but it did not reach the same success of that of John Kemp Starley's version in Coventry. In 1887, he was involved with the development of Edward Butlers' 'Butler Petrocycle'. On leaving Merryweather's he became the works manager at the Vulcan Engine Works at Northampton, before joining the cycle manufacturers Humber & Company as chief engineer at their Beeston works in 1893. After some three years at Humber, Crowden became engaged at the Motor Mills in Coventry in a senior capacity, working for the Great Horseless Carriage Company at a time of great significance. At the Motor Mills, Crowden was part of the very beginning of the British motor industry, either working on or witnessing the creations of the very first home-made Daimler, Humber, and Pennington motors. Whilst working in Coventry, Crowden chose to make a home for his family at 10 Eastnor Grove in Leamington Spa. There, he later acquired the old factory of the coachbuilder Henry Mulliner, and in 1898 started a motor company on his own account, putting many of his designs to work. Crowden's first patent concerning motorised transport came in 1896 whilst still at Beeston, but in his new Leamington works he set about experimenting with steam and paraffin-powered models, yet it was the petrol motor on which he ultimately concentrated.

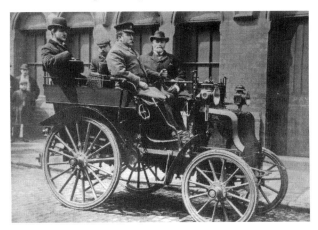

His 1900 dog-cart was powered by a 5hp horizontal single-cylinder engine with three-speed belt drive. In 1903, he supplied the first motorized fire engines to the Leamington Corporation, followed by fire tenders for both Leicester and Worcester. In 1905, he moved to Ramsgate in Kent, where he worked as a 'consulting engineer' while seemingly retaining the Warwickshire business. There he continued to develop motors and other devices over the following years, including automatic sprinklers, and machineguns by 1916. He died at Nottingham in 1922, aged 63.
(See also GHCC.)

Apparently, Charles Thomas Crowden is seated inside this 1897 Daimler whilst on the Birmingham Run. Having been born in 1859, this would make him around 38, so could he be the man at the back in the cloth cap?

COVENTRY MOTORCAR MANUFACTURERS QUICK LIST

The following list hopes to cover all known abd discovered manufacturers of motor cars in Coventry from 1880 to present day. The names where ★ appears denotes that the production of complete motor cars has not yet been substantiated and therefore would either appear doubt-ful, or requires furhter investigation if possible.

Coventry Motorcar Manufacturer or Marque	Years of Car Manufacture
A.B.F. (ALL BRITISH FORD)	1918–1923
ACADEMY (E.J. WEST & CO.)	1905–1908
ACME/COVENTRY ACME	1919
AERO & MARINE★	1910–1927
AIRCRAFT★	1919–1927
ALBATROS	1923–1924
ALLARD	1898–1902
ALLIANCE★	1898
ALPHA (JOHNSON, HURLEY & MARTIN)★	1904–1927
ALVIS	1922–1967
ARDEN	1912–1916
ANDY ROUSE	1983–1997
ARIEL	1907–15 & 1922–25
ARMSTRONG-SIDDELEY	1919–1966
ARNO	1908–1912
AURORA	1903
AUTO FORGE	1987–90 & 1994–96
AUTOVIA	1936–1938
AWSON★	1926–1932
B. & A.★	1937–1939
BAKER	1922
BARNETT★	1921–1932
BAYLISS★	1919–1927
BEESTON	1896–1901
BILLING	1900
BLUEBIRD (MOTOR PANELS)	1960–1962
BRAMCO	1920–1922
BRITISH BUSINESS MOTORS	1912–1913
BRITISH MOTOR COMPANY★	1895–1900
BRITISH MOTOR TRACTION★	1901
BROADWAY	1913
BROOKS	1900–1902
B.S.A.	1921–26 & 1933–36
BUCKINGHAM	1912–1923

CALCOTT	1913–1926
CARBODIES/LTI	1946–PRESENT
CARLTON	1901–1902
CENTAUR	1900–1905
CHALLENGE★	1912
CHARLESWORTH★	1914
CHRYSLER	1967–1978
CLARENDON	1902–1905
CLEMENT (SWIFT MOTOR CO.)	1908–1914
CLIMAX MOTORS	1904–1907
CLULEY (CLARKE, CLULEY & CO.)	1920–1932
C.M.S. (COVENTRY MOTOR & SUNDRIES)	1929–1931
CONCEPT CLIMAX	2007–PRESENT
CONDOR	1912 & 1933–1940
COOPER	1922–1923
CORONET	1903–1906
COVENTRY CENTRAL★	1903
COVENTRY ENSIGN★	1913
COVENTRY MOTETTE (COVENTRY MOTOR CO.)	1896–1899
COVENTRY MOTOR BODIES★	1914
COVENTRY PREMIER	1914–1924
COVENTRY VICTOR	1919–38 & 1949
CRAWFORD ★	1901–1903
CROMWELL ★	1911
CROUCH	1912–1928
CROWDEN	1898–1904
CUNARD★	1901–1905
DAIMLER	1896–2002
DAISY★	1912–1925
D.A.W. (DALTON & WADE)★	1901–1903
DAVID BROWN AUTOMOTIVE	2013-PRESENT
DAVISON★	1919–1930
DAWSON	1918–-1921
DEASY	1906–1911
DOHERTY★	1904–1910
DONALD HEALEY★	1946–1970
DURYEA	1904–1907
DUTSON-WARD★	1903
EMMS	1922–1923
ENDURANCE	1898–1900
FERGUSON	1950–1972
FLEET★	1900-1914
FOLESHILL★	1905
FORCE★	1902–1905
FORMAN	1904–1906
GARRARD & BLUMFIELD (RAGLAN CYCLE CO.)	1894–1896
GENERAL AUTOMOBILE★	1926–1932
GLOVER	1912–1913
GODIVA (PAYNE & BATES)	1900–1901
GREAT HORSELESS CARRIAGE	1896–1898
GRAVENOR★	1906–1910
HAMILTON	1900–1910

HARDY	1905
HARRIS★	1899–1940
HILL★	1919–1924
HILLMAN	1910–1972
HILLMAN-COATALEN	1907–1910
HOBART-ACME★	1923
HOBART-BIRD	1901
HOLLICK & PRATT★	1904–1914
HOTCHKISS	1920
HUBBARD	1903–1905
HUMBER	1895–1976
IDEN	1903–1908
JAGUAR	1945–2005
JONES★	1914
KALKER★	1903
LADY	1899
LANCHESTER	1931–1956
LAWSON	1880
LEA-FRANCIS	1903–1906 & 1919–1961
LEE-EABB★	1926–1934
LEE-STROYER	1903–1907
LYONHEART	2012-PRESENT
MAGUIRE	1977–1999
MANLY & BUCKINGHAM★	1911–1912
MARSEEL/MARSEAL	1919–1925
MAUDSLAY	1902–1954
M.M.C.	1898–1905
MONOPOLE	1900
MOORE & OWEN★	1904
MOTOR AGENCY★	1899–1900
MOTORIES★	1912–1920
MOTOR BODIES★	1905
MOTOR RADIATOR★	1912–1913
NEVILLE-SINCLAIR★	1904–1906
NEWSOME	1939
NOBLE★	1911–1912
NORTON★	1904–1905
OMEGA (W.J. GREEN LTD)	1925–1927
PAYNE & BATES	1898–1902
PENNINGTON (G.H.C.C.)	1896–1898
PEUGEOT	1986–2007
PEUGEOT-TALBOT	1979–1986
PRIORY	1901–1905
PROGRESS	1897–1903
QUADRANT★	1909
RAGLAN	1899
RANGER	1913–1915
RECORD★	1904–1905
REMINGTON★	1919–1939
REX	1902–1914
RIDLEY	1901–1904
RILEY	1898–1948

ROVER	1899–1945
ROYAL EAGLE (COVENTRY EAGLE)	1900
RUDGE	1912–1913
RYLEY (RYLEY, WARD & BRADFORD)	1901–1902
SAXON (BRANDES & PERKINS)	1902
SIDDELEY	1902–1905
SIDDELEY-DEASY	1911–1919
SINGER	1905–1945 & 1956–70
SPEEDAUK★	1923
SPITTLE, W.J.	1914
SS CARS	1928–1945
STANDARD	1903–1963
STARLEY	1888
STONEBOW (PAYNE & BATES)	1900–1901
STONELEIGH	1912–1932
STURMEY	1907–1912
SUNBEAM TALBOT	1946–1956
SUPERCAR ★	1937–1940
SWIFT	1898–1931
TALBOT	1978–1979
TAYLOR-SWETNAM	1912–1913
T. G. JOHN LTDS	1920–1922
TITAN	1910–1913
TRIUMPH	1923–1980
VELOX	1902–1904
VERNON★	1905–1910
VICTORIA★ (BRANDES & PERKINS)	1902
VIKING★	1914
WARWICK (S.H. NEWSOME)	1923
WEST, E.J.	1904–1905
WEST LTD	1905–1913
WHITEHOUSE★	1914
WHITE & POPPE★	1899–1933
WHITLEY	1903–1905
WIGAN-BARLOW	1922–1923
WILLIAMSON	1913–1916
WILLIS★	1914
WOOLLISCROFT★	1903

INDEX